Anna Moszynska
studied art history at University College London
and did her graduate work at the Courtauld Institute of
Art. She lectures extensively and has conducted guided
visits to the National Gallery, London, the Tate Gallery
and the Saatchi Collection. She is Senior Tutor and
Course Leader for the MA Degree Course in Post-War
and Contemporary Art at Sotheby's Educational Studies,
London, has acted as exhibition coordinator for the Arts
Council of Great Britain and has contributed
to various art magazines.

WORLD OF ART

This famous series
provides the widest available
range of illustrated books on art in all its aspects.
If you would like to receive a complete list
of titles in print please write to:
THAMES AND HUDSON
30 Bloomsbury Street, London WC1B 3QP
In the United States please write to:
THAMES AND HUDSON INC.
500 Fifth Avenue, New York, New York, 10110

Printed in Singapore

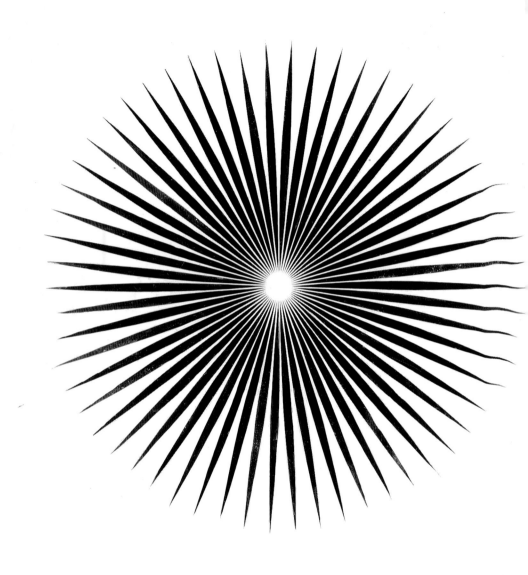

Anna Moszynska

Abstract Art

With 162 illustrations, 25 in color

Thames and Hudson

For Colin

Frontispiece: TAAFFE *Big Iris* 1986

ACKNOWLEDGMENTS

In writing this book, I am particularly indebted to
Beth Houghton and staff at the Tate Gallery library;
Christopher Green and Sarah Wilson for reading the
manuscript at an early stage and commenting upon it;
Lynne Cooke and Tony Godfrey for their extremely
helpful comments in discussion; and Angela Cowhey for
help with the typing. I would like to extend my thanks to
them and to the many artists whose works have inspired
me. Sadly, not all of these could be discussed within the
confines of this book.

First published in the United States of America in
1990 by Thames and Hudson Inc., 500 Fifth Avenue,
New York, New York 10110
Reprinted 1995

Library of Congress Catalog Card Number 88-51347
ISBN 0-500-20237-0

Printed and bound in Singapore

Contents

1 HALLEY *Yellow Prison with Underground Conduit* 1985

Preface

Abstract art has frequently baffled many people, largely because it seems unrelated to the world of appearances. Like other forms of modernist art, it poses difficulties of understanding and judgment, and calls into question the very nature of art. Unlike portrait or landscape paintings, which are believed to represent the world, abstract painting apparently refers only to invisible, inner states or simply to itself. It thus challenges the spectator and raises puzzling questions: What is this kind of art about? Is it art, or is it mere decoration? What is it trying to say (or do), and how is one supposed to react to it? What criteria can be used to evaluate it? Why have artists in the twentieth century chosen to turn their backs on the commonly perceived world, which, after all, seems to have served earlier artists perfectly well for centuries? Is depiction an accurate record of perceived reality in the first place? What is, in terms of art, an accurate record?

In fact, abstract art exists in varying degrees and forms. Some abstract art is 'abstracted' from nature; its starting point is the 'real' world. The artist selects a form and then simplifies it until the image bears only stylized similarities to the original, or is changed almost entirely beyond recognition. This tendency has been evident in the art of many cultures throughout history, but even within the representational tradition that dominated Western art from the Renaissance, artists have always been aware of the gap between depicted image and reality, and of the artist's role in transforming perceived reality into art. It was not until the early years of the twentieth century, however, that an abstract art with no apparent connection to the external world began to emerge. This new, 'non-representational' mode provided a thorough-going challenge to the depictive tradition, governed since the Renaissance by the rules of single-point perspective, and during the course of the twentieth century it was refined and developed in a startling variety of ways.

The evolution towards this kind of abstract art did not occur in isolation but was only one aspect of the social, intellectual and technological upheaval that took place at the turn of the century.

From the discovery of X-rays to the development of the motor car, science helped to create very different perceptions of the world. As the artist Fernand Léger declared in 1914, 'if pictorial expression has changed, it is because modern life has made this necessary.'

Central to the spirit of modernism which this comment reflects was an avant-garde attitude that permeated all the arts. Artists sought new ways of responding to the world around them, sometimes by rejecting it, or by pursuing strategies of dissolution, flux and fracture in place of Western notions of aesthetic unity and wholeness. The search for new strategies led to a more polemically conceptual attitude to art.

The emergence of abstract art also relates specifically to changes that were occurring within painting itself. Most importantly, the advent of photography in the 1840s had initiated a critical re-examination of the artist's adequacy in creating a convincing depiction of reality. Eventually freed from the need to recreate external appearances, many artists turned to the depiction of more subjective, interior realities and of emotions. Gauguin's advice to 'paint by heart', for example, suggested that artists draw on their own inner resources – an avenue later explored by the Surrealists and Abstract Expressionists, among others.

The smoothly monochromatic qualities of the photograph, combined with the commercial availability of an increased range of paint colours from the mid-nineteenth century onwards and discoveries concerning the perception of light and colour, encouraged artists to focus on those qualities that are essential to painting: colour and surface texture. As the painter Maurice Denis stated in 1890, 'a picture – before it is a battlehorse, a nude woman, or some anecdote – is essentially a plane surface covered with colours assembled in a certain order'.

Denis' statement offered a theoretical rationale that was to be developed later in a variety of ways. In the meantime, a further factor that opened up new pictorial avenues for artists to pursue was the example of non-Western art, in which spatial perception and artistic depiction were based on different, less rationalistic premises.

This book traces the complex and fascinating history of abstract art in the West from the early years of the twentieth century up to the present time. Whatever the difficulties abstract art may have posed when it first emerged, it is widely accepted today as a mode of art that is as viable and legitimate as the representational tradition. In fact, to many artists, the distinction between representational and abstract art

now seems meaningless, because their work daily brings them face to face with the fact that in certain essential ways all art is abstract; and equally, all art is representational, in that it represents something – if only an intention.

What abstract art has helped to show us is that in fact all art makes theoretical assumptions and exploits conventions. Although it may seem more accessible, representational art is based on quite complex suppositions and rules concerning reality and imitation. Abstract art also rests on a wide range of assumptions and conventions – less familiar, perhaps, but no less valid. By examining the various ways in which abstract art works, I hope this book will go some way towards making it more generally understood and readily enjoyed.

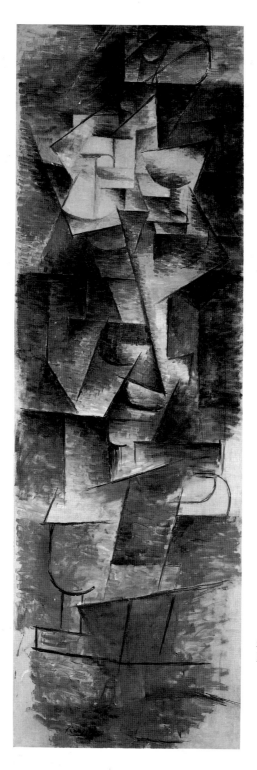

2 PICASSO
Female Nude 1910

CHAPTER ONE

Observing the World: Paths to Abstraction 1910–14

*What occurred at that time in the plastic arts will be
understood only if one bears in mind that a new epoch
was being born, in which man (all mankind in fact)
was undergoing a transformation more radical than any
other known within historical times.*

D. H. KAHNWEILER

Around 1910, several artists began to experiment with abstraction.
They drew inspiration from various sources, but they had in common
the desire to question representation as the be all and end all of art.
Some artists challenged traditional treatment of form; others decided
to pursue the options offered by colour and light. To some, speed and
energy became a preoccupation, while for others, the example of
music provided a new direction. In some cases, their work cut across
several of these categories. Whatever their chosen way of observing
the world, artists, like novelists, philosophers, scientists and poets,
were seeing it with fresh eyes.

THE FRAGMENTATION OF FORM

A major stimulus for future developments in abstract art was the
Cubist painting of Picasso (1881–1973) and Braque (1882–1963). As
early as 1910 Picasso was pushing the forms in his compositions so far
away from any naturalistic starting point that without the title, the
subject of his *Female Nude*, for example, is almost impossible to read. 2
This extreme fragmentation of form marked a fundamental break
with existing modes of pictorial expression. Cézanne had earlier
investigated the structural properties of nature in his work, and had
confronted the problem of reconciling these with the two-
dimensional surface of the picture plane. He had realized that it was in
fact impossible for the artist to maintain a fixed position, as required
by the Western perspectival system. The very slightest shift to left or
right was capable of altering the entire view, and thus the

composition. Artists had obviously been aware of this anomaly in the past, but had overcome the difficulty by adhering to the convention of monocular vision. By trusting his eyes and attempting to express natural, binocular vision, Cézanne allowed for the 'truth' of the shifted viewpoint and incorporated it into his late paintings.

Going beyond Cézanne, Picasso approached his subject from many more imagined angles, combining various viewpoints until the final image was scarcely recognizable. The anti-naturalistic treatment of the form in *Female Nude* shifts the emphasis from the perceptual act of looking to the more conceptual process of invention. Already, ties to the natural world are becoming tenuous. The artist does not need to counterfeit nature in order to create his pictorial structures; evocation of the subject and inventive treatment of form have taken the place of direct imitation.

Picasso's experimentation with nude figure compositions was complemented by Braque's investigation of the landscape, portrait and still life. Braque's later comment, that 'The whole Renaissance tradition is antipathetic to me. The hard-and-fast rules of perspective which it succeeded in imposing on art were a ghastly mistake which it has taken four centuries to redress', holds equally true for the work he was completing between 1909 and 1911. Like Picasso's, his Cubist work at this time became progressively hermetic. In *Le Portugais* (1911), for example, the form is fractured into tiny facets, the figure is flattened against the background, and with the uniform colouring of subject and ground, and the use of *passage* (open-ended facets) to unite them, the two areas can hardly be differentiated. This approach points towards a self-sufficient art that makes little reference to the outside world of appearances.

Although a radical step forward, the extraordinary treatment of form and space in the work of Picasso and Braque of 1909–11 was only part of a transformation taking place in the world at large. In the field of science, for instance, atomic theories of matter and new concepts of space, time and energy were challenging theories accepted since Newton's day. In his Special Theory of Relativity (1905) Einstein destroyed the long-held belief that basic quantities of measurement were absolute and unvarying, by demonstrating that they depended on the relative position of the viewer. He also suggested that inert objects have energy and that 'the mass of a body is a measure of its energy content'. Although these revolutionary proposals did not gain wider currency until after the First World War, they indicate the pervasive challenge to tradition that existed in the

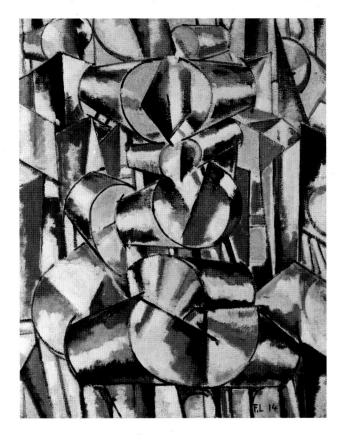

early years of the century; and they had obvious counterparts in the field of painting.

Significantly, Picasso and Braque both remained committed to the subject in their paintings. They enjoyed exploring the tension between apparent abstraction and suggested representation, and by confronting these two opposites together, they maintained a fine balancing act without recourse to pure abstraction. Their work quickly became known to other artists through publications such as *Du Cubisme* (1912), by the artists Albert Gleizes and Jean Metzinger, and *Les Peintres cubistes* (1913), by the poet-critic Guillaume Apollinaire. These texts were quickly translated, and Apollinaire's in particular helped to suggest how Cubist ideas might be taken further. In his discussion of the work of a set of artists he called Orphic Cubists (who included Marcel Duchamp, Robert Delaunay, Fernand Léger, Francis Picabia and Frantisek Kupka) he mentioned the possibility of

creating a 'pure' (abstract) art. However, his description was rather broad. In his book, Apollinaire defined Orphism as 'the art of painting new structures out of elements that have not been borrowed from the visual sphere but have been created entirely by the artist himself. . . . It is pure art.' Yet in referring to painting that has an internal structure independent of nature, Apollinaire did not intend 'Orphism' to refer to non-representational painting alone, but to a wide variety of modes of visual expression. All the artists he described in these terms did experiment with abstraction during the period 1912–14, but in very different ways.

Léger (1881–1955), following on from Picasso, was particularly interested in the study of form. His *Study of a Nude* (1912–13) presents
2 a similar difficulty of interpretation as Picasso's *Female Nude*. Léger uses curves rather than the rectangular faceting of Picasso's forms, and by tracing the outlines of these, it is just possible to distinguish the nude, seen from multiple viewpoints. By 1914, though, Léger's
3 *Contrasting Forms* goes further in denying any figurative intention, contrasting simple geometric shapes and colours within a shallow picture space – as Apollinaire put it, 'the subject no longer counts'. Significantly, despite the non-representational and non-figurative appearance of the work, the artist maintained that such paintings retained a subject: the dynamism of modern life. He believed that the dissonant contrast of man-made machines against the natural landscape could be captured in a pictorial 'equivalent'. Even his most abstract works recall the metallic surfaces and cylindrical forms of machinery, and it was partly this interest that later led him back to more figurative, mechanized forms.

While other artists pursued the fragmentation of form towards an abstract conclusion, from 1912 Picasso and Braque began to introduce collage and *papier collé* (pasted paper) as a new way of presenting their subject, and of reintroducing colour into their work while still releasing it from the conventions of naturalism. Torn pieces of paper and fabric were now assembled onto the surface of their work. By the addition of a few drawn lines, an image could appear over what would otherwise remain an abstract pictorial substructure. In Picasso's *Head* (1913), the inscribed charcoal line transforms the paper elements into a face; an apparently random collection of coloured stripes becomes – if only just – a representational image. In this case, the use of colour is arbitrary and non-naturalistic, while in other images the coloured paper is closer in hue to the actual object. Ironically, this further refinement in their art was equally influential

on the later development of abstract art, since, firstly, it opened up the possibility of using real materials in place of painted artifice, and, secondly, it suggested that the completed work of art could enjoy an autonomous existence, no longer imitating the world of things, but participating in it like any other object.

COLOUR FREED

If collage offered one route into colour experimentation, another was provided by scientific theory. Nineteenth-century texts on colour proved a source of inspiration for various French, Italian and American artists, impelling them towards abstraction. From the point of view of the new century with its climate of discovery, the theories provided a framework by which artists could investigate colour freed from the demands of the object. The resultant work was usually prismatically fragmented and light-infused, and was more often influenced by the Divisionist techniques of the Neo-Impressionists than by the flat forms of Cubist collage. However, whereas the French Neo-Impressionists of the *fin de siècle*, such as Georges Seurat and Paul Signac, had applied colour theories to naturalistic ends, several twentieth-century artists used the same theories to approach abstraction.

The Czech painter Frantisek Kupka (1871–1957) was one of the first artists to venture into pure colour abstraction. His experiments began as early as 1911 whilst working in Paris, where he had settled in 1896. In manuscript notes dating to 1910–11, he wrote about the pictorial possibilities of curved and straight lines, and of vertical planes, and he was prepared to ignore subject matter derived from nature in favour of technical exercises or 'subjective motifs' seen in the mind's eye. Something of this intention can be seen in his *Disks of Newton* (1911–12). Using a colour chart published by the colour theorists Hershel and Young in Ogden Rood's text *Modern Chromatics* (1879), Kupka investigated the power of colour alone to suggest dynamic movement when freed from representational function. The short length, low density and 'velocity' of the wavelengths of red, for example, help to anchor the upper disc firmly in the composition, while the other, undifferentiated colour discs appear to shift in their relationships, creating an effect of spinning motion. Kupka was associated with the Orphic Cubists, but his motivation for pursuing such a path was more metaphysical than that of his French colleagues, and, consequently, more lasting.

6

15

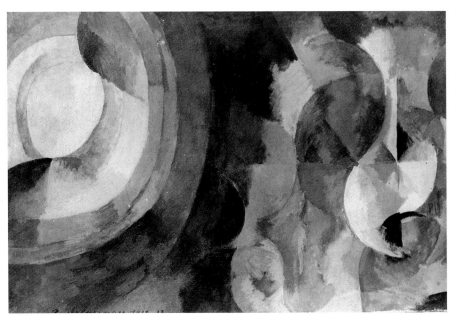

4 ROBERT DELAUNAY *Sun and Moon (Circular Forms series)* 1913

At this time, it was the French Orphist Robert Delaunay (1885–1941) whose work was more influential, however. Between 1905 and 1907 Delaunay studied Michel-Eugène Chevreul's treatise, *On the Law of the Simultaneous Contrast of Colours* (1839), which had been of great significance for the Impressionists. Chevreul's optical analysis of prismatic and complementary colours showed that certain colour juxtapositions intensify the adjoining hue, creating quite different effects according to their placement. A dark blue will make an adjoining yellow appear more green, while a light blue will create a more orange effect on the same yellow, for instance. In *Modern Chromatics*, Ogden Rood took these theories further by identifying the separate ingredients of outdoor colour as affected by light.

With knowledge of both these texts and of Cubism, Delaunay evolved the idea of creating a type of painting that would be technically dependent on colour and on colour contrasts, but would both develop in time and offer itself up to 'simultaneous' perception. Taking Chevreul's term ('simultaneous contrast of colours'), Delaunay extended the scientist's sense to suggest that colour could be the major means by which not only form, but also the illusion of

movement, could be created in abstract painting. He began to develop these ideas in a series of paintings, *Windows*, which from the spring of 1912 show a greater interest in the play of light than in the representation of an actual view. Consequently, in *Windows Open* 7 *Simultaneously, 1st part, 3rd motif* (1912), only vestigial references to the Eiffel Tower can be traced in the triangular green planes, while the rest of the 'view' from the window is dispersed across the oval in prismatic fragments. In looking at the painting, the eye moves to and fro across the surface, finding pleasurable relations of hue, tone and shape. In an accompanying text to the *Windows* series, Delaunay wrote: 'Light in Nature creates movement in colour. The movement is provided by the relationships of uneven measures, of colour contrasts among themselves and constitutes Reality.' The celebration of colour and light, both in the *Windows* and in works such as *Sun and* 4 *Moon* (1913) from the *Circular Forms* series, demonstrates Delaunay's diminished interest in painting objects and his increasing concern to capture optical effects, which – as the above quotation attests – he believed were more profound, or 'real'.

5 MARC *Tyrol* 1913–14

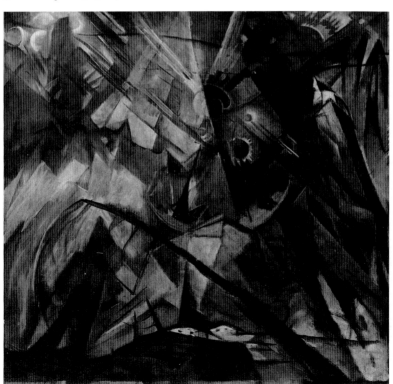

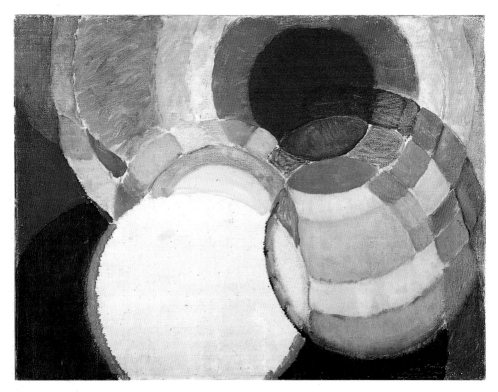

6 KUPKA *Disks of Newton*, 1911–12

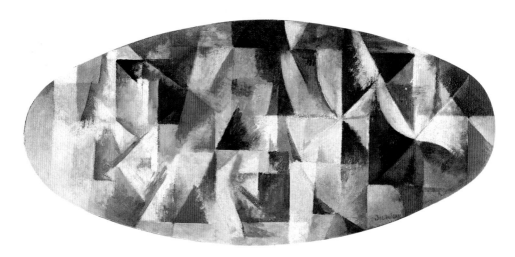

7 ROBERT DELAUNAY *Windows Open Simultaneously, 1st part, 3rd motif* 1912

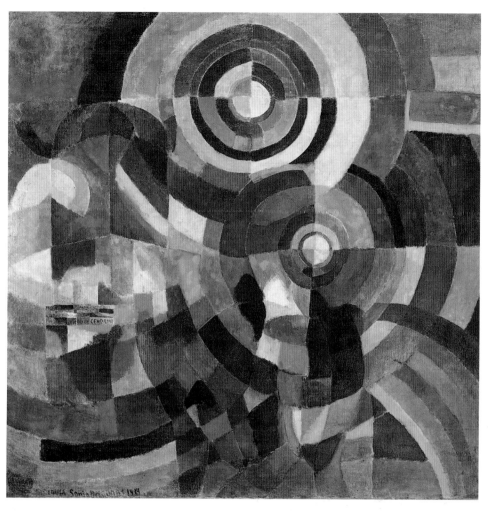

8 SONIA DELAUNAY *Electric Prisms* 1914

Delaunay's influence can be traced as far afield as Germany where it affected the formal, if not the metaphysical concerns of Franz Marc (1880–1916), August Macke (1887–1914) and Paul Klee (1879–1940). Marc had visited Delaunay in Paris in the autumn of 1912, and his large painting *Tyrol* (1913–14), with its splintered, shafted colours, is reminiscent of Delaunay's work, as well as that of the Italian Futurists. Yet the tenor of Marc's work is more tragic and apocalyptic – closer in spirit to Expressionism. Delaunay also corresponded with Macke, writing to him in February 1912 of 'the laws of complementary and simultaneous contrasts of colours' to suggest movement. Macke produced several abstract works at this time which reflect his interest in Delaunay's colour ideas, though some of these appear to relate to designs for objects, reflecting Macke's training in the applied arts.

Delaunay's wife Sonia (1885–1979) also produced abstract art at this time. Her colour accompaniment to Blaise Cendrars' poem *Prose on the Trans-Siberian Railway and on Little Jehanne of France* (1913) shows the influence of poetry in freeing art from strict representation. Apart from a slight echo of the Eiffel Tower at the base of the design, the composition evolves in a dynamic colour arrangement of billowing curves. Here colour is exploited unashamedly for its decorative potential, while still emphasizing the sensation of movement contained in the written text. The same poem also provided inspiration for Sonia Delaunay's vast canvas *Electric Prisms* (1914). In this painting, Cendrars' title is picked out in a small cartouche on the left-hand side of the painting, while the rest of the composition spirals out in vibrant colour circles, as if to evoke the dazzling effect of electric light illuminating the Parisian night sky.

During the previous year, two American artists living in Paris, Stanton Macdonald-Wright (1890–1973) and Morgan Russell (1886–1953), developed a colour theory known as Synchromism based on the same scientific studies of colour that had been read by the Neo-Impressionists and Delaunay. The name 'Synchromy' was chosen to suggest 'with colour' and because of its rhythmic and musical associations with 'symphony'. Russell's desire was to impose on colour 'the same violent twists and spirals that Rubens and Michelangelo etc. imposed on form', and the curving forms of the study *Synchromy to Light* (1913) in fact relate to sketches he had made of Michelangelo's *Dying Slave*. An early, purely abstract Synchromist painting was Morgan Russell's *Synchromy in Deep Blue Violet* (1913). Although now much restored, the painting is important as one of the few completely abstract paintings to have been exhibited at the joint

exhibition with Macdonald-Wright in Munich and Paris (1913), and also in New York (1914). These occasions gave both artists the opportunity to publicize their colour theories through written statements as well as through practical examples, and led them later to proclaim that they, not Kupka or Delaunay, were the originators of colour abstraction. Nevertheless, it is hard to imagine the emergence of a painting like Macdonald-Wright's *Conception Synchromy* (1915) without the example of Kupka's discs or Delaunay's chromatic undulations.

9 MACDONALD-WRIGHT *Conception Synchromy 1915*

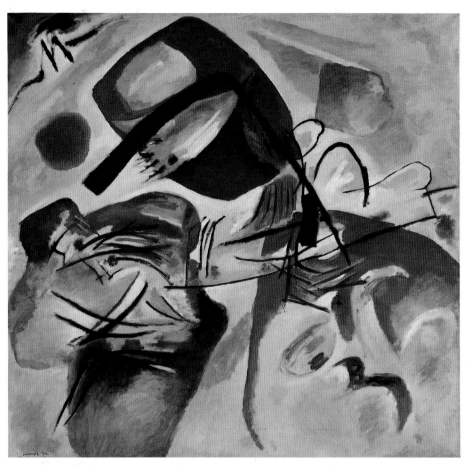

10 KANDINSKY *Painting with the Black Arch* 1912

Several other American artists, such as Andrew Dasburg and Thomas Hart Benton responded to Synchromism during the early years of the War in Europe. Arthur Dove (1880–1946), Max Weber (1881–1961) and Georgia O'Keeffe (1887–1986) also experimented more independently with colour abstraction. Dove worked from *12* 1910 on what he called 'extractions', which, like *Abstraction No. 2* (1911), were abstract compositions based on the pulsating forms of nature. Fascinated by the possibility of creating images expressive of sounds, he went on after the War to explore this direction in equally organic compositions, such as *Fog Horns* (1929). Weber was more

11 BALLA *Iridescent Interpenetration No.13* 1914

interested in Cubism, and only ventured towards a more expressive

13 abstraction during the 1930s. O'Keeffe, in such works as *Evening Star III* (1917), created delicate abstracts derived from a naturalistic starting point but transformed into powerfully simple forms.

Certain Italian Futurists also became interested in freeing colour from a representational function and, like Delaunay, turned to colour theory to help them do so. Gino Severini (1883–1966) played a vital role in establishing links between Paris and Milan. There was already interest in the theory of Divisionism in Italy, and in 1906 a treatise was published on the subject by G. Previati (*Principi scientifici del divisionismo: La Technica della pittura*). It was during this year that Severini met the Neo-Impressionist Paul Signac in Paris and was able to augment his knowledge of Divisionist theory (which involved painting 'solely with pure tints, divided and balanced, and mixing

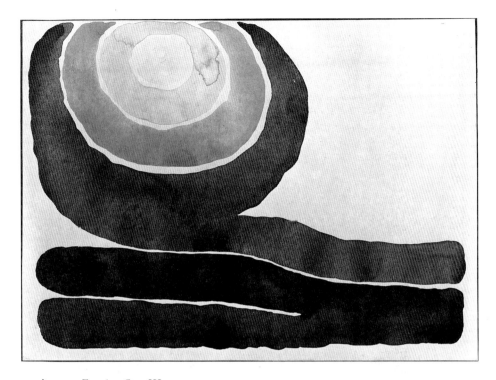

13 O'KEEFFE *Evening Star III* 1917

optically, following a rational method') with examples at first hand.

Severini's painting *Sea = Dancer* (1914) employs a Divisionist *14* technique, even following the Neo-Impressionist device of continuing the pigment onto the frame. The intention behind the work is quite different, however. Rather than placing the subject (dancer) against a background (sea), Severini has fused the two elements together in a prismatic ebb and flow, recalling Delaunay's interest in the power of light to suggest movement, but breaking up the forms even further. Rather than being concerned with formal investigation rooted in optical observation, Severini's work by this stage was based on analogy. As the founder of Italian Futurism, Filippo Marinetti, developed the concept of *parole in libertà* to bring together disparate ideas in poetry by an imaginative leap, so Severini explored unusual associations in his painting. The strange title *Sea = Dancer* compares the movement of a dancer with that of the sea, though the painting was probably inspired, like others at this time, by a remembered experience (of dancers) fused with current sensation (watching the

< 12 DOVE *Abstraction No.2* 1911

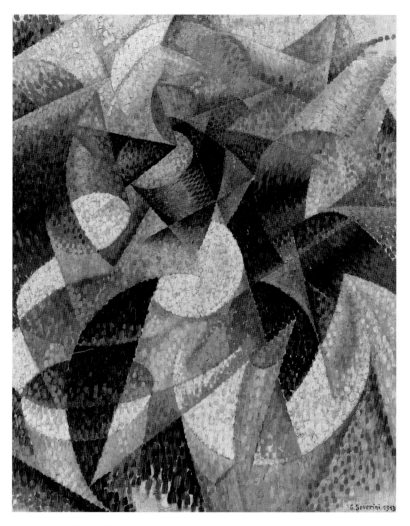

14 SEVERINI *Sea = Dancer* 1914

sea). Such a blending of past and present, of memory and experience recalls the influential writings of the French philosopher Henri Bergson, while echoing the 1913 statement of Severini's fellow Futurist Carlo Carra: 'We stand for a use of colour free from the imitation of objects and things as coloured images; we stand for an aerial vision in which the material of colour is expressed in all of the manifold possibilities our subjectivity can create.'

26

While French optical theories provided an important source for many artists looking to 'free' colour, it was an earlier German treatise that at least in part inspired the colour investigations of the Russian Wassily Kandinsky (1866–1944) in Munich. Goethe's *Theory of Colour* (1810) was important both for its anti-Newtonian (or non-scientific) stance in determining the physical properties of colour, and also for the author's belief in the 'moral effects' of colour (its metaphysical or allusive potential). To this end, Goethe had drawn up a table of plus and minus, or active and passive, colour sensations. Turner had explored Goethe's theories in his *Deluge* paintings of 1843, but it took a major change of outlook in the early twentieth century to allow the ramifications of such theories to be worked out in terms of abstraction.

By temperament, Kandinsky was far more drawn to Goethe's intuitive approach than to the scientific basis of the French colour theorists. His early writings about colour, published in the seminal text *On the Spiritual in Art* (1912), were by his own declaration, 'not based on any exact science', but were the result of 'empirical feeling'. Like Goethe, Kandinsky drew up a list of antitheses, opposing yellow to blue, white to black, red to green, and orange to violet. By this scheme yellow was classed expressively as the 'typical earthly colour', embodying 'active warmth', ex-centric and advancing qualities, while blue, as the 'typical heavenly colour', was considered to possess 'active coolness', concentric and retreating properties. Earlier artists, such as Van Gogh, had also suggested a relation between colours and feelings, but the vital point for Kandinsky was to arrive at a grammar of colour – where colour could embody properties formerly denoted by objects. It is scarcely surprising that 'heavenly' qualities should be ascribed to blue (the colour of the sky or the Madonna's robe). What is significant is that blue should still be seen to represent such qualities when placed in a totally non-representational context.

Although there are possible links between notions of colour opposition and the theories of the German psychologist Wilhelm Wundt, Kandinsky's attitude was governed more by a Romantic and spiritual belief than a psychological one. He writes that 'Colour is a means of exerting direct influence upon the soul'; and that it has a physical and psychic effect on the beholder: 'Colour is the keyboard, the eyes are the hammers, the soul is the piano with many strings. The artist is the hand which plays, touching one key or another purposively to cause vibrations in the Soul.' As the language suggests, Kandinsky's beliefs were informed by metaphysical, rather than

scientific concerns: German Idealist philosophy, a *Jugendstil* background and, as we shall see later, Theosophical doctrine. Writing in 1910–11, Kandinsky implies that the use of colour as a route to full abstraction will be left to 'the art of the future'. His own most fully abstract work dates from after the outbreak of the First World War, but in certain pre-War paintings he nevertheless pushes recognizable imagery to the very limits. The first *Abstract Watercolour*, dated 1910, is a case in point. Some art historians believe it to be misdated, and relate it to a series of studies for *Composition VII* of 1913. Whether or not this is true – and it is disputed by the artist's widow – other early paintings do include floating forms and colours that appear to have very little connection with landscape or natural imagery. It is only when one compares an apparently abstract composition, such as
10 *Painting with the Black Arch* (1912), with another, earlier painting, such
15 as *Composition IV* (1911), that traces of residual imagery can be found in the later painting: birds, sabres, the legs of rearing horses. At this period there are still references to the outside world, however remote.

15 KANDINSKY *Composition IV* 1911

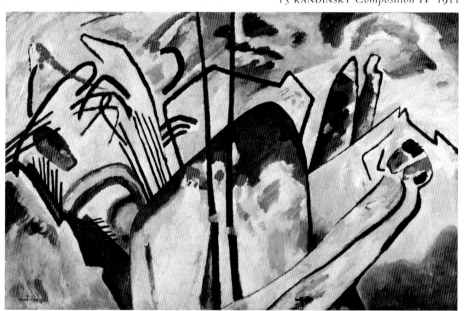

If the beginnings of abstract art involved a thorough-going analysis of the basic principles of painting – form and colour – the particular conditions of the twentieth century introduced the heady intoxication of speed and the power of the machine as new material to draw upon. The sense of excitement was encapsulated in the fourth point of the first Italian Futurist manifesto, published in *Le Figaro* (Paris, 1909): 'We declare that the splendour of the world has been enriched with a new form of beauty, the beauty of speed. A racing car adorned with great pipes like serpents with explosive breath . . . is more beautiful than the Victory of Samothrace.'

In terms of painting, the Futurists wished to galvanize the static Cubist still life: 'The movement we want to reproduce on canvas will no longer be one single, fixed moment of universal dynamism. Quite simply, it will be dynamic sensation itself. For everything moves, runs, changes rapidly. No outline is ever still before our eyes: it appears and disappears constantly.' Gino Severini's *Sea = Dancer* 14 suggests something of this ambition, as we have seen, but certain factors outside the sphere of painting contributed a sense of topicality to Futurist researches. Experimentation in chronophotography, by which multiple depictions of the figure were shown photographically 'frozen' in the process of consecutive movement, had been conducted by Giuglio Bragaglia in Italy, as well as by the British photographer Eadweard Muybridge, and the French physiologist Etienne Marey. On a philosophical level, Henri Bergson's theories provided a justification for the concern with flux, with the momentum of existence, the theory of duration (the fusion of past and present), and the notion of the simultaneity of states of mind (memory brought to bear on perception). Considering also the recent invention of electricity, of X-rays and of the internal combustion engine (all alluded to in the various Futurist manifestos), a vast number of external factors served to prepare the ground for the exploration of dynamic sensation in abstract art.

Giacomo Balla (1871–1958), who was associated with the Futurists, was one of the first artists to evolve a fully abstract style through a fascination with motion and electric light. His first works to deal with the representation of movement, such as *Girl Running on a Balcony* (1912) or *Dog on a Leash* (1912), are rather literal; strongly indebted to chronophotography for the means of conveying motion, they rely on Divisionist techniques to render the forms. However, in the same year, Balla was commissioned to produce furnishing designs for the

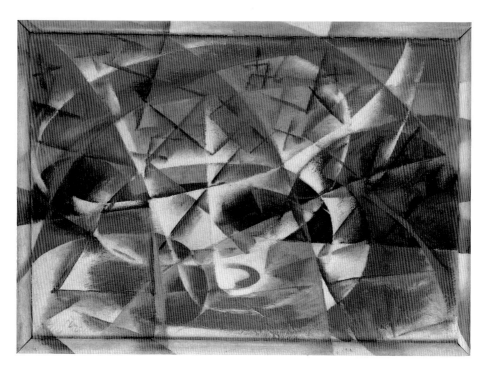

Löwenstein house in Düsseldorf, and the experiment led to a series of
11 completely abstract works called *Iridescent Interpenetrations*, which
conveyed the impression of movement purely by means of colour
juxtaposition. How did Balla reach such completely abstract
statements?

Two series of paintings on which he was working at that time,
Swifts in Flight and the *Speeding Automobile*, provide the clue. Once
again these suggest the Futurist preoccupation with velocity, but here,
movement is evoked through patterns of lines rather than broken
contours. In the *Swifts* series, Balla concentrated not on the depiction
of the birds themselves (as he had with the animal in *Dog on a Leash*),
but on the patterned curve of the flight path. Curved arcs lead the eye
across the surface in a delicate series of sweeping lines. As in Marey's
photographs of a flying bird, the specific physiological details are lost
in the concentration on the physical investigation of winged flight.
The second series explored the new phenomenon of mechanical
power as embodied in the car. However, rather than depicting the

17 BOCCIONI *Dynamism of a Speeding Horse + Houses* 1914–15 >

vehicle itself, the series investigated the effect of its passage on the observer. *Abstract Speed + Sound* (1913–14) suggests the beams of the car's headlights crossing and penetrating the surrounding landscape, while the acoustic reverberations of the car's engine (or hooter) are suggested by the sequence of small crosses. As related studies show, Balla was attempting to find visual equivalents to all the technical manifestations of the car's propulsion: light, speed, rhythm and sound. If in the past artists had used the human figure to personify abstract concepts, Balla was now employing abstract forms to deal with such ideas. Consequently, by 1914 he could expand upon the decorative brief given to him at the Löwenstein house, using his continuing study of motion and light to create self-sufficient abstract compositions in the *Iridescent Interpenetrations* series. Like Delaunay's *Circular Forms*, the optical and prismatic movement of light remained a starting point for these works, but the end result shows a geometric clarity and a fine honing of colour relations that anticipate Op art of the 1960s.

Meanwhile, in works such as *Dynamism of a Speeding Horse + Houses* (1914–15), Balla's colleague Umberto Boccioni (1882–1916) was exploring the potential of sculpture to evoke movement, basing his study on the recent physical notion that 'no one can any longer

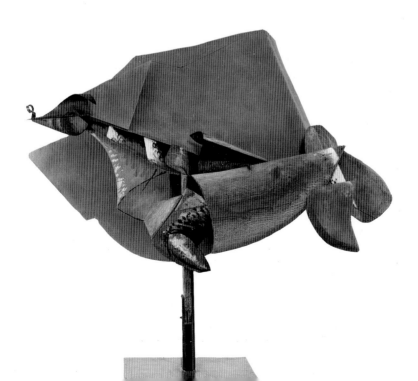

believe that an object ends where another begins'. The forms of the 'horse' are literally cut through by the planes of the 'houses', and the interlocking shapes make a clear, unfettered perception of the subject difficult without help from the title. Such treatment echoes Boccioni's earlier proclamation in his sculpture manifesto of 1912 that 'sculpture is based on the abstract reconstruction of the planes and volumes that determine the forms, not their figurative value'. Also underlying his conception is a recently formulated theory concerning the nature of vision: that an illusion of fused forms is created when a moving object crosses a stationary one. By concentrating on the dynamism of this interpenetration, rather than on the 'figurative value' of the forms themselves, Boccioni was exploiting the abstract potential of sculptural construction and setting a major example for future artists.

Equally significant in the sculpture manifesto was Boccioni's denial of the need to employ one material exclusively for the entire sculptural ensemble, and his statement that 'even twenty different materials' can compete in a single work, including 'glass, wood, cardboard, iron, cement, horsehair, leather, cloth, mirrors, electric lights'. *Dynamism of a Speeding Horse + Houses* was actually constructed from wood, cardboard, copper and coated iron. With its list of non-traditional materials and its call for 'the absolute and complete abolition of definite lines and closed sculpture', the manifesto remains a pioneering document for the development of abstract sculpture.

The notion of the efficacy of manifesto writing spread fast across Europe from Italy. In 1913 the Russian artist Mikhail Larionov (1881–1964) published his manifesto on Rayonism, cast in the same challenging spirit as that of the Italians. The style of Rayonist painting itself owes much to Futurism. Like the Italian movement, it began from a naturalistic starting point, but went further in allowing the 'lines of force' to dominate the underlying subject. In the early *Rayonist Landscape* (1912), for example, reflected rays of light from behind the trees cross over to meet the branches themselves. Later, the individual lines or 'rays' take over the rhythm of the whole painting to effect a fully abstract result. Thus, in *Rayonist Composition: Domination of Red* (1913–14), any naturalistic starting point is obscured, and the painting, composed from a sequence of coloured rays crossing the surface, exudes dynamic energy. This kind of work seems to fulfil Larionov's prophecy in the manifesto that 'From here begins the true freeing of art; a life which proceeds only according to the laws of painting as an independent entity, painting with its own

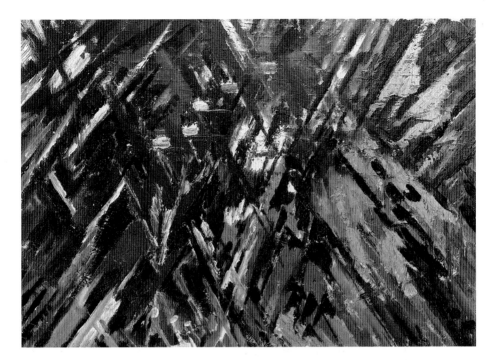

18 LARIONOV *Rayonist Composition: Domination of Red* 1913–14

forms, colour and timbre.' This formalist conviction was to be
elaborated in later Russian revolutionary art, while the force and
delicacy of Rayonist compositions by both Larionov and Natalia
Goncharova (1881–1962) anticipate the fine line-sheaves of Hans *80*
Hartung after the Second World War (p.130).

While Futurist ideas affected developments in contemporary
Russian art, they also spread to America through Joseph Stella (1877–
1946), who spent the years 1902–1912 in France and Italy. A painting
made on his return to the United States, *Battle of Lights (Coney Island)* *19*
(*c.* 1913–14), shows the direct influence of Futurism both in terms of
ideas (clashing forces of the power of light) and of forms (curved lines,
interlocking facets and dynamic interplay of surface composition).

In Paris, meanwhile, certain artists chose to use the machine as a
reductive symbol or paradigm of energy. Notable examples are two
more of Apollinaire's Orphic Cubists: Marcel Duchamp (1887–1968)
and Francis Picabia (1879–1953). Both pursued a path that led them
briefly to an associative abstraction in their paintings, before turning

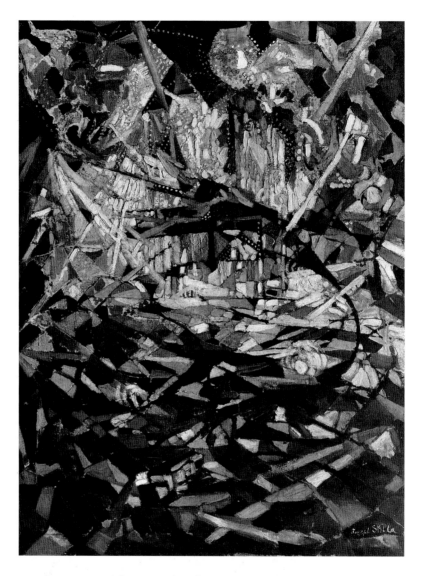

to other means (objects and collages). Marcel Duchamp had drawn upon the lessons of Cubism as well as chronophotography for his notorious rendition of *Nude Descending a Staircase* (two versions, 1911 and 1912). If this seems similar in concept to Balla's *Girl Running on a Balcony* (which was actually completed after Boccioni's painting), Duchamp's aims are not to be confused with those of the Futurists. His

declared concern was to decompose the forms, not to suggest movement for its own sake.

In *The Bride* (1912) and the sets of paintings and sketches related to it (*King and Queen Surrounded by Swift Nudes* and *The Passage from the Virgin to the Bride*) Duchamp's interest in 'reducing' the human figure led him to transform it into mechanomorphic parts. Because of the imprecision of reference in the work – there is no apparent relation to the natural world, and no particular object is distinctly recognizable, however volumetrical its form – the finished painting looks abstract. Yet the referential title – *The Bride* – immediately pulls us back from such a supposition by the strength of its metaphoric allusion and the force of its irony. We are encouraged to engage imaginatively in the range of organic, mechanical and sexual associations that are released through the suggestion of human content, and hence to attempt interpretation. 20

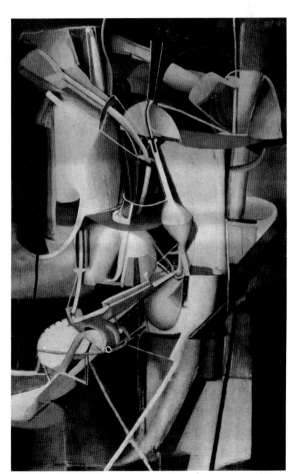

< 19 STELLA
*Battle of Lights
(Coney Island)*
c.1913–14

20 DUCHAMP
The Bride 1912

More significant perhaps for the future as a problematic within abstract art was Duchamp's first 'ready-made' of 1912, which also drew upon machine analogies. By setting up a bicycle wheel on top of a stool 'pedestal' in his studio in Paris, Duchamp effectively declared the autonomy of the 'object', while at the same time neatly sidestepping the issue of both representation and abstraction. The wheel is real – it does not represent – but at the same time it wrestles on a conceptual level with the problems of suggesting movement in abstract terms (as Delaunay and Kupka, his fellow Orphists, were trying to do). If real motion can be created, why bother to imitate or evoke it? The spinning wheel, propelled by its own momentum, presents 'dynamic sensation' itself. The *Bicycle Wheel*, along with Duchamp's other exhibited 'ready-mades', was to become an example for later artists who walked the conceptual tightrope between representation and abstraction, and for those who pursued the path of kinetic art.

Francis Picabia, a close friend of Duchamp who was also to be closely associated with the Dada and Surrealist movements, was equally obsessed with the machine in the early part of his career. In 21 *Udnie* (1913) and *I see again in Memory my dear Udnie* (1914) Picabia converted the female form into mysterious machine parts. In the watercolours made on his 1913 transatlantic crossing, of the ballerina who had inspired the title of the series, it is possible to see the gradual breakdown of form and its reconstitution into mechanomorphic shapes. At this time, Picabia's intention was to communicate emotions inspired 'by the soul'. Having read Kandinsky's *On the Spiritual in Art*, he believed that pictorial content could be expressed by non-representational form and colour, and that associations could be made by the observer to gain the artist's meaning. Like Duchamp, however, Picabia was not content to remain a 'pure' painter, and by 1915 his work was already using collage principles and leaning towards Dada.

What becomes apparent is that few of the Orphists (except Kupka) felt sufficiently motivated to sustain an entirely abstract mode of painting throughout their careers (although Delaunay returned to abstraction in the 1930s). Brought up to believe in painting as the expression of feeling, subjective thought or sensory experience, they lacked the necessary metaphysical conviction to pursue the notion of communicating a single, universal 'Idea'; this was left to other European artists to develop. Interestingly, the English Vorticists, who were developing abstract analogues of the precision and autonomous

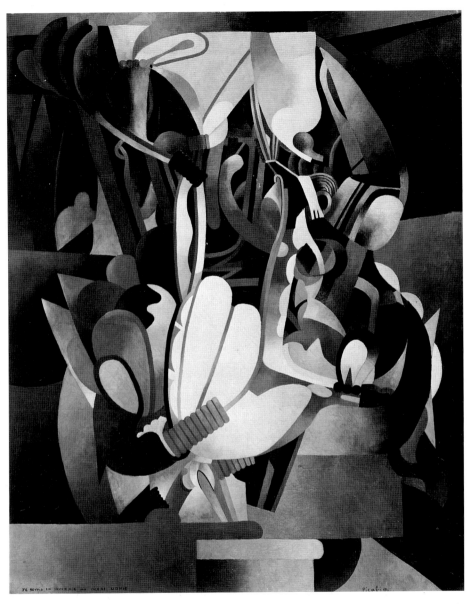

21 PICABIA *I see again in Memory my dear Udnie* 1914

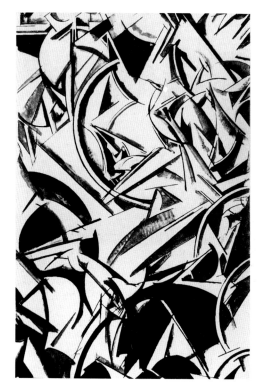

22 LEWIS
Composition
(for *Timon of Athens*)
1912

power of the machine in their work, were also unable to sustain strong commitment to abstraction after the War. Wyndham Lewis (1884–1957) is a good example of this. In 1912 he produced some apparently non-representational compositions for his print portfolio *Timon of Athens* (published late in 1913); the sharp, angular geometries of the shapes in his *Composition* (1912) suggest, rather than imitate machine forms. They bear out Lewis's conviction that twentieth-century artists could use associations provided by machinery, as long as they portrayed the machine 'apart from its function'. While such ideas might anticipate the 'machine aesthetic' that was to inspire later art, Lewis declared after the War that his 'geometries needed filling', and criticized Vorticism for being 'too architectural'.

22

MUSICAL ANALOGIES

Many pioneering abstract artists were drawn to music as a model – both in their theorizing and in the titling of their compositions.

Kupka, Kandinsky, Delaunay and the Swiss artist Paul Klee (1879–1940) were only some of the artists to make such links. This was by no means an innovation; the theoretical possibility of a correlation between colour and sound goes back to antiquity, and had been the complex subject of much detailed debate and experimentation. Certainly, by the mid-nineteenth century, comparisons between the two arts were rife, especially in discussions of painting. With the turn of the twentieth century, however, colour became a major issue in the move towards abstraction and prompted the search for, amongst other things, 'laws [of painting] based on the transparency of colour, which can be compared to musical tones' (Delaunay).

One of the major concerns was to discover what music could offer art. When in 1897 the Austrian Symbolist designer August Endell predicted the birth of a new art that would use 'forms which mean nothing and represent or recall nothing', he completed his statement with a musical analogy, saying that the new art would yet 'rouse our souls as deeply, as powerfully as only the tones of music have ever been able to do'. This notion was developed further by the Munich philosopher Wilhelm Worringer in an influential treatise called *Abstraction and Empathy* (1908). Like Endell, he felt that music offered a model in the search for the work of art 'as an autonomous organism that stands beside Nature on equal terms and, in its deepest and innermost essence, is devoid of any connection with it'. Such views were to support some of the major excursions into the realms of abstract painting, most notably those of Klee and Kandinsky.

Although Klee started out with doubts about the parallelism of music and art, by 1917 he confidently felt that 'Polyphonic painting is superior to music in that here, the time element becomes a spatial element. The notion of simultaneity stands out even more richly.' As recent research has shown, Klee's vision of 'higher polyphony' stemmed from his great admiration for late eighteenth-century polyphony (Mozart, especially) and its architectural organization of multiple independent themes and melodies. The sense of building a composition, of adding or subtracting colours or tones until the picture was harmonious, underpinned the rest of Klee's career and affected his teaching at the Bauhaus. The seeds for this change of heart were sown, in the pre-War period, in his discovery of colour. Although Klee was already exploring the potential of music in his art before 1914, as the abstract compositions *Sound of the Fanfares for the Psalm* (1913) or *Sounds of the Organ* (1914) suggest, the type of abstraction he employed at this time was purely linear; the sound

waves of the musical instruments in these works were rendered by intricate patterns of line, executed in a series of fine but firm draughtsman's strokes.

The breakthrough to new ideas and techniques resulted from his visit to Tunis in 1914 with August Macke. It was here that Klee was 'taken possession' of by colour and finally able to free it of naturalistic connotations, converting impressions from nature into abstract colour equivalents. From this time on, colour, as much as line, became vitally significant in his work and lent another dimension of delicacy to his abstract works on paper, such as the small-scale *Abstract: Coloured Circles with Coloured Bands* (1914). In other watercolours, like *The Niesen* (1915), organic phenomena are only partly translated into geometric forms, but the quiet relation of the three colour zones traversing the surface suggests a musical chord. This – and the subtle treatment of colour itself – is reminiscent of Delaunay, whose striving for the simultaneity of independent colour themes in *Windows* was

23 KUPKA *Amorpha, Fugue in Two Colours* 1912

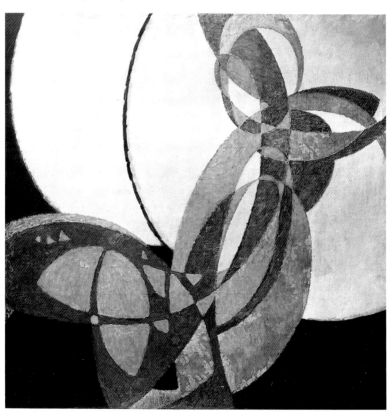

24 KLEE *Abstract: Coloured Circles with Coloured Bands* 1914

perhaps analogous to the 'simultaneity' of musical polyphony (where separate notes sound harmoniously together). Having seen some of Delaunay's *Windows* at the Zurich Moderne Bund exhibition in August 1913, Klee likened them to the fugues of Bach in an exhibition review.

Klee's reference to Bach had a counterpart in the first purely abstract work to be exhibited by Kupka: *Amorpha, Fugue in Two Colours*, shown in the Salon d'Automne in Paris, 1912. Both artists were evidently impressed by the formality of eighteenth-century musical composition precisely for its sense of order and balance. If art was to move away from the traditional task of representation, these artists obviously felt the need to preserve structure. Consequently, although *Amorpha* was a huge, bold painting composed of swelling curves and arcs, it nevertheless obeyed a rigorous order, in which the two primary colours red and blue, working together contrapuntally, were formally controlled within strict linear outlines. In speaking of the genesis of *Amorpha* in 1926–27, Kupka explained its connection with fugues, 'where the sounds evolve like veritable entities,

23

intertwine, come and go'. He also mentioned colour as 'recalling the eighteenth century', and spoke of the significance of the canvas 'rhythm'. In fact, his concern with rhythm recalls his notes of 1910–14, in which he expressed his interest in universal rhythm and his desire to reach back behind appearances to expose the 'Idea'. The example of music reinforced his belief that abstract painting could communicate meaning. Although other sources besides music affect *Amorpha* (such as charted movement, cosmic rotation and stained glass motifs), it is music that provides the guiding impulse and unites the different elements.

Unlike Klee and Kupka, who used classical musical composition as a model for their abstract work, Kandinsky drew musical inspiration from the very opposite to eighteenth-century formality: the Romantic chromaticism of Wagner and Schoenberg. An amateur musician himself, Kandinsky was fascinated by the links between the two arts. The experience of hearing *Lohengrin* at the Court Theatre, Moscow, was one of the two events 'that stamped my life and shook me to the depths of my being'. (The other was seeing Monet's *Haystacks*.) Hearing Wagner's music provoked in him the synaesthetic experience of seeing colours and line simultaneously with the music, and prompted the realization 'that painting could develop just such powers as music possesses'. Although he later repudiated his allegiance to Wagner as 'youthful fanaticism', Kandinsky's interest in music continued to grow. Between 1908 and 1912 he collaborated with the composer Thomas von Hartmann on the stage composition *The Yellow Sound*. Never performed in Kandinsky's lifetime, the scenario is notable for its correlation to Kandinsky's paintings of that period. There is no plot in the conventional sense, although the text includes references to giants, humans, hints of landscape and other recognizable objects; the real content of the composition is the play of colour, movement and noise. In the fifth tableau, for instance: 'Some groups are lighted from above, more or less brightly with different colours; one . . . with a bright red, [another] with a pale blue, and so forth. . . . Suddenly all colours vanish . . . and a dim white light fills the stage. In the orchestra, single colours begin to speak corresponding to each colour sound, single figures rise from different places' In formal terms, this freedom from narrative combined with the expressive use of colour and composition can equally be seen in Kandinsky's *Composition IV* (1911), in which detailed delineation of forms seems to be subordinated in favour of a tension between the lines and 'colour sounds' within the painting.

15

42

On 1 January 1911, Kandinsky experienced another great musical turning point in his career as an artist: a performance of Schoenberg's second string quartet and the *Three Piano Pieces* (1909). Schoenberg's atonal music provoked Kandinsky to inaugurate a lengthy correspondence with the composer. Only a few days after the performance Kandinsky wrote to Schoenberg: 'In your works, you have realized what I, albeit in uncertain form, have so greatly longed for in music. The independent progress through their own destinies, the independent life of the individual voices in your compositions is exactly what I am trying to find in my paintings'. What Schoenberg had done was to allow dissonance to enter musical composition. He transformed the structure of musical harmony from one of thirds to one of fourths, thus challenging traditional notions of tonality, and embracing atonality.

Although Kandinsky's *On the Spiritual in Art* was written before he established contact with Schoenberg, the composer's remarks on reading the text must have given Kandinsky confidence in his judgment, especially as Schoenberg himself also painted. To the composer, Kandinsky's comments 'about colour in comparison to musical timbre' were most 'certainly right'. Kandinsky had compared each colour of the spectrum to the sound of a particular instrument (yellow to the trumpet, vermilion to the tuba, etc.). In so doing, Kandinsky was aware that the different tones of colours, 'like those of music', are of a much subtler nature and awake far subtler vibrations 'in the Soul' than can be described in words. Musical analogies thus pointed a way for Kandinsky to relinquish loose representation and develop towards a more total abstraction after the War.

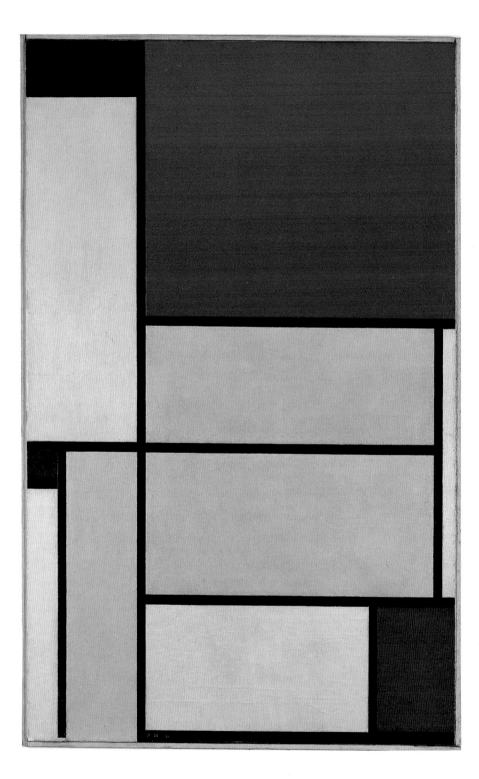

Looking Inwards: Investigations 1912–20

*When religion, science and morality are shaken
(the last by the mighty hand of Nietzsche), when the
external supports threaten to collapse, then man's gaze
turns away from the external towards himself.*

KANDINSKY

By the beginning of the twentieth century, a number of accepted beliefs had undergone attack from a variety of sources. Charles Darwin had claimed a natural rather than a divine origin of species; Friedrich Nietzsche had rejected Christian morality in favour of a doctrine of the will; and Karl Marx had declared that religion was the opiate of the people. In 1900 Sigmund Freud published his *Interpretation of Dreams*, which in its analysis of subconscious human sex drives seemed for some to undermine the moral fibre of society. Nor did later developments in science provide compensatory stability: Einstein's theories of relativity overturned conventions established since the seventeenth century, while the splitting of the atom by Ernest Rutherford in 1909 was equally disturbing. On a social level, rapid industrialization and the growth of capitalism served to highlight the discrepancies between the working and propertied classes, and led to the rise of socialism across Europe. In Russia, where the rift was most extreme, the 1905 uprising was followed in 1917 by the decisive Revolution of the proletariat. As the 'external supports' began to collapse, and Europe became divided against itself in the Great War of 1914–18, artists as disparate as Wassily Kandinsky, Piet Mondrian, Kasimir Malevich, Hans Arp and Kurt Schwitters turned towards an abstraction that relied less on the forms of the uncertain and changing world, and more on universal values, based on philosophical or mystical doctrines. In renouncing the 'soulless materialism' (Kandinsky) of the nineteenth century they hoped to find a new spiritual focus for the future.

KANDINSKY

Kandinsky was the first abstract artist to publish a theory justifying abstraction. Besides writing *On the Spiritual in Art*, he explored the

45

possibility of creating an abstract art in an important essay called 'On the Question of Form', published in Munich in the influential *Blaue Reiter Almanac* (1912). In fact, the question of form, like the notion of the 'spiritual' in art, was a topical issue inherited from nineteenth-century German Idealist philosophy. Since Hegel's time there had been a widely held belief that art and philosophy could express the same content. For Hegel, who wrote a *Philosophy of Fine Art* (1835), the highest function for art, as for philosophy and religion, was to express the Divine, or Absolute Spirit. Schopenhauer went further towards providing a rationale for abstraction in his text *The Metaphysics of Fine Art*, where he suggested that 'the picture leads us at once from the individual to the mere form; and this separation of the form from the matter brings the form very much nearer the Idea'. It was logical to move on from this to suggest that the Idea could be better expressed if the form were divorced entirely from 'matter'.

Such general theories would have been familiar to Kandinsky through his sojourn in Munich and contact with the *Jugendstil* circle. When he came to write 'On the Question of Form', Kandinsky set up an opposition between inner and outer elements in the work of art, arguing that external, 'outer' form is less significant in the artist's work. What counts is the quality of the content, which is determined by 'inner necessity'. This alone can justify the form, and thus the onus is on the artist's inner feeling; as long as this is genuine, pictorial expression may take any form the artist wishes. The genuine art of all ages is united by one essential quality – that of soul (or 'inner sound'). It is this that gives old artifacts their 'living' properties; 'dead' artifacts, or mechanical copies, will disappear with time because they lack the soul of the original. Kandinsky gave a practical example of this in his choice of illustrations for the *Blaue Reiter Almanac*. Works of various periods and of totally different cultures were mingled together, and representational images were set alongside others verging towards total abstraction, such as his own woodcuts.

As Kandinsky saw it, artists had a choice: to pursue the 'Great Realism' or to take the path of the 'Great Abstraction'. As long as art possessed 'soul', there was nothing to prevent its being abstract. According to Kandinsky, any object, even a printed letter on a page, has a dual effect: it is both a 'sign', with a particular purpose, and also a form capable of producing an 'inner sound' that is self-sufficient and completely independent. Once the viewer is attuned to this duality, any object is capable of reverberation, as the world itself 'sounds. It is a cosmos of spiritually effective beings.' Thus, abstract form is equally

capable of communicating inner resonance, but to create abstract compositions, the artist must develop not only his eyes but also his soul, for only then will he be able to weigh colours in the balance and provide a determining force in the work of art.

In considering pictorial form in *On the Spiritual in Art*, Kandinsky had maintained that there were two essential issues to bear in mind: the composition of the whole picture, and the creation of the individual forms within it, which are related to each other in various combinations, while yet remaining subordinate to the whole. In this text Kandinsky was very much aware that the full emancipation from direct dependence on nature in painting was still to come. Although he writes, 'in a composition in which corporeal elements are more or less superfluous, they can be more or less omitted and replaced by purely abstract forms, or by corporeal forms that have been completely abstracted', he also suggests that, for the time being, the artist should use a combination of abstract and representational elements in order fully to exploit expression and to utilize the reverberations of both. This strategy is apparent in Kandinsky's paintings of this period, as we have already seen. Nevertheless, his woodcuts (such as those for his collection of poems *Sounds*, 1907–12) show an increasing, and even total departure from references to the external world.

In 1913 Kandinsky's paintings became still more abstract. *Composition VI*, for example, suggests that the 'few hours' separating Kandinsky's theoretical writings from the 'pure composition' he prophesied, had now elapsed. The colours and forms of the painting are turbulent, suggesting perhaps a tragic presentiment, despite the lack of obvious iconography. In the midst of the tumult, flecks of pink are dispersed over the canvas as if to mitigate the drama of the scene and to strike a different chord within the painting – one of a lighter tone. In his own words, what Kandinsky had in mind in this work was the question of how to hold two opposing forces of an event – destruction and calm – in balance: 'What thus appears a mighty collapse in objective terms is, when one isolates its sound, a living paean of praise, the hymn of that new creation that follows upon the destruction of the world.' Such concerns are evident in the studies and finished paintings of the immediate pre-War period, including *Last Judgement* (1910 and 1912), *The Deluge* (1912) and *Composition VII* (1913).

Underpinning these concerns in Kandinsky's work, and a clue to understanding his path to abstraction, is the rich synthesis of diverse

26

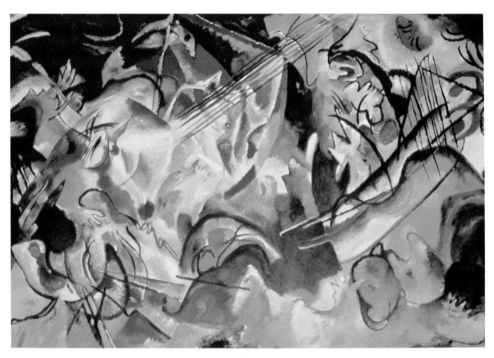

26 KANDINSKY *Composition VI* 1913

influences absorbed from his particular cultural experience. A Russian Orthodox Christian, he became deeply interested in 'the forms of occultism, spiritualism, Monism, the "new" Christianity, Theosophy and religion in its broadest sense'. The sometimes apocalyptic tone in his work of this period is related to prevalent revivalist tendencies in his home and adopted countries, as testified in his *Reminiscences* (1913). The writings of the Theosophist (later turned Anthroposophist) Rudolf Steiner were also influential. The Theosophical Society was founded in New York in 1875 by a group of people with spiritualist concerns, who were reacting against nineteenth-century materialism. Although the main founders, Mme Blavatsky and H. S. Olcott went on to re-establish the Society in India, Theosophy had a wide impact throughout Europe at the turn of the century. Between 1908 and 1911 Kandinsky read and annotated books by Rudolf Steiner and was probably aware of Steiner's belief that a final spiritual world would emerge after a great catastrophe.

48

Both Steiner and certain other Theosophists emphasized the visual aspects of the spiritual. Steiner, for instance, urged that in meditating, the initiate 'must learn to think in images even when there is no object to arouse his senses'. The book by the Anglo-Indian Theosophists Annie Besant and C. W. Leadbeatter, *Thought Forms* (read by Kandinsky in 1908), illustrated cloud-like configurations, and similar shapes were used by Kandinsky in a number of watercolours and drawings in 1913. Kandinsky's pictorial practice of creating a 'running-over of colour beyond the boundaries of form' in, for instance, *Composition IV* (1911), seems also to relate to these ideas. This technique was the basis of his early compositional approach to abstraction: dissolving outline and allowing spots of colour to float outside set contours. 15

In addition, Kandinsky may well have absorbed and concurred with the Theosophists' belief in the mysticism of colour and form. According to them, colour and form, like music, have the power to call forth 'vibrations' which enrich the soul. Although to mystics, the transference of psychic vibrations to another person is only possible through a clairvoyant, Kandinsky's concern with the 'fine, uncorporeal mind vibrations of the artist' suggests that he saw the artist as a potential medium. His own use of abstract colour and form was for a purpose: to affect the spectator and arouse each individual soul. While such an ambition belonged to the wider mystical desire to prepare the world for change, the reassuring belief was that 'in the twenty-first century, this earth will be a paradise by comparison with what it is now'. Although Kandinsky's attitudes towards Theosophy later changed, the affective purpose of art remained with him as an ideal and encouraged his move to geometric abstraction after the War.

MONDRIAN

Piet Mondrian (1872–1944) also reached his abstract idiom through an awareness of Theosophy. Though the influence of Theosophical thought was not apparent in his work until several years later, he joined the Theosophical Society in 1909, in reaction to his family's prevailing Calvinism, and kept Theosophical mementoes, such as a portrait of Mme Blavatsky, a lecture by Steiner and a text by Krishnamurti, in his home. Having previously subjected motifs from nature to a variety of approaches (Symbolist, Impressionist, Fauve), he came under the influence of Cubism and began to emphasize drawing over colour when he went to work in Paris between 1911

and 1914. Following Cubist practice, Mondrian began with a naturalistic starting point but, as in *Tree* (*c*. 1912), took this to its very limits, abstracting the tree almost beyond recognition until the vague sense of an upright form was all that remained of the subject. He soon came to feel, however, that 'Cubism did not accept the logical consequences of its own discoveries; it was not developing abstraction towards its own goal, the expression of pure reality.'

Although before the War Mondrian restricted his work to 'the customary world of the senses', he was already aware, through Theosophy, that art could 'provide a transition to the finer regions, which I shall call the spiritual realm'. In 1914 Mondrian returned to Holland to visit his sick father, and with the outbreak of war he was unable to return to Paris. During a visit to Domberg, the small coastal region where he had painted before, Mondrian worked on a series entitled *Pier and Ocean* (1914–15). In comparison to *Tree*, the elements in these compositions are reduced to the greatest simplicity: short vertical and horizontal black lines within a basic oval format. As he remarked later on, 'Observing sea, sky and stars, I sought to indicate their plastic function through a multiplicity of crossing verticals and horizontals. Impressed by the vastness of Nature, I was trying to express its expansion, rest and unity.' As the drawings progress towards the finished paintings, the naturalistic reference is increas-
27 ingly lost. In *Composition No. 10* (1915), for example, the painting has become a sequence of plus and minus notations, and no longer indicates any connection with the sea as starting point.

The importance of the horizontal and the vertical was elaborated in Mme Blavatsky's *Isis Unveiled* (1877), a seminal Theosophical text. From this, Mondrian would have learned of the mystical significance of geometric symbols such as the triangle and the cross. Blavatsky also elaborated the theory of the orthogonal by referring to 'the celestial perpendicular' and the 'terrestrial horizontal base line', equating the vertical with the 'male principle', and the horizontal with the 'female principle'. In Blavatsky's view, the cross, formed by the intersection of the two lines, expresses the single, mystical concept of life and immortality. When the cross is inscribed within the perfect square it is 'the basis of the occultist', for 'within its mystical precinct lies the master key which opens the door of every science, physical as well as spiritual'. The basic principle of the orthogonal was to be of major importance to Mondrian's abstraction.

In 1917 Mondrian began to experiment with coloured squares and rectangles, under the influence of a fellow Dutch painter at Laren –

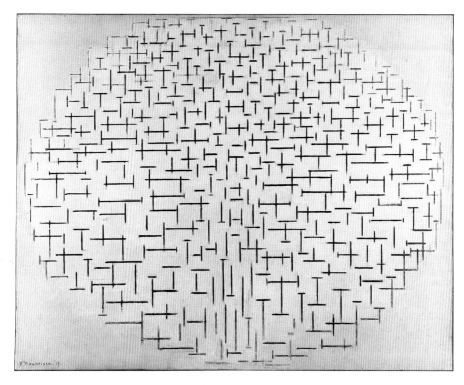

27 MONDRIAN *Composition No.10 (Pier and Ocean series)* 1915

Bart van der Leck (1876–1958). The latter's *Geometric Composition* 28
No. 2 (1917) exemplifies how the artist's 'exact technique' allowed
him to place each block or bar of colour in an independent position
from every other. Van der Leck had reached this position by
gradually whittling down the coloured bars of his finished compo-
sition from increasingly stylized renderings of a natural subject; this
can be seen by comparing *Composition 1917 No. 6 (Donkey Riders)*
with the early gouache studies. By playing off negative against
positive outlines, van der Leck was able to arrive ultimately at his flat,
geometric configurations, such as *Geometric Composition No. 2*,
achieving a purity of effect that much impressed Mondrian and is
reflected in his own painting.

Having experimented with line and colour independently, Mon-
drian's next step was to combine the two elements in a single

51

29 composition and to establish a relationship between them. *Composition in Colour B* (1917) illustrates the effect of this conjunction. The black lines are placed either adjacent to the colour bars or superimposed upon them, creating a rhythmic, staccato effect. The colour blocks themselves, being un-anchored within the picture space, appear to float. Yet because of the overlap in certain places, a shallow depth is also implied in the composition (reminiscent of Cubist space); the eye cannot rest on the surface but must delve below it. To stabilize the surface, the next logical step was to integrate line and colour on the same plane. *Checkerboard* (1919) does exactly this: line and colour are locked together with equal prominence. A regular grid is set up to allow nuances of colour and tone to be worked out, and a mutual relationship is established. Such regularity, however, also presents limitations. There is no room for dynamic linear tension in such an ordered format; only colour modifications provide variety.

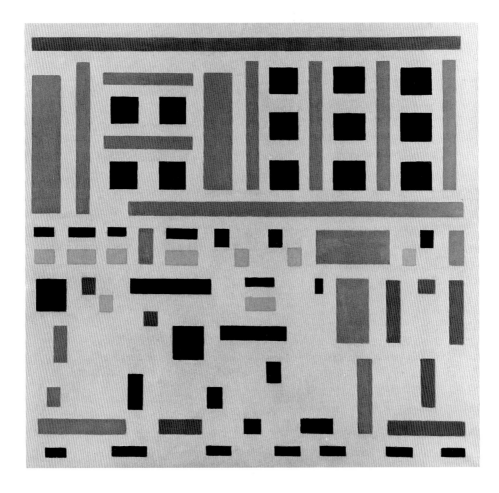

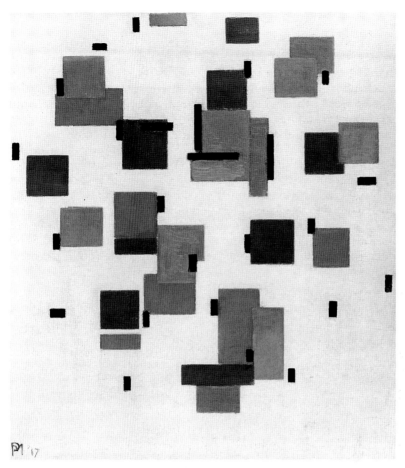

29 MONDRIAN *Composition in Colour B* 1917

Within a year, Mondrian had formulated the pictorial solution to this problem. The regularity of the checkerboard was displaced in an asymmetrical arrangement of various-sized rectangles, while colour was reduced to the three primaries (red, yellow and blue) plus the three non-colours (black, white and grey). With the exception of grey, these basic components formed the syntax of all Mondrian's subsequent works. The static composition was enlivened by the use of 'dynamic equilibrium': a rhythm forged by the dynamic placement of the components in relation to each other, as in *Painting I* (1921). 25

< 28 VAN DER LECK *Geometric Composition No.2* 1917

While still revealing his adherence to the Theosophical orthogonal, Mondrian's use of the three primary colours reflects another influence on his work at this time: the mystical philosopher and mathematician M. H. J. Schoenmaekers. During his enforced stay in Holland (1914–19) Mondrian read the latter's new publications as they appeared. In the quasi-mystical text *The New Image of the World* (1915), Schoenmaekers, who was himself interested in Theosophy, reinforced the notion of the cosmic pre-eminence of the orthogonal, but went further to establish the mystical essence of the primary colours: 'The three principal colours are essentially yellow, blue and red. They are the only colours existing. . . . Yellow is the movement of the ray . . . blue is the contrasting colour to yellow. . . . As a colour, blue is the firmament, it is line, horizontality. Red is the mating of yellow and blue. . . . Yellow radiates, blue "recedes" and red floats.'

In 1919 Mondrian echoed Schoenmaekers' ideas in his own essay 'Natural Reality and Abstract Reality', in which he evolved the theory of universal beauty contained in abstract form: 'This new plastic idea will ignore the particulars of appearance, that is to say, natural form and colour. On the contrary, it should find its expression in the abstraction of form and colour, that is to say, in the straight line and the clearly defined primary colour.' To Mondrian, these basic elements represent the 'exact reconstruction of cosmic relations' and thus express the 'universal'. Like the Neo-platonic philosophers, Mondrian wanted art to reflect a higher reality, or a truth that transcended nature, believing that in its perfection such art would help others to reach greater understanding and knowledge. In the wake of the First World War, the certainty of absolutes was perhaps more comforting than the contingencies of either the natural or the man-made world. For him, the 'positional relation' of the right angle expressed 'perfect harmony', and it was this beauty that he wished to convey to the viewer.

Mondrian's geometric abstract painting is thus a direct pictorial equivalent of mystical beliefs prevalent at the time, which were themselves rooted in the Idealist metaphysics of the nineteenth century. The artist's unswerving goal, as expressed both in his polemical writings and in the uncompromising nature of his art, was to pay tribute to the universal principles which he believed (in common with the Theosophists and Schoenmaekers) to exist at a deep level within human consciousness. He wished, like Kandinsky, to produce a harmonious chord that would strike also in others. Unlike Kandinsky, however, he sought to do this by harnessing as his means

what he believed to be universal absolutes: primary colour and the orthogonal. Having found the language that best suited his purposes, he was able to make repeated use of it, but flexibly, without duplicating the image. For however rational and pre-ordained Mondrian's system may appear, each individual painting was created by visual adjustment, and many of his works show traces of underpainting. His compositional principle, called by him 'abstract plasticism' or 'Neo-Plasticism', became the cornerstone of the formal preoccupations of the Dutch De Stijl movement and had great effect on future geometric abstract developments.

MALEVICH

In the Suprematist painting *Eight Red Rectangles* (1915) by the Russian 30 artist Kasimir Malevich (1878–1935), geometric elements are placed against a white ground, and their colour sings out from the surrounding space. But, as with Mondrian, such painting is scarcely static. Here there may be no dynamic tension between line and shape, no grid to hold the elements in place, but there is an extraordinary sense of movement between shape (figure) and ground. *Eight Red Rectangles* suggests this effect as a kind of spatial dislocation. Each rectangle is placed flatly and separately on the white ground. Yet where one would expect the forms to appear motionless and fixed, they in fact shift almost imperceptibly in their mutual relationships. There is a sense of ebb and flow between the quadrangles – some push forward while others slip back – and a strong sensation that the rectangles are floating, as though gravity had ceased to have a hold on them.

This painting was first shown publicly in an exhibition held in December 1915 at the Dobychina Gallery in Petrograd, entitled '0–10, The Last Futurist Exhibition of Paintings'. Malevich hung almost forty paintings in the exhibition – all completely abstract, all composed of flat geometric shapes placed against light grounds. Yet if the paintings appeared to contain only two-dimensional forms, some of the titles referred to a 'fourth dimension' – as in the case of the work surprisingly entitled *Painterly Realism of a Football Player – Colour Masses in the Fourth Dimension*, where no footballer is in evidence at all! The paintings were completely different in style from Malevich's previously exhibited canvases, such as *The Knife-Grinder* (1912–13), which incorporated a mixture of Cubism and Futurism (known as Cubo-Futurism).

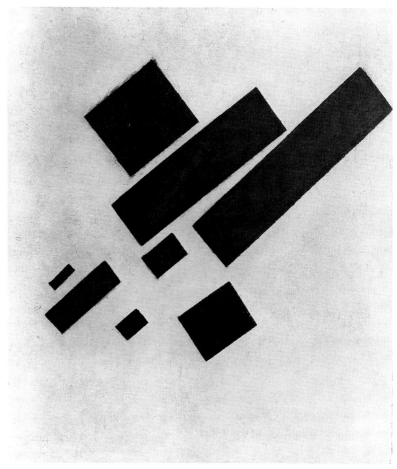

30 MALEVICH *Eight Red Rectangles* 1915

The notion of the Fourth Dimension was a prevalent topic of conversation and study in Russia in the pre-War years. The Russian philosopher Peter Demianovich Ouspensky had written popular books on the subject: *The Fourth Dimension* (1909) drew on the hyper-space theories of the Englishman Charles Howard Hinton, while *Tertium Organum* (1911) developed his own Promethean philosophy. Rather than interpreting the Fourth Dimension as time, as some had done, Ouspensky and other Russian mystical theorists conceived it as synonymous with a new consciousness. According to

Ouspensky, the Fourth Dimension provided an escape from death into the real world of the spirit. The underlying supposition was that our entire life is merely a shadow of reality, and that reality itself is only accessible to 'a new category of man for whom there exist different values than for other people'. The three-dimensional world was in fact the result of man's limited 'psychic apparatus', but man would be able to perceive the true, four-dimensional reality if only he could find his 'cosmic consciousness'. Following a fellow Russian, Vladimir Solovyov, Ouspensky maintained that the new consciousness would first reveal itself in art, rather than as a religious or mystical manifestation.

Taking his lead from Hinton, Ouspensky drew a visual analogy for the perception of the Fourth Dimension: a plane surface on which solids are projected as though falling through it from space. The image resulting from a geometric solid (such as a cube, for example) passing through this plane, would be a flat (two-dimensional) shape whose outline would be determined by the angle at which it had passed through. Diagrams illustrating such a configuration were published in the American books *Man the Square: A Higher Space* 32 *Parable* (1912) and *A Primer of Higher Space; The Fourth Dimension*

31 MALEVICH
Volumetric Suprematist Elements 1915

32 BRAGDON
Personalities: Tracings of the Individual (Cube) in a Plane (from *Man the Square*) 1912

(1913) by Claude Bragdon, and even if Malevich did not see them at first hand, he would have been familiar with the theories through his reading of Ouspensky. Whatever the case, it is likely that his own *30* Suprematist paintings, such as *Eight Red Rectangles*, were composed by projecting three-dimensional geometric forms onto paper at *31* sketch stage and concentrating on simply one of the planes in the final painting.

As important to Malevich as the visual possibilities offered by the Fourth Dimension, was the underlying mystical and idealistic vision offered by the theories. Although Malevich expressed doubts about pursuing further theories of higher dimensions (fearing that art could be 'imprisoned in a cube'), his own writing shows a great affinity with the mystical suppositions of the Fourth Dimension. If the three-dimensional world is limited and transitory, perception of the four-dimensional world is comparable to 'cosmic revelation'. As Ouspensky put it, once the horror of the abyss has passed, fear and sadness are transformed into joy. Cosmic space encapsulates this sensation, and Malevich's writings are full of phrases that hint at this transcendence. In his essay 'From Cubism and Futurism to Suprematism: The New Realism in Painting' (1916), Malevich wrote, 'I transformed myself in the zero of form and emerged from nothing to creation, that is, to Suprematism, to the new realism in painting – to non-objective creation.' Elsewhere he declared that 'At the present time [1919] man's path lies through space, and Suprematism is a colour metaphor in its infinite abyss.' Such references to the 'zero of form', to 'nothing' and to 'space' are all redolent of Ouspensky's understanding of the 'circle of the fourth dimension': the circle of life passing through the phases of birth, death and rebirth, which also inevitably escapes 'our space'. In Malevich's writing, our space is too much circumscribed by the 'ring of the horizon', which 'confines the artist and the forms of nature'. To reach cosmic integration, we must break free – and that involves not only replacing the forms of nature with completely abstract forms in art, but also venturing into a new space continuum which extends beyond the circumscribed horizon.

Something of these concerns may be sensed in Malevich's later development of Dynamic Suprematism. In an untitled painting of *33* 1915, smaller geometric forms are superimposed upon larger elements. Consequently, a sense of floating movement becomes more evident than in the previous works, and a much greater spatial tug is established between the shapes, although the white ground remains consistent with the earlier paintings. The choice of white had a

33 MALEVICH *Untitled: Dynamic Suprematism* 1915 >

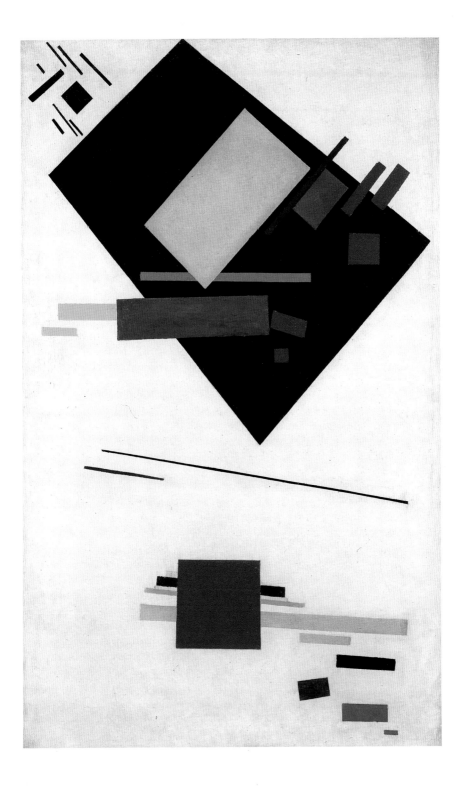

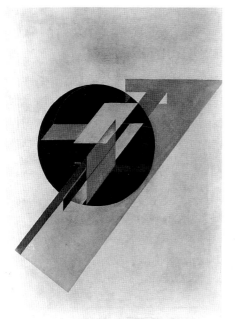

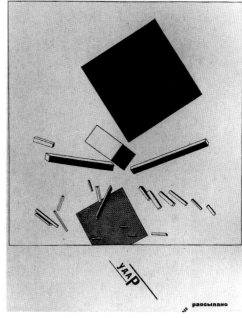

34 KLUTSIS *Axiometric Painting c.*1920

35 LISSITZKY *Crack! All is shattered!*
(from *A Story of Two Squares*) 1920

particular significance for Malevich. In an influential catalogue for the '10th State Exhibition' in Moscow, January 1919 (which contained 230 abstract works and established non-objectivity as the Soviet revolutionary style), Malevich referred to his use of white in terms of space travel: 'I have torn through the blue lampshade of colour limitations and come out into the white; after me, comrade aviators sail into the chasm. I have set up semaphores of Suprematism.' The following year, Malevich wrote also about the possibility of building a Suprematist satellite, saying that the Suprematist form itself was 'a distant pointer to the aeroplane's path in space'. In order to suggest deep space, he wrote, a white background was more appropriate than blue for giving 'a true impression of the infinite'. The 'ring of the horizon' would thus be pierced by myriad satellites leading the voyager to an infinite realm beyond.

Ilya Chashnik (1902–29), Gustav Klutsis (1895–1944) and Lazar El Lissitzky (1890–1941) were some of the 'comrade aviators' who, at least in part, followed Malevich's path of Dynamic Suprematism in the early 1920s, adapting it in their own individual ways. Chashnik's

Vertical Axes in Motion (1922–23), Klutsis' *Axiometric Painting* 34
(*c.* 1920) and Lissitzky's *A Story of Two Squares* (1920) all show the 35
influence of Malevich's floating elements against a white background
in terms of their compositional approach. Ivan Kliun (1873–1943),
who had been influenced by Malevich's ideas at the time of the
Revolution – his *Composition* (*c.* 1917) used a Suprematist flat form to 36
suggest the sensation of fading away at the edge – ended up
challenging the tenets of Suprematism at the '10th State Exhibition'.
Kliun attacked what he saw as its 'congealed, motionless forms', and
demanded instead a colour art in which 'compositions are subject only
to the laws of colour and not to the laws of nature' – a direction he
pursued in his own work of the Twenties. Other artists, such as
Aleksandra Ekster (1882–1949), adapted Suprematist designs for
'agit-prop' purposes: a functional approach within Russian art that
will be examined in the next chapter.

Having achieved Dynamic Suprematism in his work, Malevich
arrived at the very crossroads of 'nothing' in his *White on White* series

36 KLIUN *Composition c.*1917

(1917–18), in which a single white shape is placed on a white ground. These paintings reveal the very essence of non-objectivity; Suprematism departs still further from the object and becomes like 'the cosmos creation of nature'. If such works seem to reduce painting to its most minimal visual statement, in his own history of Suprematism Malevich connected his third, 'white' stage of Suprematism to 'pure action', and referred to white and black as though they were both capable of producing energy. Although this may sound rather obscure, Malevich's theory was actually close in spirit to earlier esoteric investigations into cosmic energy, such as Wilhelm Ostwald's concept of 'energetic imperative' and Gurdjieff's belief in the psychic translocation of objects over distances and the transference of telepathic power.

Both Malevich and Mondrian felt that painting had the power to transport the individual into a further realm of consciousness, and that only abstract means were appropriate to achieve this. 'Non-objective' form or 'pure plastic painting' had the advantage of bearing absolutely no resemblance to the world of nature, or, by implication, to the materialistic spirit of the nineteenth century. 'Little corners of nature' were despised and eschewed by Malevich, Mondrian and, eventually, by Kandinsky at the time of the First World War, precisely because they fettered the creative mind with references to the world of 'things'. If the theoretical language they used in turning against 'the rubbish-filled pool of academic art' was deliberately and provocatively strong, it was because of the nature of the opposition. The call was for a fundamental new order capable of changing man, and this was to go further than even the vaunting ambitions of Futurism.

However hopelessly idealistic the claims of these major pioneers may seem to us in retrospect, it is essential to remember that they were working during an extraordinary period. Despite their destructiveness, the War and then the Russian Revolution pointed to a world of new possibilities. Art itself could be an instrument of change, destroying the old system of individualistic values and providing a universal, mystically inspired language in its place.

ARP, TÄUBER AND SCHWITTERS

The social and political circumstances in Europe which culminated in World War made it inevitable that certain artists should address themselves directly to such pertinent issues as chaos and order.

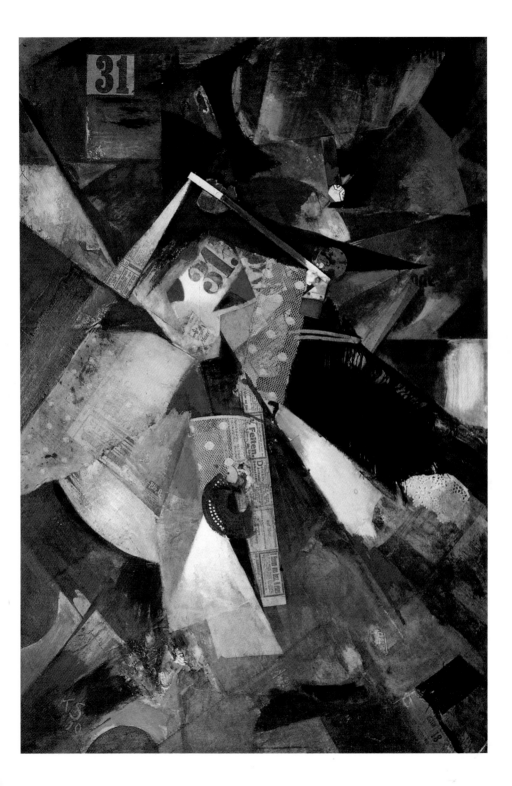

Reactions of disillusionment and disgust at the senseless barbarities of the War itself, protest against traditional values that had made war possible, and hatred of the standards and conventions of respectable society, took a variety of artistic forms. Originating in the neutrality of Zurich, the movement Dada was born in 1916 as an instrument of revolt. Youthful writers, poets and artists joined forces to ridicule society and to pour scorn on the pre-War artistic movements, including those of the avant-garde, that had accompanied the passage to war. Although complex, contradictory and wide-ranging – 'a state of mind' rather than a style or technique – Dada spread quickly to other European capitals and to New York, where it was developed by Duchamp and Picabia, among others. Included in its European ambit were certain artists who were equally important for their role within the development of abstract art: the Alsatian Hans (Jean) Arp (1886–1966), his Swiss wife Sophie Täuber-Arp (1889–1943), and the German artist Kurt Schwitters (1887–1948).

Born in Strasbourg, a German national but sympathetic to France, where he had trained, Hans Arp was inevitably distressed by the outbreak of war and disgusted by the human egotism that had partly led to it. The strength of his antipathy towards the old order, and of his own aesthetic aims, was made clear in the one creative credo he published before 1930, in a Zurich exhibition catalogue (1915). Working in non-conventional media, such as wood reliefs, *papiers collés* or even textiles, and sometimes in collaboration with other artists, he described his works in 1915 as, 'Structures of lines, surfaces, forms, colours. They try to approach the eternal, the inexpressible above man. They are a denial of human egotism. They are the hatred of human immodesty, the hatred of images, of paintings. . . . Wisdom [is] the feeling for the common reality, the mystical, the definite indefinite, the greatest definite.'

38 At this stage, the flat planar areas and compositional curves and diagonals in works such as *Paper Picture: Construction with Planes and Curves* (1915), are reminiscent of Cubism and Futurism; but the repudiation of illusion and the yearning for the eternal apparent in his stated aims of 1915, point to Arp's interest in the German philosophical tradition and link him to Kandinsky. Recent studies have shown that Arp was steeped in the Romantic Neoplatonism of the German poet Novalis, who suggested that the manifestations of the outer world are only appearances which obscure the higher essence, or ideal reality. Another writer known to Arp, the seventeenth-century mystic Jakob Böhme, believed that the universe

itself is a revelation of God. The legacy of these writers, combined with his great admiration for Kandinsky (whom he met in Munich in 1912), provided the philosophical interest that prepared Arp for his transition to abstract form. The outbreak of the War and the rise of Dada in Zurich further encouraged him to deny 'human egotism' in art and 'the bombast of the gods of painting (the Expressionists)'. Instead, searching for the eternal, Arp turned to geometry.

This interest was inspired considerably by the textile experiments of his future wife, Sophie Täuber, who was Professor of Textile Design and Techniques at the School of Applied Arts, Zurich, between 1916 and 1929. As early as 1915 Täuber was using horizontal and vertical elements placed against square or rectangular grounds in her textile designs. In the following year, Täuber and Arp began to work together, and according to Arp's later account they 'painted, embroidered and did collages. All these works were drawn from the simplest forms and were probably the first examples of concrete art. These works are realities pure and independent with no meaning or cerebral intention. We rejected all mimesis and description, giving free rein to the elementary and spontaneous.' A number of *Duo-Collages* (1918) show the results of their collaboration. The geometric quality, ultimately derived from textile design, was in marked contrast to Arp's earlier curves and diagonals. Feeling that evidence of the personality was 'burdensome and useless since it had developed in a world now petrified and lifeless', Arp and Täuber also renounced any marks of the artist's hand, even using a paper-cutter instead of scissors to make their paper pieces. The impersonality of the technique and the rigour of their geometry were essential to them, as they believed that people would be able to draw strength from such work because of its remoteness both from things and human beings. Such an elementary art, Arp felt, might 'cure man of the frenzy of the time'.

It was also between 1916 and 1919 that Arp produced collages composed from more random arrangements of pieces of paper than his geometric works. One such work, *Collage with Squares arranged* 39 *according to the Laws of Chance* (1916–17), though harmonious in its aesthetic result, questions the notion of order by the very process of its composition. The pieces of paper were torn rather than cut, and probably assembled through trial and error, treading a path between accident and design. As the (later) title suggests, this work, like others executed at the time, introduces an element of chance into Arp's compositions – a factor which was an important matter of principle to the Dadaists generally, and which was developed particularly within

the Zurich group. The Romanian poet Tristan Tzara advocated cutting words from a newspaper and pasting them together at random to make chance poetry; Marcel Janco (b. 1895), the Bucharest-born artist, utilized chance in his constructions of plaster and wire, and Arp himself used chance formulations of cut-up words for his poetry at this time. The attraction of chance for the Dadaists undoubtedly lay in its very opposition to structural order. In the context of the War, chance offered a paradigm of the chaos they sensed all around them. By abandoning normal ordering processes, random configurations offered a whole new set of possibilities, a new order. This concept was later taken up by the Surrealists; following Freud's diagnosis in *The Psychopathology of Everyday Life* (1901), they believed that chance actions were relevant for their demonstration of unconscious motivations.

Arp's interest in chance may again have come from Novalis, who professed that 'all that we call chance comes from God', and that 'conjunctions of chance' may be found among all the patterns and structures of nature which contain life's meaning. These views are echoed in Arp's later statement that the introduction of chance in his work was part of a search for 'essential order', and that 'the law of chance' was unfathomable, 'like the primal cause from which all life arises'. Although Arp was to develop the chance element more fully in his torn papers of 1932, it is significant that the *Collage*, described on p. 65, was illustrated as early as 1917 in the magazine *Dada 2*. The random appearance of the composition suggested to other artists the possibility of pursuing a new type of abstraction that was neither expressive – like Kandinsky's – nor geometric – like Mondrian's.

The freedom offered by chance probably also helped Arp to look at nature once again and to incorporate its forms within an abstract framework. His drawings and prints of 1916–17 show a vitality and apparent spontaneity similar to the *Collage*, and in his attempt to create 'new constellations of form such as nature never stops producing' his series of organic reliefs – *Plant Hammer* (1917–18) for instance – develop these ideas in wood. Nature's higher irrationality seems to replace the limitations of human rationality, for as Arp later remarked, 'Dada aimed to destroy the reasonable deceptions of man and recover the natural and unreasonable order.' The rigidities of geometry were in the end too restrictive for him, since they mirrored the rational constructs of the mind. Greater freedom and interest were to be found in nature's infinite variety, even in the natural formation of a single leaf. Consequently, Arp decided to combine abstract and

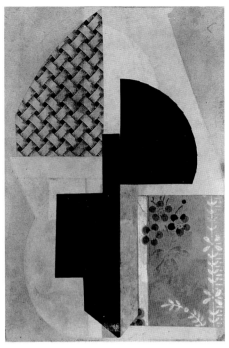

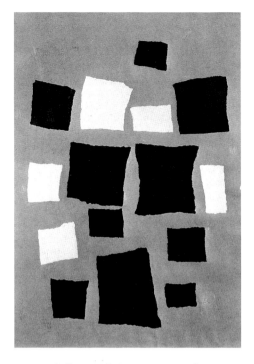

38 ARP *Paper Picture: Construction with Planes and Curves* 1915

39 ARP *Collage with Squares arranged according to the Laws of Chance* 1916–17

natural forms in a new synthesis, while Sophie Täuber went on to pursue the geometric logic of form in her later abstracts. 75,77

Although born in the same year as Arp, Kurt Schwitters came to abstraction later. At the end of the War, he was still painting Expressionist landscapes, and his style changed only after his visit to Berlin in 1918 and his contact there with Arp and the Berlin Dadaists Raoul Hausmann and Hannah Höch. Despite his friendship with these artists, Schwitters' application to join the Berlin Club Dada was rejected by the ex-Zurich Dadaist Richard Huelsenbeck on the grounds that Schwitters was an Expressionist and not sufficiently political. In the context of the major upheavals in Germany at this time – her defeat in the War, the revolution of 1918–19, the Spartacist uprising in Berlin, its bloody suppression, continuing strikes and riots – aesthetic 'interiorization' seemed out of place to Huelsenbeck and Berlin Dadaists such as George Grosz. They felt that Dada should engage in life and 'pose no longer before it'. Huelsenbeck poured scorn on the 'bogus' spirituality of Expressionism and its perpetrators,

and by 1920 (in *En avant Dada*) he had extended his doubts to abstract art, saying that the Zurich Dadaists were wrong to make abstract art 'the cornerstone of their new wisdom'. The call for an engaged, as opposed to a purer, less socially interventionist art was to gain strength as the 1920s progressed, pushing abstract art into a difficult corner.

In artistic terms, Schwitters' rejection by Berlin Dada gave him new impetus. During 1919 he published a popular, if avant-garde poem, *Anna Blume*, and created a personal brand of Dada which he called *Merz*. The exhibition of his new work at the Der Sturm gallery in Berlin, in July, presented a new challenge to Huelsenbeck. Schwitters went out of his way to declare that *Merz* was thoroughly apolitical; it was aimed, he said, 'only at art because no man can serve two masters', and he claimed moreover that his *Merz* pictures were 'abstract'. While his Berlin counterparts (such as Grosz) used collage and photomontage for the didactic purpose of political and social satire, Schwitters ironically employed similar non-traditional materials, but insisted on the autonomy of art, upholding abstraction as a valid pursuit.

Schwitters' insistence on formal qualities was nevertheless unusual. He called for 'the combination . . . of all conceivable materials', even those which had originally been formed for another purpose. Declaring that 'a perambulator wheel, wire netting, string and cotton wool [have] equal rights with paint', he combined such disparate materials as used bus tickets, stamps, calling cards, postcards, printed advertisements and newspaper clippings in his *Merzpicture Thirty-One* (1920). As well as showing his success with discarded materials, the *Picture* demonstrates his ability to combine elements from other artistic sources – Cubist collage, Boccioni's 'Manifesto of Futurist Sculpture', Futurist *parole in libertà*, Arp's torn papers, and Dada chance poetry – and to produce a work of original and surprising beauty, in which a sense of ordered wholeness emerges from a disparity of parts. Schwitters departed still further from Cubist or Futurist examples in his assemblages; *Revolving* (1919) goes beyond the flatness of collage to become an abstract relief made of 'real materials', a concern which is close to the investigations being carried out in Russia at this time.

It is his intention behind the *Merz* work that is particularly important for Schwitters' contribution to abstract art: 'The medium is as unimportant as I myself. Essential is only the forming. . . . I take any material whatsoever if the picture demands it. When I adjust

materials of different kinds to one another, I have taken a step in advance of mere oil painting, for in addition to playing off colour against colour, line against line, form against form etc., I play off material against material, wood against sackcloth.' In his emphasis on using a whole range of materials and in concentrating on the purely formal element of their compositional design, Schwitters anticipates the International Constructivist movement, which he joined in the early 1920s. With Arp, Tzara and even the Dutch De Stijl artist Theo van Doesburg (with whom he signed a manifesto entitled *Proletkult* in 1923), Schwitters could maintain, contrary to Huelsenbeck, that 'Art is a spiritual function of man, which aims at freeing him from life's chaos (tragedy). Art is free in the use of its means in any way it likes, but is bound to its laws and to its laws alone. The minute it becomes art, it becomes much more sublime than a class distinction between proletariat and bourgeoisie.' It was precisely this kind of debate that was to characterize developments in abstract art during the next decade.

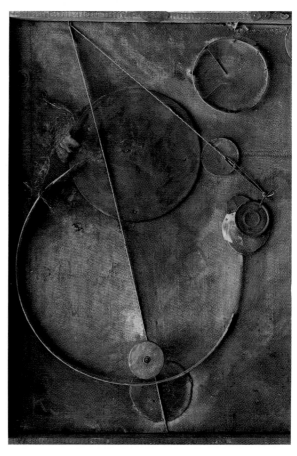

40 SCHWITTERS
Revolving 1919

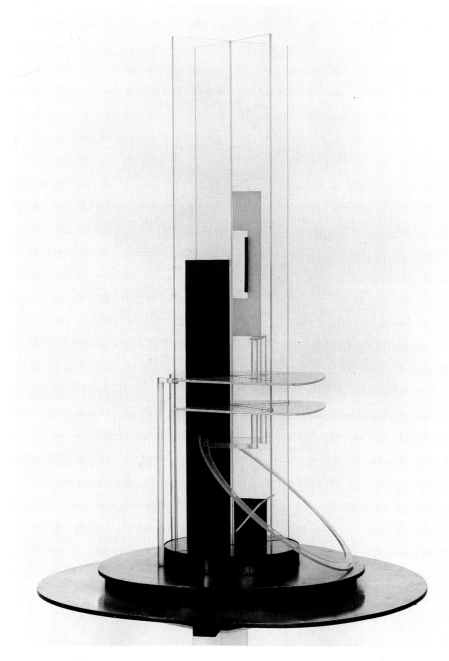

41 GABO *Column* 1923

Social Ideals: Constructing the Future 1920–39

Art which has no part in life will be filed away in the archaeological museum of antiquity.

RODCHENKO

Despite its devastation and massive death toll, the War ushered in a period of political and cultural change. On the one hand, it helped to hasten revolutionary developments in Europe, and on the other, it helped to nurture the avant-garde movements born in the pre-War period. Following the national hostilities of 1914–18, abstract artists began to seek international collaboration during the 1920s. With the advent of new media such as the radio, gramophone and cinema, a much wider public could now be reached and affected by the 'new spirit' that pervaded all spheres of life. If for some the sense of change undermined the old order and hence appeared threatening, for others it represented challenging possibilities in which fresh concepts of man and society could be linked to new artistic techniques. In the eyes of its practitioners, abstract art became unequivocally related to progress and change.

This was particularly noticeable in Russia (with Constructivism), in Holland (with the De Stijl group), and in Germany (at the Bauhaus). However, it was in Paris that an important theoretical basis for the new aesthetic emerged the year the War ended. In a book called *Après le cubisme* (1918), the French artist Amédeé Ozenfant and the Swiss Charles-Edouard Jeanneret (who became Le Corbusier) affirmed 'that art must tend always to precision', and called for an art that 'would inoculate artists with the new spirit of the age'. In giving 'especial importance to the lessons inherent in the precision of machinery', the artists themselves chose to pursue representational art in a form they called Purism. Nevertheless, the mathematical and geometric basis of their 'purist' aesthetic was widely influential, being disseminated not only through this book and their later *La Peinture moderne* (1924), but also through a periodical significantly entitled *L'Esprit nouveau* (1920–25), which inspired artists to extend some of the purist concepts to incorporate abstract ends.

In Russia it was the 1917 Revolution that provided fresh opportunities for the development of modernist ideas in the visual arts. As we have seen, the fever of modernist art in Russia dates from just before the First World War, when ideas inspired by Cubism and Futurism became quickly transformed into Cubo-Futurism, from which Malevich later went on to develop Suprematism. However, it was the particular conditions arising from the political climate after 1917 that gave committed modernist artists unprecedented opportunities to experiment across a whole variety of fields and media. For in the early years of its formation, the Soviet State, under the auspices of the Commissar of Education Anatoly Lunacharsky, was the first not only to condone abstract art, but also to patronize it officially. Although by the mid-1930s, a hardening of the social and political outlook under Stalin and Zhdanov made Soviet Social Realism the new official style, from 1917 to the early 1920s modernist art was welcomed – as much as anything because it challenged the representational traditionalism and, thus, conservatism, of the Tsarist regime. Two main, if opposing, directions developed within the Russian artistic avant-garde: one entailed relinquishing the bourgeois 'art' connotations of the easel and actively participating in 'life' through a materialist policy of 'Constructivism'; the other involved the continuation of fine art, frequently overlaid with a higher purpose. Despite lack of funds and materials, the two impulses set under way one of the most fertile periods of abstract experiment.

The tendency away from easel art and towards 'Constructivism' first became evident in the '0–10, The Last Futurist Exhibition of Paintings' of 1915, which included constructions by the artist Vladimir Tatlin (1885–1953), as well as Malevich's first exhibited Suprematist paintings. Tatlin's non-representational *Corner Counter*
42 *Reliefs* (1915) concentrated on physical matter by employing 'real materials in real space' (such as wood, metal and string) and by exploiting the inherent properties and colour of each substance. Tatlin had been inspired by a visit to Picasso's studio in 1913, where he saw reliefs based on motifs such as the guitar. On his return to Moscow, Tatlin took Picasso's ideas to their logical conclusion by producing completely non-representational reliefs, before moving on to constructions, like the *Corner Counter Reliefs*, which protruded outward into the spectator's real space, rather than being placed flat against a wall. These broke new ground and pointed to directions that would be explored by other sculptors. By being literally suspended in the air,

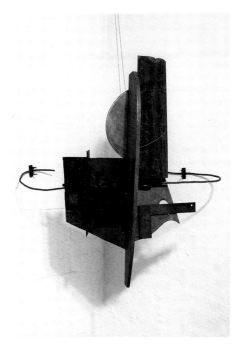

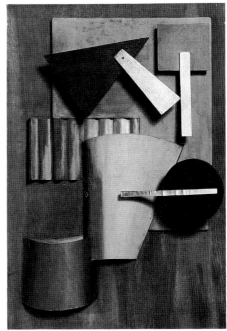

42 TATLIN *Corner Counter Relief* 1915 43 PUNI *Suprematist Construction* 1915

piercing and cutting into the space around them, these complex reliefs repudiated the flat, two-dimensional surface (or wall) from which reliefs had projected in the past. At the same time, the interpenetration of planes challenged traditional concepts of sculptural mass, while the new technique of construction replaced the standard techniques of carving and modelling. Although Picasso had pioneered these methods in his own reliefs, Tatlin was important for showing that the depiction of objects could be transcended by a concern with real materials.

Tatlin's respect for materials and his synthesis of their forms was related to his belief in obeying natural laws, in creating forms of universal significance which would therefore appeal to a mass audience. However, his commitment to a 'culture of materials' rebelled against Malevich's interest in the cosmic space of Suprematist painting and caused a rift between the two artists. Their division anticipated the dialectical opposition of materialist and spiritual attitudes in post-Revolutionary art. Certain artists, such as Ivan Puni (1894–1956) – who funded the '0–10' exhibition – combined

influences from both artists in their exhibits. Using Tatlin's concept of 'real materials', Puni extended the forms of Suprematist painting into three-dimensional space in reliefs such as *Suprematist Construction* (1915). Yet in a manifesto published with his wife, Xana Boguslavskaya, at the '0–10' exhibition, he declared that 'a picture is a new conception of abstracted, real elements deprived of meaning'. The repudiation of meaning, as well as the commitment to 'real elements', indicates an early attempt to justify the abstract art work as a self-sufficient entity, with no further motive. This formalist point of view – an abstract 'art for art's sake' philosophy – was to recur later with Concrete art in the 1930s and Minimal art in the 1960s.

Meanwhile, Tatlin's ideas were passed on to other artists in Moscow through the system of design he taught at the Vkhutemas (Higher Technical Artistic Studios) and through the fame of his official commission: the *Monument to the IIIrd International* (1919–20), known as Tatlin's Tower. Embodying concepts related to engineering and architecture rather than fine art, the Tower also had a symbolic function. It pointed to a way in which artists could help to plan a new world for the Soviets by moving beyond domestic art and creating something functional, collective, yet essentially modern – both in materials and in appearance. Intended to rise higher than the Eiffel Tower, Tatlin's Tower was constructed on the basis of two spirals. Separate geometrical components (to house offices) within the skeletal structure were to revolve upon their axes, while messages to the proletariat were to be relayed across the sky. Although it was never actually built, the Tower represents an artistic watershed. Following the exhibition of a fifteen-foot-high maquette in Petrograd in November 1920, Tatlin called for other artists to follow him in 'uniting purely artistic forms with utilitarian functions' and summoned 'producers to exercise control over forms encountered in our new everyday life'. This summons was quickly answered by those artists eager to extend 'art into life'.

In January 1921 three artists of the Obmokhu Group (Society of Young Artists, trained at the Vkhutemas), Vladimir (1899–1982) and Georgii (1900–33) Stenberg and Kasimir Medunetsky (1899–1934), announced themselves to be 'Constructivists of the World', and called on artists to take 'the shortest path to the factory'. The Stenbergs' *KPS Apparatus* series was built from industrial materials using assemblage techniques borrowed from engineering. Although the pieces looked like abstract sculpture, they were designed (like Tatlin's Tower) as experimental prototypes for utilitarian structures. If the term

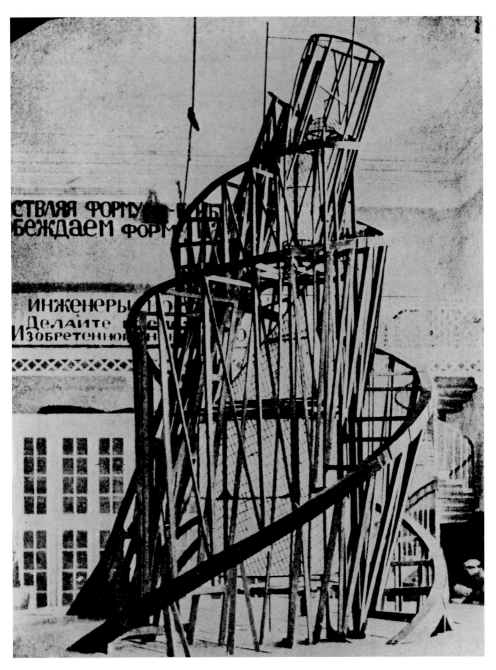

44 TATLIN *Monument to the IIIrd International* 1919–20

45 Obmokhu exhibition, Moscow, 1921, including works by the Stenbergs and Rodchenko

'Constructivism' was already entering into use, it was taken yet further in an exhibition called '5 × 5 = 25', held in Moscow in September 1921. This effectively declared the death of easel painting. The five exhibitors (who each showed five works – hence the title), Aleksandr Rodchenko (1891–1956), Aleksandra Ekster, Lyubov Popova (1889–1924), Varvara Stepanova (1894–1958), Rodchenko's wife, and Aleksandr Vesnin (1883–1959), all contributed a text to the handmade catalogue. Stepanova argued for the primacy of technology and industry, and declared that 'the sanctity of a work as a single entity is destroyed'. Popova declared that her pictorial constructions were to be considered simply as a series of preparatory experiments towards 'concrete materialized constructions'; while Rodchenko, whose own exhibits included three monochrome paintings, maintained that 'representation is finished: it is time to construct'.

As well as indicating support for Tatlin, Rodchenko's position confirmed the internal logic of his own development. In his earlier work, his interests had extended across a wide variety of media, covering ruler and compass drawings (1916), linocuts (1919), collages (1919), metal structures (1921), and wooden constructions such as the *Hanging Oval* (1920–21). In all these works, and even in certain *45* Suprematist-inspired paintings – the extreme *Black on Black* (1918), for example – all traces of artistic individuality, expressiveness and handiwork were suppressed. Instead, each work rested on the appropriate exploitation and handling (*faktura*) of the specific material employed. This technique was closely associated with the formalist linguistics of contemporary writers, including Rodchenko's friend Osip Brik, who denied further 'readings' beyond the material presentation of the work itself.

A rather different notion of construction was developed by the sculptor Naum Gabo (1890–1977). During the limited years he spent in Russia after the Revolution, Gabo actively explored the de-materialization of traditional mass and volume; he investigated dynamic forms in space, and even kinetic possibilities for sculpture, as in *Kinetic Construction No. 1* (1920), where a single metal rod was attached to a small motor, making it vibrate into a pattern. However, his long-term intentions were never utilitarian in the same sense as those of the Soviet Constructivists. He believed in the experimental basis of art and in the pursuit of knowledge as an ennobling aspect of human endeavour, but he did not feel that art needed to have a socially functional purpose as well. Whilst he planned, and even reached model stage on certain social structures, such as fountains and a standing *Column* (built on a larger scale only when he had left Russia), *41* the aesthetic intentions behind his work meant that he felt out of sympathy with the ideals of Soviet Constructivism. As Gabo's work also became known in Europe as 'Constructivism' this has rather confused the use of the term, but it serves to show how differing aesthetic aims could co-exist (at least for a time) side by side within the Soviet state.

The two positions were polarizing. Gabo and artists such as Malevich and Kandinsky (who had returned to Russia at the outbreak of the War) believed that abstract art had a vital contribution to make to contemporary society in raising men's consciousness and unlocking the door to higher awareness. Tatlin, Rodchenko and their followers, on the other hand, saw such a position as Romantic and out of keeping with the urgent requirements of the day. In the new

Communist state, torn apart by Revolution, world and civil war, they viewed the very concept of the artist as an out-moded bourgeois luxury; in the midst of devastation, they came to feel there was no place for art. 'Construction', in both its semantic and ideological sense, was to replace art, and 'constructively organized life' was to act as the rallying call for all 'artist-technicians' sympathetic to the cause. Although both kinds of abstract artist practised and taught within the educational system during the early years of the New Economic Policy, at Inkhuk as well as at the Vkhutemas (where a strong 'realist' faction was also apparent), the socially committed 'Constructivist' wing quickly gained the upper hand, and the positions of Kandinsky, Gabo and Malevich became untenable as the 1920s progressed and political pressure was brought to bear.

Although Soviet Realism was only made 'official' in 1934, the powerful Association of Artists of Revolutionary Russia, set up in May 1922, argued that with the problems of mass illiteracy, what was needed was a realist art that could be understood by all. Although the socially committed abstractionists might be temporarily tolerated, there was no room for the 'pure' abstract artist in the Soviet state. While this argument also had a political motive – which would culminate in a rationale for propagandizing realism under Stalin – it did highlight one of the major problems that abstract art was already having to face: how to find and reach a public? In the particular context of post-Revolutionary Russia, art which did not convey an immediate message or serve a utilitarian purpose became difficult to accommodate and potentially suspect. Significantly, Kandinsky and Gabo left Russia in 1921 and 1922 respectively, while Malevich, remaining behind, became increasingly isolated in his laboratory art experiments.

For the utilitarian Constructivist wanting to make immediate practical contributions, the obvious step was to enter industry as a 'Productivist'. Artistic involvement here was given a considerable boost by the state. The official body Narkompros (The People's Commissariat of Enlightenment), under Lunacharsky, opened an Applied Arts Section which was committed to training new artists in schools such as the Vkhutemas. Through this intervention, direct entry was provided into the textile and ceramics industries for artists of various persuasions. Ironically, the ceramics industry was revitalized by Malevich's pupils, Suetin and Chashnik. From 1922 they decorated the plain white dinner services left over at the Imperial 46 Porcelain Factory, created Suprematist tea-sets and designed func-

46 CHASHNIK
Suprematist porcelain design 1923

47 STEPANOVA
Abstract textile design 1924

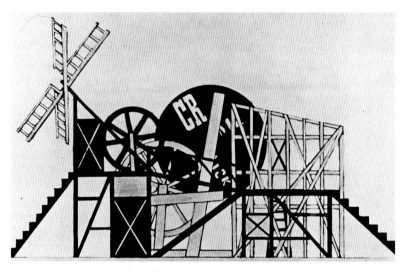

48 POPOVA Set design for *The Magnanimous Cuckold* 1922

tional objects such as teapots (a practical venture in which even Malevich briefly participated). The textile industry was resuscitated with the arrival of Popova and Stepanova in the workshop of the First Cotton Printing Factory, Moscow. A report by Stepanova in 1924 defined the task for artists working in industry, and stressed the importance of replacing floral, with geometric or non-representational designs. Following her recommendations, the new designs often included repeated motifs, strongly abstract in appearance but at times evoking industrial machinery and the Soviet ideals of mass-production and industrialization. The essential qualities were clarity and the restricted use of strong colour. Popova took abstract pattern a stage further by designing everyday clothes for women in which subtle geometric patterns were placed against a plain background; Rodchenko and Stepanova produced designs for working clothes based on contrasting colour blocks and bold articulation of shape; while Aleksandra Ekster worked in both industrial design and *haute couture* until 1924, when she settled permanently in Paris.

If, due to technical problems, mass production of a design was not possible, the unused patterns were often applied to other media, such as poster and theatre design, through which artists could enter the public arena and reach a wider audience. The sympathetic under-standing given to Constructivist aims by the director Vsevold Meyerhold, meant that the theatre provided a welcome venue for

47

artists who agreed with Meyerhold's declaration in 1920, that
' "Decorative" settings have no meaning. . . . What the *modern*
spectator wants is the placard, the juxtaposition of the surfaces and
shapes of *tangible materials*.' Popova's constructions for Meyerhold's
production of *The Magnanimous Cuckold* (1922) consisted of a *48*
structural framework embodying linear and geometric elements
('tangible materials') which were designed to move and rotate in
response to the actors' movements. Although loosely suggestive of a
windmill – a necessary function of the set – the construction also
appears as an early form of abstract kinetic sculpture, an impression
reinforced by its drawn design. Among many other designs for the
theatre, Stepanova produced geometric shapes for the costumes of
Tarelkin's Death (1923), while El Lissitzky's set design for Meyer-
hold's planned production of *I want a Child* (1926) was so ambitious
that the play had to be postponed until the theatre could be rebuilt to
accommodate it; consequently, it was never staged.

Poster design and magazine publishing attracted many artists due
to the possibilities of mass-production. El Lissitzky's poster *Beat the* *49*

49 LISSITZKY *Beat the Whites with the Red Wedge* 1919

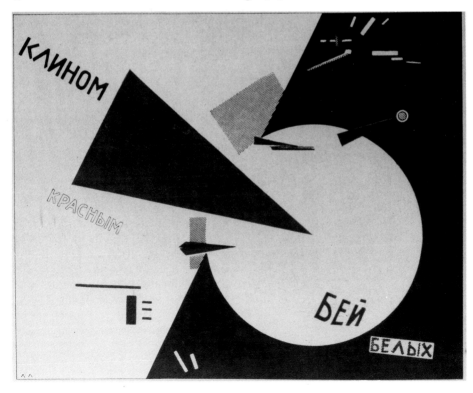

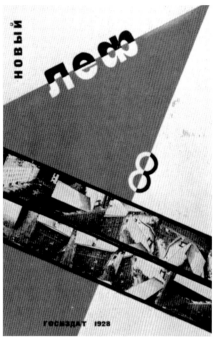

50 RODCHENKO Cover design for *Novy Lef* 1928

Whites with the Red Wedge (1919) is one of the best known examples of abstract art employed for propaganda. Rodchenko used bold, abstract arrangements of geometric forms and two-colour design for
50 the covers of the Constructivist magazines *Lef* (1923–25) and *Novy Lef* (1927–28). Several issues show the influence of El Lissitzky, whose asymmetrical placing of typography is already echoed in Rodchenko's designs from 1923. Photomontage and collage also left their mark, in the unusual placing of compositional and typographical elements in a great variety of poster and book design, and Olga Rozanova's (1886–1918) collages for Aleksei Kruchenykh's poem
51 *The Universal War* (1916) are effective early examples of non-objective art as illustration.

By the early 1920s most Soviet artists adhering to the tenets of Rodchenko and Tatlin had taken the step of bringing art into life. Today their activities would be classed as applied art or design, rather

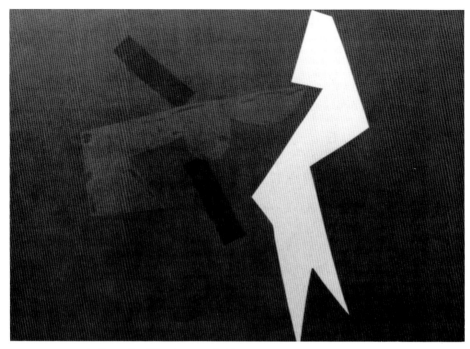

51 ROZANOVA Collage for *The Universal War* 1916

than as fine art. In justification, the artist–critic Aleksei Filippov argued, in an article for the Visual Arts Department of Narkompros' publication *Art in Production* (1921), that the division between 'high pure art' and traditionally subservient 'applied art' no longer existed: 'the fine and easily eradicated dividing line between abstract and productional art can present us with a new synthesis and new, joyful artistic attainments'. This synthesis found a more lasting fulfilment in the De Stijl movement in Holland and the Bauhaus in Germany.

DE STIJL

The periodical *De Stijl* first appeared in October 1917 and ran until 1932. Of great importance in disseminating abstraction throughout Europe during these years, the magazine shared its name, 'The Style', with an associated group of artists and architects. Although members

changed during the magazine's lifetime, the founding group included Mondrian, Bart van der Leck, Theo van Doesburg (1883–1931), the Hungarian painter Vilmos Huszar (1884–1960), the Belgian sculptor Georges Vantongerloo (1886–1965) and three Dutch architects: J. J. P. Oud, Jan Wils, and Robert van t'Hoff. The introduction to the first issue of the magazine stated clearly the aims of its editors: 'This periodical hopes to make a contribution to the development of a new awareness of beauty. It wishes to make modern man receptive to what is new in the visual arts. . . . The Editors will try to achieve the aim described above by providing a mouthpiece for the truly modern artist, who has a contribution to make to the reshaping of the aesthetic concept and the awareness of the visual arts. Since the public is not yet able to appreciate the beauty in the new plasticism, it is the task of the professional to awaken the layman's sense of beauty.'

The truly modern artist was seen to have a two-fold task: to produce 'the purely plastic work of art' and 'to prepare the public's mind' for it. One way to do this was through collaboration. A greater contact was called for between the practitioners of the different visual arts and between artists of different countries. In an attempt to create international interest and to promote synthesis and involvement, a four-language manifesto was published in the second volume of the magazine in November 1918. In this, the recently ended War was seen as an apocalyptic divide between the 'old individualistic world' and the new 'universal' society. Along with eight other points in their programme, the signatories claimed that 'the new consciousness is ready to be realized in everything, including the everyday things of life'. They clearly felt that painting need no longer be restricted to the canvas but should enter other realms. As in Russia and the German Bauhaus, the abstract artist was seen to have a broader social function.

The driving force behind De Stijl was not so much Mondrian as van Doesburg. It was his energy that lent impetus to the magazine's investigation of the potential role of abstract art in its application to modern life. At the time of De Stijl's emergence as a periodical, van Doesburg had moved into abstraction and was beginning to apply abstract forms to applied art. His prevalent interests were architectural, and similar designs are found in both his paintings and his commissions for buildings. Architectural details, such as his stained-glass windows for a house at Alkmaar (1917), employ similar abstract forms as his contemporary painting *Rhythms of a Russian Dance* (1917–18). As van Doesburg said at this time, his main aim was 'to place man within (instead of opposite) the plastic arts and thereby

enable him to participate in them'. His embracing of abstraction was wholesale. It was not enough simply to paint pictures; the entire surrounding environment had to conform to 'The Style'. The implication was that by changing man's environment to reveal the universal harmony in the 'purely plastic work of art', man's consciousness would be changed also. To effect this transformation the particularity and individualism of representation had to be transcended. The basic rules involved the use of the horizontal and vertical, and flat areas of primary colour. Not surprisingly, it was Mondrian's formal vocabulary and his theoretical philosophy that underpinned the grammar of De Stijl.

Although sympathetic to architecture and sufficiently interested in interior design to plan his own Paris studio as a De Stijl working environment, Mondrian took abstract design no further than constructing a De Stijl theatre model. The important difference between the originator of Neo-Plastic painting and his colleagues lay in the fact that Mondrian, the ascetic, felt that painting was historically more advanced than the other arts and should constitute the main field of activity for De Stijl practitioners. Van Doesburg, the peripatetic propagandist, and others based at Leiden and the Hague, believed on the contrary, 'that art and life are now no longer separate domains. . . . The word "art" no longer has anything to say to us. In place of that, we insist upon the construction of our surroundings according to creative laws deriving from a fixed principle.' By 1919 van Doesburg believed that Neo-Plasticism was concerned with solving the problem of 'creative harmony' in *all* the arts, and obviously felt that Mondrian's commitment to painting – at least in practice – was too dogmatic and individualistic. For van Doesburg, De Stijl was part of 'a transition towards something else' and did not end with Neo-Plastic painting.

Despite similarities in this respect with the ideas of the Russian Constructivists, the De Stijl practitioners believed that they could pursue their researches according to a 'fixed principle', while for the Russian artists there was no single concept of style. Within De Stijl, the emphasis on constructing new surroundings according to a fixed idea did ensure a mutual influence between artists and architects. Thus, Oud's façade for the Café de Unie (1924) echoes Neo-Plastic \quad 53 painting. Oud had formed a small collection of works by Mondrian, studying them for their finely adjusted balance of parts, and in the case of the Café the front elevation reflects the harmonious relationships of coloured blocks and grid in Mondrian's *Painting I* (1921) for example. \quad 25

85

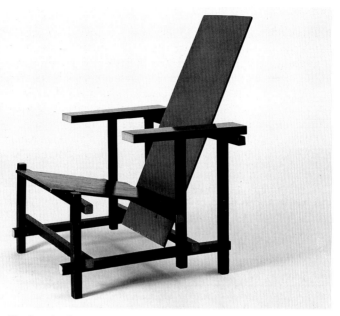

52 RIETVELD 'Red and Blue' chair 1917–19

53 OUD Design for the façade of the Café de Unie 1925

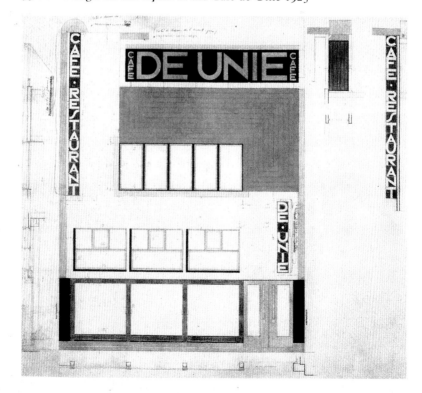

In the Schroeder house (1923–24), designed by Gerrit Rietveld (a Utrecht-based craftsman and architect who came into contact with van Doesburg around 1919 and was loosely associated with the De Stijl circle), the flat planar surfaces of Neo-Plastic painting are punctuated by elegant rectilinear coloured bars which articulate the balconies and windows of the exterior walls. While suggesting a formal closeness between the disciplines of abstract painting and architecture, such De Stijl designs relate to the broader development of what was to become known as the International Style in architecture. Rietveld's famous chair (1917) was as much a departure *52* in twentieth-century furniture design as Mondrian's geometric painting was in art. With the seat and back painted (two years later) in bright primary colours and the listels in black, it conforms to De Stijl principles, looking like a three-dimensional Mondrian painting.

Of all van Doesburg's interior designs, the largest and most significant was the redecoration, in collaboration with Hans Arp and Sophie Täuber, of the Café d'Aubette in Strasbourg (1926–28). This instigated a formal change within De Stijl which is shown most clearly in the principal room he redesigned: the Cinema Dance Hall. *54*

54 VAN DOESBURG Interior of the Café d'Aubette, Cinema Dance Hall 1926–28

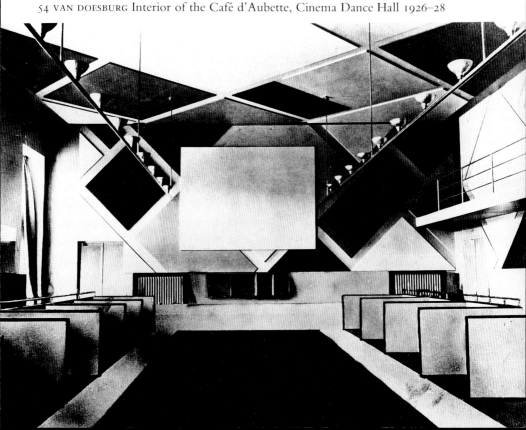

Rather than adhere to the individual integrity of the wall and ceiling (as Mondrian would have insisted), van Doesburg broke up the literal flatness of the surface of the end wall by an unconventional treatment of space: a bold series of diagonal planes concealed the perimeters of the wall, thus obscuring the definition of wall and ceiling as separate architectural entities. The breaking of the planar surface had in fact 55 been anticipated in more public fashion by Lissitzky's Proun Room (a part of the important Grosse Berliner Ausstellung in 1923), where the division between separate walls was dissolved by running the structures continuously round the corners, and so conveying the suggestion of a floating space. However, while El Lissitzky's unconventional treatment may have been acceptable in an exhibition, van Doesburg's radical designs were not appreciated by the Café's clientele. Shortly after the Café was reopened in 1928, public demand caused the decorations to be overpainted. Although this was a cause of bitter disappointment to van Doesburg, it illustrates the continuing problem for abstract artists of finding an audience.

The formal significance of van Doesburg's use of the diagonal was that it posed a challenge to Mondrian's concept of dynamic equilibrium contained within the orthogonal. Throughout his life, Mondrian continued to maintain not only that the orthogonal was essential for the Neo-Plastic style, but also that it contained sufficient potential for dynamism within itself. He even developed a varied 98 format – the lozenge. By turning the canvas at an angle of 45°, he created a diamond shape as the support. The painted grid-lines were still horizontal and vertical, but because they were no longer visually bound by the four sides of the canvas, they appeared to extend spatially beyond it. Whether using simple black lines or adding colour to the lozenge, Mondrian always adhered to the orthogonal. Van Doesburg, however, had already rejected this tenet in 1923, in an architectural design for Amsterdam University, and by 1924 he was 68 producing Counter-composition paintings which totally repudiated Mondrian's upright grid in favour of a diagonal disposition of flat, coloured elements in a tilted, disequilibrious relation, accentuated at times by the use of a diagonal black grid.

Van Doesburg's 'heresy' of the diagonal can be ascribed to his natural restlessness, to his Hegelian concept of progress (in art) and his search for a strongly dynamic rhythm within the confines of a fully abstract, geometric style. In his Counter-compositions he sought to conceive, as he saw it, 'a phenomenon of tension rather than one of relations in the plane'. He described his new venture as Elementarism,

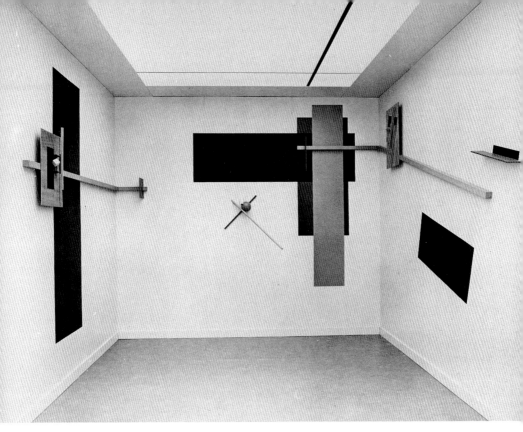

55 LISSITZKY Proun Room (reconstruction) 1923

publishing a manifesto in 1926 to defend it. However, his decision to break with one of Mondrian's central rules also points to some of the difficulties inherent in conforming to a pre-set formula. For although Mondrian's painting was designed to appear impersonal and universal, and although he was able to create different paintings within the strictures of his own formulation, his immediately recognizable, strongly individual style made it difficult for other painters to follow him without appearing to imitate. While van Doesburg broke with the basic premise in order, among other reasons, to free himself of Mondrian's all-pervasive influence, other artists, like Georges Vantongerloo, got round the problem by subjecting the principles of Neo-Plasticism to a mathematical perfection – Mondrian adjusted the relations in his paintings visually – and by making De Stijl

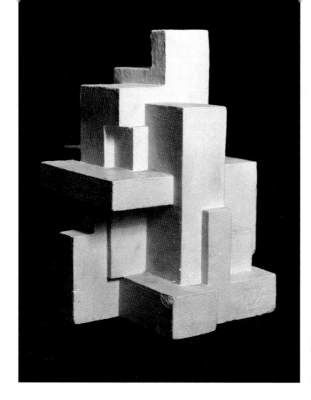

56 VANTONGERLOO
*Construction of
Volumetric
Interrelations* 1924

56 constructions. Many of Vantongerloo's sculptures up to 1930 look
like projections into three dimensions of the flat planes of a De Stijl
painting, and constitute a rare venture into De Stijl sculpture.

Van Doesburg's travels brought him into contact with new artistic
ideas and practices in other parts of Europe, and in 1922 he invited
both Dada and Constructivist artists to participate in De Stijl
activities. Hans Arp and Hans Richter (1888–1976) collaborated on
the Dada side, leading to the publication of a *De Stijl* supplement,
Mecano (1922), while links between De Stijl and Constructivism were
reinforced by the participation of El Lissitzky, whose book *A Story of
Two Squares* was republished in a special Suprematist issue of *De Stijl*
(1922). The dynamic thrust of the red and black squares on the page
35 'Crack! All is shattered!' is a good example of the energy of the
diagonal, and it must have appealed to van Doesburg in his later
development towards Elementarism. Other artists sympathetic to De
Stijl were also invited to join the group; the Dutch artist César
Domela (b. 1900), based in Berlin, and the German painter Friedrich
Vordemberge-Gildewart (1899–1962) joined in 1924. Domela used

the diagonal both in his paintings and in his constructions in plastics and plexiglass, and Vordemberge-Gildewart followed De Stijl principles in his severely geometrical paintings and relief constructions.

The range of artists participating in later De Stijl suggests some degree of success, at least, for the original aims of the founders. Artists of different countries *were* being brought together, even if the objective of preparing 'the public's mind' for the 'purely plastic work of art' was proving more difficult to achieve.

THE BAUHAUS

The Bauhaus School of Applied Art and Architecture in Weimar, Germany, opened by the architect Walter Gropius in 1919, provided an excellent training ground for applied artists. In an attempt to elevate the status of crafts to the level of fine art, Gropius intended that all the arts should be taught at the School, and that fine artists as well as craftsmen should provide the core teaching. Although there was no painting course on the curriculum until 1926, several abstract painters were employed to teach students the elements of design theory. Consequently, under the guidance of artists as varied as Johannes Itten (1888–1967), László Moholy-Nagy (1895–1946), Josef Albers (1888–1976), Wassily Kandinsky and Paul Klee, the Bauhaus became a vital international centre for the investigation of compositional principles based on an abstract treatment of form.

Johannes Itten was a Swiss artist, trained in Stuttgart under Adolf Hölzel, whose primarily intuitive colour theories (based on Goethe, the German Romantic painter Philipp Otto Runge and Chevreul) were adapted by Itten for his teaching on the principles of colour and form in his compulsory introductory course at the Bauhaus. Itten was the first teacher to arrive at the School with a fully developed theory, which he based on the notion that 'form and colour are one'. Believing that 'Geometric forms and the colours of the spectrum are the simplest, most sensitive forms and colours and therefore the most precise means of expression in a work of art', Itten placed these concerns at the centre of his teaching, and encouraged students to work on the principle of contrast in their compositions: of light and dark, warm and cold, of complementary colours, and so forth. Although his intention in this was expressive (and undoubtedly derived from Kandinsky's *On the Spiritual in Art*), Itten's emphasis on the analysis of basic form and colour prepared students to think out

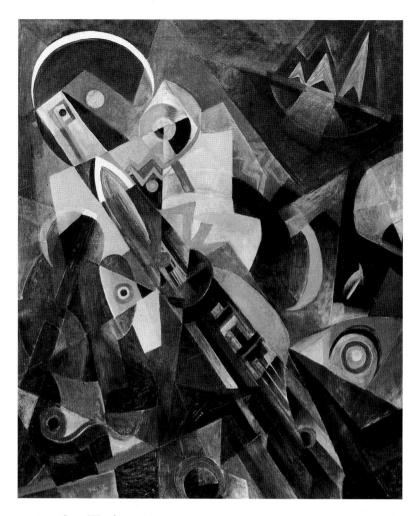

57 ITTEN *Last Watch* 1918

questions of design from first principles, leading in many cases to abstract conclusions. Employing principles of colour gradation, Itten's own paintings and textile designs veered between a loosely

57 expressionist, abstract style (*Last Watch*, 1918) and one that was more geometric.

In 1923 Itten was replaced at the Bauhaus by the Hungarian artist László Moholy-Nagy, whose interests were entirely different. In place of the hand-crafted approach of Itten, Moholy-Nagy advocated

knowledge, understanding, emulation and use of the machine. As he stated in 1922, 'The reality of our century is technology: the invention, construction and maintenance of machines. To be a user of machines is to be of the spirit of this century. It has replaced the transcendental spiritualism of past eras.' This position also reflected a much wider European tendency in the 1920s which, as we have seen, aimed to combine technological functionalism with aesthetics. The Purists in *L'Esprit nouveau I* (1920), for example, maintained that 'the spirit of construction is as necessary for creating a picture or a poem as for building a bridge'. However, Moholy-Nagy went further to affirm a social principle: 'Everyone is equal before the machine . . . there is no class consciousness. . . . Everyone can be the machine's master or its slave.'

Moholy-Nagy's comments reflect his Central European background. Having been a co-founder of the Hungarian MA ('Today') group of avant-garde painters in Budapest, he met leading Russian Constructivists and Dadaists during his sojourns in Vienna and Berlin (1919–21). Under such influences, he produced abstract works based on rectilinear forms with quasi-mathematical titles, such as *A pn 3* 58 (1923), in which the simplified elements of the composition and the clear structural approach to line suggest the influence of Malevich and El Lissitzky. However, unlike those artists, Moholy-Nagy was extremely committed to machine accuracy. Even before arriving at the Bauhaus, he 'ordered' an abstract series of paintings, *EM 1, 2, 3* (1922), from an enamels factory. The works were manufactured in accordance with the artist's graph-paper blueprint, which was then reproduced in three different sizes by the factory. The impersonality of the execution and the highly finished, mechanical quality of the works prompted Moholy-Nagy's observation that such works could be ordered over the telephone – thus anticipating a conceptual attitude that was to gain prevalence in the art of the late 1960s and 1970s.

Moholy-Nagy's arrival at the Bauhaus ensured a decisive change in the School's procedures and training. This led to a more streamlined approach to all aspects of design, by which the elements of any given object were rationalized, making use of whatever suitable materials were available. His Constructivist attitude to work and materials was softened by a humanist tendency in his teaching, so that his ambition to nurture 'the spirit of Construction' was extended both to 'school and man'. His own designs, such as the prototype for the new light fittings of the Dessau Bauhaus, blended a Constructivist approach

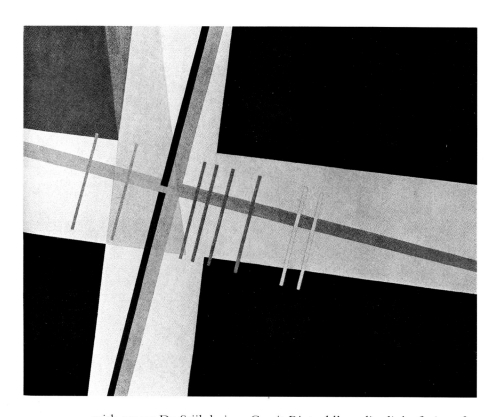

with recent De Stijl design. Gerrit Rietveld's earlier light fittings for the Schroeder house (a set of neatly compacted tubular fixtures) were adapted by Moholy-Nagy to an institutional rather than a domestic function. As these objects show, he was prepared to tackle a great range of media, taking abstract design into many walks of life. Besides painting, sculpture and industrial design, he also experimented – with great success – in film, theatre, photography and typography. Such versatility was also encouraged among the students, and is one of the Bauhaus' most prominent and influential characteristics.

59

In 1925 Moholy-Nagy oversaw the publication of the first eight volumes of the Bauhaus Books, which included the latest theories in art, design and architecture of Bauhaus staff and international artists such as Le Corbusier (Jeanneret), Malevich, Mondrian and van Doesburg. Moholy-Nagy's asymmetrical designs for the covers echo the clarity of his paintings and photographs. His techniques were emulated by his Bauhaus students Herbert Bayer, who combined bold red lines and clean-cut type in poster typography, and Joost

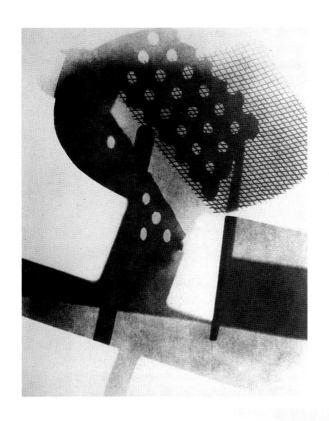

58 MOHOLY-NAGY *A pn 3* 1923

59 MOHOLY-NAGY
Photogramme (Positive) 1922–26

60 SCHMIDT
Poster for the Bauhaus
exhibition 1923

61 SCHLEMMER Costume designs for the *Mechanical Ballet* 1923

60 Schmidt, whose black and red, asymmetrically designed poster for the Bauhaus exhibition (1923) shows how radically the De Stijl/ Constructivist influence had affected the School by this time; only four years before, it was Lyonel Feininger's expressionist representation of a cathedral that had provided the School's image.

 The bold, flat and geometric elements which characterized the two-dimensional arts at the Bauhaus were also employed in other media. Although the paintings of Oskar Schlemmer (the School's theatre design teacher) were based on the simplification of forms found in nature, and were thus representational in origin, his designs

61 for the Bauhaus' *Mechanical Ballet* (1923) were completely abstract, employing brightly coloured geometric forms. Once the figures were in motion, the costumes created moving abstract patterns – a live version of the experiments that Hans Richter and Viking Eggeling (1880–1925) had recently been pursuing in film. Eggeling's *Diagonal*

62 *Symphony*, first shown in Berlin in 1922 and considered the first purely abstract film, created continuous sequences of abstract images. The preoccupation with endless flow and mechanical movement was perhaps related to the contemporary German fascination with productivity: Henry Ford's autobiography, published in Germany in 1923, had been widely read, and an assembly-line car was created at

his plant in Cologne in 1924. This machine aesthetic was reflected in the impersonality of the abstract, geometric forms pursued by many of these artists. Basic abstract forms were also used in the metal workshop of the Bauhaus. Sauce-boats and jugs produced by Josef Albers, Marianne Brandt and Wilhelm Wagenfeld were given semi-circular handles as a modification of traditional form while, to comply with the new thrust of design in the School, the overall shapes of the vessels were streamlined. Simple geometric features were applied even to chess sets (such as that designed by Josef Hartwig in 1924) – the game was clearly well suited to abstract principles.

Klee arrived at the School at the end of 1920 (staying until 1931), and Kandinsky, in the summer of 1922 (leaving in 1933). Both taught the compulsory classes in colour and form on the preliminary course, but had other duties as 'Masters of Form' in some of the workshops.

62 EGGELING Film stills
from the *Diagonal Symphony* 1922

Kandinsky was particularly well prepared for such a post through his teaching at the Vkhutemas in Moscow. However, neither Kandinsky nor Klee was temperamentally drawn to the technological approach of Moholy-Nagy, nor to that of the new director after 1927, the architect Hannes Meyer. The presence of two conflicting tendencies within the Bauhaus reflects the dichotomy that had existed within the ranks of abstraction almost from its inception. On the one hand, there was the mathematical precision and cool, objective approach of the Central European Constructivists, and on the other, the more intuitive, subjective and expressionist attitude of Klee and Kandinsky. As Klee put it in 1928: 'We construct and keep on constructing, yet intuition is still a good thing. . . . We document, explain, justify, construct, organize, but we do not succeed in coming to the whole.' And in 1931, Kandinsky was still affirming that he and Klee were painters of 'spiritual' essence.

Nevertheless, their own paintings of the 1920s do reflect a formal change which corresponds to the new direction at the Bauhaus. Kandinsky's paintings show a crispness of outline and an increasingly geometric choice of abstract elements, in contrast to the freer, expressive and more painterly abstraction of his pre-War style. The floating, variegated colour areas surrounding the linear contours of 63 *Swinging* (1925) are similar to his earlier approach, but the hard outline and the presence of such distinct elements as the triangle, are new. The introduction of more geometric forms perhaps also suggests the influence of Suprematism. Working and teaching at Petrograd between 1914 and 1921, Kandinsky inevitably came into contact with current Russian abstract work, and his own forms became sharper and clearer as a result. He later observed that his colours 'became brighter and more attractive' and that he 'painted in a totally different manner', in response to the 'great peace of Soul' he initially experienced as the result of witnessing the Revolution. These tendencies were confirmed when he went to the Bauhaus.

In 1926 Kandinsky published, as a Bauhaus Book, his seminal text on abstraction, *From Point and Line to Plane*, which complemented his views on colour set out in *On the Spiritual in Art*. The new book defined his views on composition. Kandinsky now wrote about line in terms of 'temperature': vertical is 'warm', horizontal, 'cold', while the diagonal tends to one or the other depending on its position. The same, he stated, is true of angles. By disposing certain elements in relative positions to the plane, different effects could be achieved, a horizontal format corresponding to 'cold', a vertical to 'warmth'.

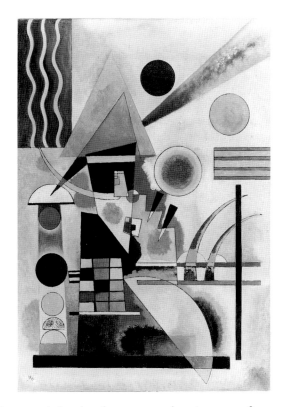

Where the eye is led upwards by the elements on the picture surface, the effect is 'free' and 'light'; where it is led downwards the effect is 'heavy' and 'dense'. The movement of an element to the left is 'adventurous' and 'liberating', while one to the right is 'familiar' and 'reassuring'.

By combining colour theory with form, Kandinsky aimed to demonstrate that particular forms corresponded to particular colours. The circle, triangle and square were paired with the three primary colours, blue, yellow and red, respectively, and he produced a questionnaire by which he sought to confirm his hypothesis. Kandinsky's ultimate aim was to create visual harmonies and dissonances through the most elemental of means. While retaining a belief in emotional expressiveness, he nevertheless now acknowledged the necessity of intellectual control. Through his investigations, he hoped to demonstrate the still-debated principle that universal laws did apply, and that abstract art was as capable of affecting the viewer as representational art.

Paul Klee's output was prolific during his years at the Bauhaus. His work and aesthetic outlook were probably affected by Kandinsky, with whom he shared a house for a while. However, Klee's relationship to abstract art is ambiguous. Many of the paintings of the mid-1920s relate, at least in their titles, to organic growth or natural forms – the image of the garden is a prominent feature, for instance – and in his writing Klee refers to the associative nature of perception: 'It is interesting to observe how real the object remains in spite of all abstractions'; and elsewhere: 'It is possible that a picture will move far away from Nature and yet find its way back to reality. The faculty of memory, experience at a distance produces pictorial associations.' Nevertheless, during his Bauhaus period, Klee's teaching and his experiments with form and colour led him towards a more thorough-going abstraction. He became interested in creating work based on a careful analysis of the inter-relationships between colour and tone, as can be seen in the early Bauhaus watercolour series *Colour Gradations*.

64 KLEE *Crystal Gradations* 1921

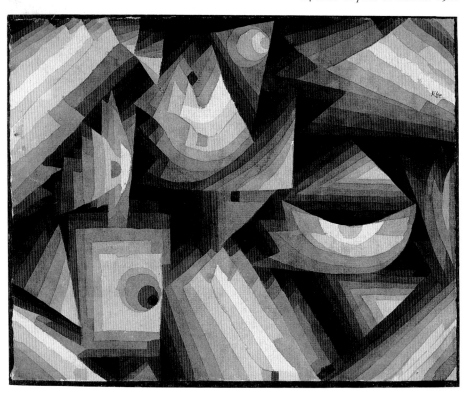

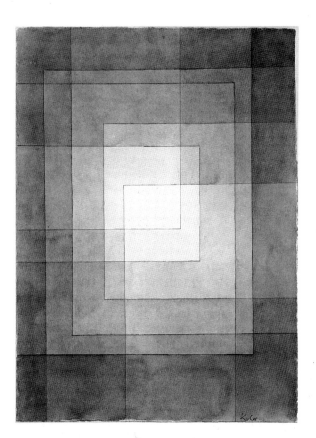

65 KLEE
Polyphonic Setting for White
1930

A chiaroscuro study *Crystal Gradations* (1921) oscillates between light *64*
and dark values while being 'weighted with colour'. The delicacy of
tonal gradation is remarkable in a composition which has no
representational purpose. Besides affecting his own work, notions of
the subtle gradation of tone and colour were extended to applied art
functions by his students. The abstract textile designs produced by
Anni Arbers and Günther Stolz in the weaving workshop, for
example, show evidence of Klee's training methods.

Like Kandinsky, Klee developed his ideas in writing. His Bauhaus
Book, *Exact Experiments in the Realm of Art* (1927), was extremely
important as a methodical study of abstract compositional method,
and as the title suggests, it reflects the quasi-scientific tendencies of the
Bauhaus at this stage. Klee discusses the nature of line in theoretical
terms, analyzing its various attributes, its 'push or pull' quality and its
temporal character. He writes, 'the longer a line, the more of the time

element it contains. Distance is time whereas a surface is apprehended more in terms of the moment'; and he insists that form, and specifically line, should be grasped by the student before progressing 65 to colour studies. *Polyphonic Setting for White* (1930) clearly demonstrates Klee's ideas about the nature of line and surface. The composition is organized into schematic rectangles which overlap, and which, although literally flat, imply recession by the careful colour and tonal gradation that leads the eye towards the centre. Such works anticipate the later experiments (1949 onwards) conducted on 67 the square by Josef Albers, who was at the Bauhaus from 1920 to 1933, and also highlight the increasing interest in a precisely contoured, geometric abstraction among many artists at this time.

Klee's 'polyphonic' paintings from 1929 aspired, according to the artist, to parallel the multiple levels of polyphonic music by creating a 'harmony of several colour voices' which could penetrate 'deep into the cosmic sphere'. Having arrived at such insights, Klee felt increasingly alienated from the rigid confines of the Bauhaus. The new Marxist director Hannes Meyer brought with him a hard-line 'productivist' attitude incorporating functionalist notions that 'no aesthetic factor is involved in design' and that 'form is a product of arithmetic'. These principles were entirely alien to Klee's intuitive sensibility, and finally prompted his departure two years before the Bauhaus was closed by the Nazis.

RETREAT TO PARIS AND BEYOND

The closing of the Bauhaus by the National Socialists in Germany in 1933, and the party line of Socialist Realism declared in the Soviet Union in 1934, demonstrated that Fascism and Communism were not prepared to tolerate 'advanced' art. Both regimes promoted instead academic, propagandist 'Realism'. Art which did not conform was either confiscated or destroyed, a situation which in Germany culminated in the infamous 'Degenerate Art' exhibition (1937), where modernist art – much of it abstract – was publicly denounced and ridiculed. Consequently, many artists were forced to seek sanctuary outside their home countries. A large number, arriving at different times, congregated in Paris, and stayed there until the threat of war in the late 1930s forced them to move further afield, in many cases to England, or, later, to New York.

Until that time, Paris was host to abstract artists as varied as the Russians Lissitzky, Puni (who changed his name to Jean Pougny),

Gabo and his brother the sculptor Antoine Pevsner (1886–1962); the De Stijl artists Mondrian, Vantongerloo, van Doesburg and Domela; Arp and Täuber, who assumed French nationality in 1926; the Polish group Henryk Stazewski (b. 1894), Wladyslaw Strzeminski (1893–1952) and Katarzyna Kobro (1898–1950); and the Italian Enrico Prampolini (1894–1956). Not least in importance was Kandinsky, whose arrival in 1933 and an accompanying exhibition helped to bring Parisians to a greater appreciation of geometric abstraction. Even before this, various events had begun to prepare the way, such as Mondrian's arrival in the city in 1919, van Doesburg's move to Meudon (just outside Paris) in 1923, Léger's abstract 'mural paintings' and film *Le Ballet mécanique* of 1924, and the 1920s polychrome abstract reliefs of the French artist Auguste Herbin (1882–1960). However, during the 1920s French abstraction derived by and large from Cubism (such as the work of Albert Gleizes), or was loosely abstracted from nature, like the work of the Romanian sculptor who settled in Paris in 1904, Constantin Brancusi (1876–1957). *70*

Brancusi's aim was for simplicity and truth, to reach the 'essence' of things through generic abstraction. His practice involved executing the same subject, such as *Maiastra* (1910–12), *Bird in Space* (1923–40) or *66* *Fish* (1924–30), a number of times, carving or casting in a whole variety of materials, and often setting the polished, streamlined shape in, say, bronze on a pedestal made of a material with a contrasting texture, such as stone. Brancusi perfected his forms by modifying and simplifying; he eliminated distinguishing details and concentrated on the characteristic form of the species. In 1926 his work and the issue of generic abstraction generally achieved international fame through a New York trial, in which it was claimed that the *Bird in Space* (sent for an exhibition at the Brummer Gallery) was not a work of art but a piece of metal, and hence required duty to be paid on it. Although the *Bird* was essentially derived from nature, the furore it provoked exemplifies the difficulties that people had in appreciating such a simplified, abstracted form as 'art'.

This kind of problem provoked abstractionists in Paris to seek collaboration during the period 1930–36 and to use periodicals (as *De Stijl* had been used) to publicize both their theory and practice. Yet because Paris was a melting pot of different abstract tendencies, there was a certain amount of disagreement over what type of abstraction should be pursued. Debates revolved around vital aesthetic and philosophical justifications for abstraction, but also, most topically, around the artist's role in society.

The first entirely French-language review to bring the various abstract, but also Cubist-, Futurist- and Purist-derived trends and nationalities together, was the short-lived *Cercle et Carré*. This was the brainchild of the Belgian critic Michel Seuphor, and the first of its three issues was published in March 1930. The choice of the circle and the square as both title and cover illustration reflected, Seuphor later felt, a certain order in the world and evoked the ancient Chinese symbols for heaven and earth, yin and yang: the world of the senses and the world of the mind. An exhibition by 46 members of the Cercle et Carré group in April 1930, contained works by Neo-Plasticist practitioners such as Mondrian, Vantongerloo, Jean Gorin (b. 1899) – a French artist who met Mondrian in 1926 and became converted to his ideas – and Vordemberge-Gildewart. These works were hung alongside those by other non-figurative artists as varied as Kandinsky, Schwitters, Pevsner and Stazewski. The grouping was therefore very loose; the artists simply held in common the ambition 'to humanize the geometrical and geometricize the human'.

It was precisely this lack of single-mindedness that laid Seuphor open to vehement attack from an unsuspected quarter. Theo van Doesburg, who had been invited to participate, instead disparaged the journal in a letter published in the second issue. Arguing that the magazine invited attack from the (French) enemies of abstraction, he criticized the catholicity of styles it embraced, and characteristically decided to publish his own review. The first and only issue of *Art Concret* emerged in Paris in April 1930, and was important for the manifesto it included. Although it did not introduce a new concept (the self-sufficiency of the art object had been fulsomely and cogently argued since 1924 in the Polish magazine *Blok*, and even earlier in Russian Constructivist circles), the publication was important as it was written in French, and because it so clearly shifted abstraction away from nature. The points of the manifesto ran as follows:

1. Art is universal.

2. The work of art should be entirely conceived and formed by the mind before its execution. It should receive nothing from Nature's formal properties or from sensuality or sentimentality. . . .

3. The picture should be constructed entirely from purely plastic elements, that is to say, planes and colours. A pictorial element has no other significance than 'itself', and therefore the picture has no other significance than 'itself'.

4. The construction of the picture should be simple and controllable visually.

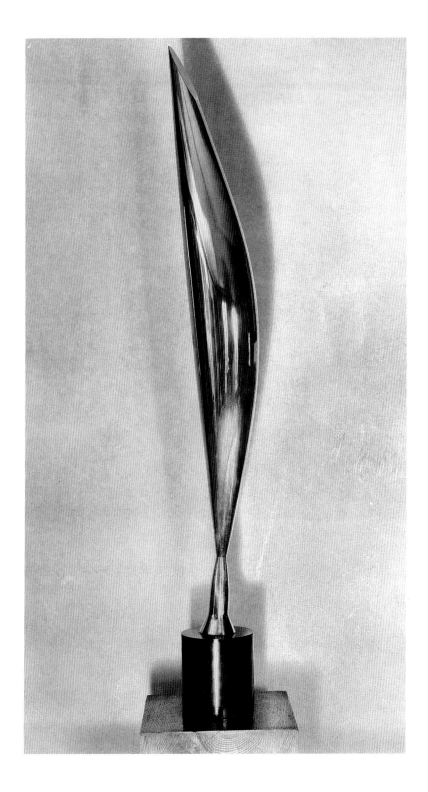

67 ALBERS *Homage to the Square: Apparition* 1959

5. Technique should be mechanical, that is to say, exact, anti-impressionistic.

6. Effort for absolute clarity.

Rather than suggesting a spiritual or social purpose for abstract art, van Doesburg was essentially arguing for an aesthetic of abstract art for art's sake. In obeying the rules van Doesburg set out, the artist would be making 'concrete' (i.e. real in material form), something

that would otherwise remain in the mental sphere alone. The term 'concrete' thus entered the language of art and was used by certain artists at this time in marked preference to the word 'abstract'. According to van Doesburg, 'we speak of concrete and not abstract painting because nothing is more concrete, more real than a line, a colour, a surface'.

Accordingly, pure, flat colours, precise contours, simplification and geometricized form are characteristic of the 1930s work of several Paris-based artists, including Delaunay, Kupka and Jean Hélion (1904–87). In the compositions of his *Equilibrium* series (1932–34), which was influenced by Alexander Calder's mobiles, Jean Hélion was involved in 'searching for the effect of space and movement on the elements', and in creating complex states of visual balance resulting from the positioning of various simple, coloured shapes (bars, planes, curvilinear forms). The purpose of this type of experiment was purely one of visual effect. The flat, rounded shapes to the left of *Equilibrium* (1933–34), for instance, create a tension with the 71 more rectangular, block-like forms on the right. The right-hand forms are contained within the confines of the picture plane, whereas the vertical red bars on the left appear to push beyond it. The rectangular blocks are placed flatly on the surface, but some of the smaller, thinner elements on the left overlap, creating a shallow space and suggesting suspended movement. The exercise is thus one of formal tension. Concomitantly, De Stijl artists such as Domela sought 69 an impersonal, constructed finish, and Vantongerloo explored a more

68 VAN DOESBURG *Counter-composition in Dissonance XVI* 1925

mathematically based art during the 1930s. Curves and diagonals were added to the rectilinear vocabulary of earlier De Stijl in a search for formal perfection that quite ostensibly did not copy Mondrian.

The far-reaching appeal of Concrete Art can be seen in the work of the Swiss artist Max Bill (b. 1908), who left the Bauhaus in 1929. Bill, who used the term 'Concrete Art' in preference to 'Abstract Art', disseminated this notion first in Switzerland, and then in Brazil and Argentina in 1941. A set of lithographs called *15 Variations on a Single Theme*, published in Paris in 1938, gave pictorial expression and theoretical support to van Doesburg's manifesto. According to the Introduction, the *Variations* were made in order to demonstrate that 'concrete art holds an infinite number of possibilities', and exemplified 'the pure play of form and colour freed from the compulsion of being something other than it really is, of which the sole aim is to give pleasure by the fact of its own independent existence'. Bill's interpretation of Concrete Art (also notable in his sculpture from 1935 onwards) anticipates Minimal Art in the 1960s. His support of Concrete Art in Switzerland was demonstrated in the important exhibition he staged in Basle (1944) and later in Zurich, where in the hands of his pupils it became known as 'Cold Art'.

One of the most important abstract groups to be formed in Paris was the association Abstraction-Création (1931–35) with its journal of the same name. Any artist could join, provided that he or she worked in a non-figurative mode, and the variety of the founders, who included Arp, Delaunay, Hélion, Gleizes, Kupka and van Doesburg,

69 DOMELA
Relief No.11c 1935

70 HERBIN
Relief in Polychrome Wood
1921

demonstrates the nature of the formal range. The first issue of *Abstraction-Création* pointed out the ambivalence expressed by the title, *Abstraction* and *Création* together comprising *art non-figuratif: Abstraction*, because certain artists arrived at the concept of non-figuration by a progressive abstraction of the forms of nature; *Création*, because other artists arrived there via a purely geometric order or by the exclusive employment of 'communicating elements' called abstract, such as circles, planes, bars and lines.

Varying attitudes and understandings of abstraction among the participants inevitably led to controversy. The artists were not only of different generations and backgrounds, but also, understandably, of differing temperaments. Auguste Herbin, one of the few French 70 painters to devote himself to geometric abstraction, and the Belgian Georges Vantongerloo (both founder members) were so rigorously supportive of 'pure' abstraction that they rejected work submitted to the group for exhibition in which they could detect the faintest trace of nature, but were willing to accept mediocre work so long as it was non-figurative. Hélion and Arp believed that this approach was too rigid, and by 1934 not only they, but also Pevsner, Gabo, Delaunay and Sophie Täuber had resigned from the association.

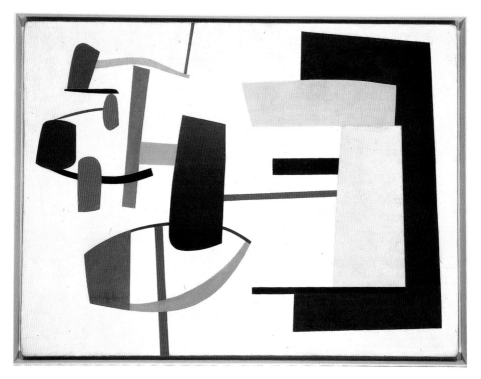

71 HÉLION *Equilibrium* 1933–34

The relationship between abstraction and the contemporaneous French movement of Surrealism was also a vexed one. As defined by the 'Pope' of the movement André Breton in 1924, Surrealism was concerned with 'pure psychic automatism'; his first manifesto placed emphasis on automatic methods of revealing the unconscious, in order to achieve knowledge of 'true reality'. Stemming largely from Freud's interest in the unconscious and the notion of 'free association' as a means of reaching it, 'automatism' was developed by the Surrealists as a creative technique. Painters such as Joan Miró (1893–1983) and André Masson (1896–1987) frequently began their pictures with a spontaneous gesture or random mark. In a second, conscious stage, the artist used the traces on the paper or canvas to prompt imaginative associations until the subject of the work emerged. In the case of Miró's imposing *The Birth of the World* (1925), the picture was started with a splash of black paint. However, the random appearance

72

of the finished painting with its blotched marks and trickles of paint means that in this case, the subject is suggested primarily by the title. In other paintings, where Miró worked up his composition to produce biomorphic shapes (based on organic forms), references are usually more obvious. Although Breton's literary concern with imagery meant that Surrealist art was seldom purely abstract, biomorphic forms proved a significant addition to the abstract vocabulary, and Surrealist improvisatory techniques were of great importance to later artists (particularly the Abstract Expressionists and Tachistes in the 1950s), who sought to use automatic gestures to reveal the unconscious directly.

During the 1930s certain artists, such as Wolfgang Paalen, Arshile Gorky and Kurt Seligmann, 'defected' from the ranks of Abstraction-Création to join the Surrealist camp, while the Swiss sculptor Alberto Giacometti (1901–66) declined an invitation to join the association and yet exhibited abstract works, such as *Suspended Ball* (1930–31), 73 with the Surrealists. Despite being attracted to representing the human body, he also felt, in the early 1930s, that abstract forms 'seemed to me to be true for sculpture'. The American sculptor Alexander Calder (1898–1976) kept a foot in both camps, combining Surrealist and abstract tendencies in his work. Calder looked to both

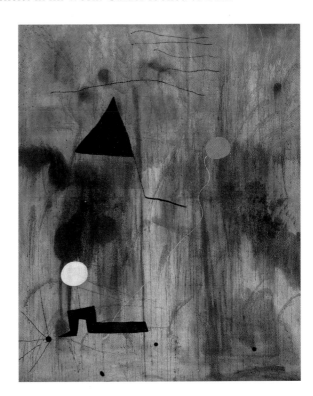

72 MIRÓ
The Birth of the World
1925

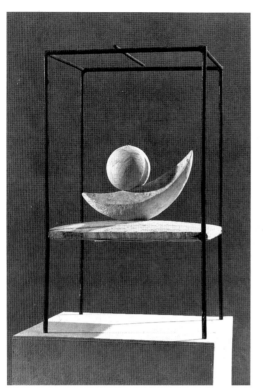

73 GIACOMETTI *Suspended Ball* 1930–31

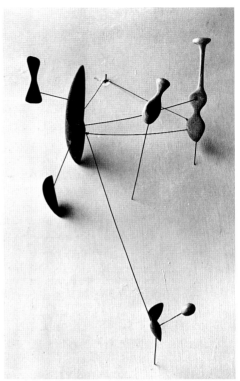

74 CALDER *Constellation with Red Object* 1943

75 ARP
Head and Shell 1933

Mondrian and Miró to transform his earlier, representational wire circus figures into more abstract creations. His first *Stabile* constructions were attached to a base, like *Universe* (1931), but from 1934 onwards, Calder began to make unpowered structures, such as the Miróesque *Constellation with Red Object* (1943), which were designed 74 to hang from a height. Made up of thin wires from which were suspended variously shaped cut-outs of metal that formed ever-changing patterns in the breeze, Calder's later mobiles became extremely influential for kinetic artists.

The most singular artist to cross both territories was Hans Arp, who was a member of the Abstraction-Création committee and of the Surrealist group in Paris. Arp liked the anonymity of abstract art and spoke in the 1930s of the work of art as 'concrete': a concretion of the imagination achieved without imitating or abstracting from nature. He wrote that 'a painting or sculpture not modelled on any real object is every bit as concrete and sensuous as a leaf or a stone'. But he also thought geometric abstraction's cold intellectual rigour lacked imagination, believing that 'it is an incomplete art which privileges the intellect to the detriment of the senses'. To Arp, art should be as a 'fruit that grows in man, like a fruit on a plant or a child in its mother's womb'. This organic relation is revealed in his first three-dimensional sculptures, such as *Head and Shell* (1933). 75

76 KOBRO *Spatial Sculpture* 1928

77 TÄUBER
Planes Outlined in Curves
1935

The Polish wing of Abstraction-Création pursued a different understanding of 'concrete'. Wladyslaw Strzeminski took the logic of non-objective abstraction to the point where the unity of the painting was the most vital concern, allowing the work to be perceived in a single glance. His wife Katarzyna Kobro applied similar, though more mathematically based ideas to sculpture. Strzeminski's theories were elaborated in the first issue of *Abstraction-Création*, where he argued for the renunciation of line (because it divides); of rhythm (because it can only exist in relation); of division (because it emphasizes contour); and of all oppositions and contrasts within the work (because they separate). He produced monochromatic and reductive paintings of a 'uniform pictorial character', as well as hard-edge abstract compositions. Sophie Täuber's organic/geometric synthesis after 1934, apparent in *Planes Outlined in Curves* (1935), shows similar concerns, but she dissolves the vestigial rectilinearity of Strzeminski in smoothly flowing curves that anticipate the paintings of the American artists Ellsworth Kelly and Leon Polk Smith during the 1960s.

If aesthetic theory and practice were of great diversity in the Abstraction-Création group, so also were opinions concerning the

76

77

social role of abstract art. The second issue of the magazine was dedicated to 'the preservation of individual expression' by each non-figurative artist in the face of growing totalitarianism abroad. While abstract art was loosely understood to symbolize the strength of the intellect against restrictive opposing forces, views as to how to express this understanding diverged. Certain artists, such as Hélion, Herbin and Otto Freundlich, joined the pro-Communist Association of Revolutionary Artists and Writers (founded in 1932), but even here there was dissent among the ranks. The lawyer Paul Vienney argued the extreme socialist position in *Abstraction-Création No. 1*, claiming that abstract art was cut off from the people and was therefore unfit for action. Herbin, on the other hand, believed in the necessity of aesthetic freedom for each individual artist, and maintained that the essential objective of Communist society was 'to liberate'. He felt art should remain based on the personality of the creative artist.

Thus, while an agreed social and aesthetic rationale for abstract art became ever more elusive – even impossible – artists found themselves led back to the artwork itself: to geometric experimentation and to justifications based on art's self-referentiality. Political and social arguments seemed to lead only into a cul-de-sac. If all that the editors could agree upon was the fact that commitment to abstraction suggested independence from and opposition to totalitarianism, this was a sadly defensive argument compared with the vaunting claims of abstraction during the 1920s. The pioneering zeal of that period, which was reflected in the vitality of the art, had diminished by the 1930s, and the work of this time sometimes appears enervated by comparison. Challenged on all sides by hostile political regimes, socially committed colleagues and a still doubtful public, it is not surprising that abstract artists took refuge in formal issues of style, concerning themselves principally with consolidation rather than with new developments. The one encouraging sign was the developing sense of affinity among abstract artists throughout the world. A numerical checklist published in the fourth issue of the magazine (1935) showed that 416 'Members and Friends' of Abstraction-Création existed in eighteen different countries, and although more than half were based in France, varying quantities were also to be found in Switzerland, America, Holland and Britain.

This proved important because, as the European situation worsened, abstract artists were forced to move on again. In 1936 Paul Klee, Johannes Itten and Hannes Meyer returned to Switzerland, followed by many of their Swiss Bauhaus students, including Max

78 NICHOLSON *White Relief* 1935

Bill. The arrival in England of Walter Gropius and Marcel Breuer (1934), László Moholy-Nagy (1935), Naum Gabo (1936) and Piet Mondrian (1938) meant that for a brief period immediately before the war, North London became a centre of Constructivist abstract tendencies. The British artists Ben Nicholson (1894–1982) and Barbara Hepworth (1903–75) had already participated in Abstraction-Création, but with the arrival of the Europeans, a 'nest of gentle artists' with views in common was established in Hampstead. Nicholson carved plain, white geometrical reliefs (such as *White* 78 *Relief*, 1935), while at around the same time Hepworth began to 79 sculpt non-organic, geometrical abstract carvings. The sculptor Henry Moore (1898–1986), also resident in Hampstead, pursued abstract form up to a point, but, unlike Hepworth, never made abstraction his main concern. In seeking to create work that had 'a vitality of its own', Moore preferred to abstract from the human figure, rather than to create an entirely independent art.

Thanks to Nicholson, the first exhibition of British abstract art was held in 1935 at the Seven and Five Abstract Group. This was followed in 1936 by the more international 'Abstract and Concrete' exhibition, organized by Nicolete Gray, which included work by Mondrian, Hélion, Miró, Gabo, Calder, Nicholson, Hepworth and Moore. The

close association of Nicholson and the British architect Leslie Martin resulted in the publication of *Circle; International Survey of Constructive Art* (1937). This reaffirmed the principal tenets of European Constructivism in the face of its detractors. Gabo upheld the importance of art in preparing 'a state of mind which will be able only to construct, co-ordinate and perfect'; while Mondrian hoped that 'by the unification of architecture, sculpture and painting, a new plastic reality will be created'. With the outbreak of the Second World War, these claims must quickly have seemed sadly idealistic. Nevertheless, Hepworth, Nicholson and Gabo moved to St Ives in Cornwall and continued their 'constructivist' work there, while many of the other European abstractionists left for America.

79 HEPWORTH
Two Forms 1937

Abstractions in Europe: 1939–56

A single line, violent, passionate, broken, or beauti-
fully calm, regular, uniform, conveys what we are
feeling. It corresponds to what we are living through.

HANS HARTUNG

By 1939 abstraction had become established as an alternative tradition in painting and sculpture, but had not succeeded in reaching a wide public. In the decades after the War, however, a different pattern emerged. Although the tradition of representation continued, notably in the individual careers of Picasso, Matisse and Balthus, abstract art came increasingly to the fore in terms of critical attention. Yet as abstraction became legitimized, it also fragmented into a variety of different styles, and it was only with the emergence of Abstract Expressionism across the Atlantic that a new unity of purpose was found.

Despite the upheavals of the Second World War and the Occupation, Paris continued as a major centre for European art after the War. However, the re-establishment of abstract painting in Paris took place in the face of official disregard and hostility. At the end of the War, Picasso was championed as the artistic hero of France, while the work of other prominent (more abstract) painters was ignored. Exhibitions by Klee and Mondrian were actually closed by the authorities in the 1940s, and as late as 1951 indigenous abstract artists had to file a petition to the French Government, asking for the right to be represented in exhibitions of French art abroad! Notwithstanding such difficulties, a wide variety of abstractions flourished in Paris, supported now by a small group of critics and gallery-owners who wrote articles and books or staged exhibitions in support of the particular tendencies they favoured. This differed from the pre-War situation, where the impulse had come from the artists themselves, and led inevitably to the bracketing of different artists.

One of the strongest branches of abstract art to hold sway in Paris after the War was geometric art. In 1945 Nelly van Doesburg (Theo's

◁ 80 HARTUNG *Painting* 1957

widow) helped to organize the historic exhibition 'Art Concret' at the Galerie Denise René. This brought together geometric artists such as Domela, Herbin, Mondrian, Kandinsky, Täuber, Arp and Pevsner, and showed that by this time, Concrete Art had become virtually synonymous with geometric art. The following year, an organization called the Salon des Réalités Nouvelles was instigated by the dealer Fredo Sidès with a policy of exhibiting 'abstract, concrete, constructivist, non-figurative art'. The first exhibition alone included nearly 400 paintings and sculptures dating from 1910 to 1946, by 89 artists; and by the third Salon, work was included by artists from 18 different countries. By 1956 internal dissension and external change had forced a complete reorganization of the Salon: its policy became less restrictive, stipulating only that the work shown should be 'abstract', and it took a new name: 'Réalités Nouvelles – Nouvelles Réalités'. Nevertheless the scale of artistic response to the Salon during its early years showed that geometric art was a formidable force in post-War France, even though such work had an essentially nostalgic flavour, harking back to the developments of the inter-war years. With the opening in 1950 of an abstract studio in the rue de la Grande-Chaumière (home of traditional, academic art), it seemed that abstract art might even be in danger of becoming equally rigid, and in the same year the critic Charles Estienne wrote a book significantly entitled *L'Art abstrait, est-il un académisme?*

However, in parallel with the dominating impulse of geometric art, other abstract initiatives had already begun to develop, and a separation came to be made between 'cold' (geometric) and 'warm' abstraction. 'Warm' abstraction, as it developed in Paris and beyond, was given a confusing plethora of names by critics eager to identify and label the new tendency in its various manifestations. Names such as *l'abstraction lyrique, tachisme, l'art informel, matérisme, un art autre* proliferated as different artists were incorporated into one or more of the categories. In contrast to the geometric artists, the general tendency they shared was towards an expressive abstraction, and this style gained international currency during the second half of the 1950s.

INDIVIDUAL EXPRESSIONS: THE RESPONSE TO WAR

In Paris, the more expressive tendencies were in part inspired by Roger Bissière's (1888–1964) teachings at the Académie Ransom during the 1930s. His influence on younger artists such as Jean Le Moal

81 MANESSIER *Morning Space* 1949

(b. 1909), Maria Elena Vieira da Silva (b. 1908) and Alfred Manessier
(b. 1911) encouraged them to create a loosely abstract painting style
that was derived from the expressive qualities of nature. The first
public display of this work was staged in 1941 at the exhibition 'Jeunes
Peintres de la Tradition Française', in which Le Moal and Manessier
participated with Jean Bazaine (b. 1904), Maurice Estève (b. 1904) and
Charles Lapicque (1898–1988). Bazaine and Manessier are interesting
for infusing a blend of late Cubism and Impressionism with a sense of
transcendence in their art of the 1940s. For both artists, the quest for
the sacred involved a freedom from traditional iconography.
Manessier underwent religious conversion in 1943, and this resulted in
his work becoming non-figurative. His painting *Morning Space* 81
(1949) and Bazaine's *The Water and the Blood* (1951) intimate a higher
reality through a treatment of space and colour that recalls the stained-
glass windows on which they both worked. With its religious
motivation, their response to the aftermath of the War was essentially
optimistic, inspired by French Catholicism and the writings of Henri
Bergson.

However, the prevailing philosophical view at this time was Existentialist, as developed by contemporary writers Jean-Paul Sartre and Albert Camus. The individual was posited as the source of all moral value, obliged to make choices in life without recourse to external or 'objective' standards. Consciousness of such freedom was seen to lead to an 'authentic' existence – but was also potentially fraught by the burden of decision-making. Sincerity and creativity were given priority, and inner conviction was considered a proper force in governing action. This philosophy gained resonance in artistic circles after the War and informed both critical responses and, frequently, the works themselves. Direct, spontaneous expression could be seen to reflect the particular condition of the individual (who represented a microcosm of mankind) and helped to justify abstraction. Post-War exhibitions of certain artists who had suffered during the War were extremely influential in this context.

The art of the German painter Otto Wolfgang Schulze, known as Wols (1913–51), was interpreted in Existentialist terms by Sartre himself. The restless stabbing strokes and the febrile scratched-out marks of paintings such as *Drunken Boat* (1945) or *The Butterfly Wing* (1947), bear testimony to Wols' nervous, volatile temperament. His intense paintings incorporate vigorous sharp brushstrokes and trickles of paint to produce scar-like marks across the surface. The intensity

82 WOLS
The Butterfly Wing
1947

83 FAUTRIER *Hostage* 1945

and dark foreboding suggested by the work may reflect his anguish during captivity in France or suggest intimations of his own early death. The spontaneous quality of his abstractions (based loosely in nature) had a great impact on future Tachistes and *informel* abstractionists.

The work of Jean Fautrier (1898–1964), as it came to light in post-War Paris, also showed a very different formal language, which was quickly emulated by artists who saw his exhibition of *Otages* *83* ('Hostages') at the Galerie René Drouin (1945). Described by André Malraux as 'hieroglyphs of pain', the *Otages* were inspired by Fautrier's experience of hearing prisoners being shot by German soldiers outside an asylum where he was sheltering during the War. Rendered in abstract form, very different from Wols' tense line, the pictorial emphasis of the *Otages* series is on texture; the densely impastoed surface, built up over time, suggests associations with human flesh. However, in formal terms, the bas-relief quality of these works – Fautrier was also a sculptor – indicates a new interest in the painting as object, as the revelation of matter (through the encrusted surface) and of time (through multiple layering).

Jean Dubuffet (1901–85) exhibited his highly textured *Hautes Pâtes* in 1946 and went on to suggest the surface of the earth in his thickly painted, apparently abstract compositions of the 1950s, called *85* *Texturologies*. These coarsely textured 'earth paintings' recreate the appearance and composition of the ground when seen from a height, and through Dubuffet's widespread inclusion in exhibitions and books, they had an immediate international influence. Although most of Dubuffet's essentially figurative work is beyond the scope of this book, it is worth mentioning that his support for Art Brut (art produced by people outside the established art world) was a vital contribution to breaking down barriers in art – including distinctions made between the art of the sane and the insane; between abstraction and representation; and between notions of beauty and ugliness.

Several other European artists, affected by their wartime experiences like Dubuffet and Fautrier, also turned to a *matière*-inspired form of abstraction. The Catalan Antoni Tàpies (b. 1923), prompted both by his memories of the Spanish Civil War and his awareness that wartime graffiti was an outlet for feelings of grief and protest, created a cult of materials in which plaster, glue and sand were mixed together, allowing signs to be scratched onto the surface of the work like cryptic graphic symbols. Tàpies felt that through meditation such works could release a message for the spectator, 'when the dull,

84 BURRI *Sackcloth* 1953

sluggish material begins to speak with its incomparable force of expression'. The Italian Alberto Burri (b. 1915), who began to gain international attention in 1952, worked with reference to his war experience as a doctor. His abstract compositions after the War, such as *Sackcloth* (1953), were formed from textured, bandage-like 84 material stretched across the canvas and drenched with paint. The dark stains revealed in various places appear like gaping wounds beneath the density of the material.

In Paris certain artists realized that paint alone could suggest physical density, an awareness that challenged the flatly painted surfaces of previous geometric painting. In abstract art, this tendency gained impetus with the arrival of the Russian painter Nicolas de Staël (1914–55) in 1943. It was further explored from 1950 in the work of his compatriot in Paris, Serge Poliakoff (1906–69), and by the French-Canadian painter Jean-Paul Riopelle (b. 1923) after his arrival in the city in 1947. De Staël had admired the painterly approach of artists such as Rembrandt, whose work he had seen in Belgium and

85 DUBUFFET *Life of the Soil (Texturologies series LXIII)* 1958

Holland, and this encouraged him to explore paint texture and colour
as qualities in his own work during the 1940s. By employing a palette
knife to drag and pull the paint into thick shafts and lines, De Staël
created tension between the energy of the strokes and the smooth,
monochromatic surface of the background. During 1947 he exploited
these rhythms in non-representational paintings, to which he gave

87 associative titles, such as *Marathon* (1948). However, in the last years
of his life, landscape and figure references increasingly entered his
work. Around 1950, Poliakoff created abstracts by juxtaposing
various colour areas, often closely related in tone. His compositions
were non-figurative even in title, but were saved from being purely
geometric by the lack of hard outlines to define the forms. For his
part, Riopelle turned away from the Surrealist-inspired 'automatism'
he had been pursuing during the 1940s, and began to use a very thick

88 medium in 1949–50. In his paintings from this period, the paint is built
up over the surface in fractured forms, tightly wedged or jammed
onto the canvas with the palette knife and held in place by an energetic
weaving line.

126

In 1952 both figurative and abstract tendencies were brought together in a major exhibition in Paris called 'Un Art Autre'. Prepared by the critic Michel Tapié, the catalogue illustrated the work of over 40 artists (including the Americans Mark Tobey, Sam Francis and Jackson Pollock, as well as Dubuffet, Fautrier and Wols). 'Difference' and 'strangeness' were cited as positive factors uniting the work and were established as the criteria by which to judge them. Although 'Un Art Autre' was effectively a convenient critical and marketing label, the choice of artists indicates that at least one critic perceived geometric and realist art to be outmoded. In the post-War situation, Tapié felt 'One needed temperaments ready to break up everything, whose works were disturbing, stupefying, full of magic and violence to reroute the public.' A very different cultural context informed such views. Replacing pre-War rationalism (exemplified in *L'Esprit nouveau* and geometric art) was a renewed interest in the imagination and in the less formulated workings of the mind. French lyrical poetry, Existentialism, Surrealism and recent investigations into phenomenology by French thinkers such as Maurice Merleau-Ponty and Gaston Bachelard, had a pervasive intellectual influence that reached well beyond France.

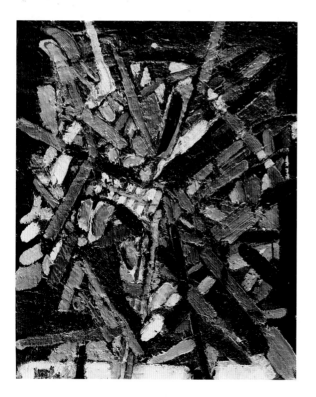

87 DE STAËL *Marathon* 1948

88 RIOPELLE *Chevreuse* 1954

ART INFORMEL AND TACHISME

Gaston Bachelard wrote in 1948, 'We always want our imagination to be the faculty of forming images. Well, it is rather the faculty of unforming images furnished by perception. . . . The basic term corresponding to the imagination is not image, it is imaginary. Thanks to the imaginary, the imagination is essentially open, evasive.' His argument helped to provide a rationale for pursuing 'unformed' images in art. During the 1950s two terms were coined to describe this direction: Art Informel (named by Michel Tapié in 1950) and Tachisme (named by Charles Estienne in 1954). The concept of spontaneous creation was common to both, but Art Informel tended to describe art that employed a form of unconscious calligraphy, while Tachisme referred generally to the free disposition of coloured blots as a sign or gesture expressing the emotions of the artist. Frequently, the terms were used interchangeably to describe such artists as Hans Hartung (1904–89), Pierre Soulages (b. 1919), Mark

Tobey (1890–1976), Henri Michaux (1899–1984) and Georges Mathieu (b. 1921).

The German painter Hans Hartung had already experimented with free-form abstraction before 1925, when a lecture by Kandinsky shocked him with the realization that another artist had already come to the same conclusions as himself about abstract art. Having served in the French Foreign Legion in the War and been severely wounded, Hartung resumed painting in France in 1945. In the ensuing years his work was characterized by intensely energetic patterns of line, suggesting various emotional states. Gradually, colour entered his compositions, providing a luminous background, emphasizing the emptiness of the plane, and allowing his sheaves of lines to become

80 more lyrical and autonomous. Yet underlying Hartung's apparent improvisation was a methodical approach to painting, reflecting a formal training at the Académie des Beaux-Arts, Leipzig. Suspicious of direct expression without reflection, Hartung insisted that 'a cry is not art'; time is essential 'to let the subject ripen', although the artist must 'try to preserve in the performance, the freshness, directness and spontaneity characteristic of improvisation'.

Hartung, who became particularly influential for a younger generation of artists, was associated with the Frenchman Pierre Soulages (as well as with the Swiss painter Gérard Schneider, b. 1896) through a joint exhibition of their work at the Galerie Lydia Conti in 1941. Their styles were considerably different, however. In Soulages'

89 characteristic work after 1946, large black *tachès* assert themselves against a luminous pale ground and suggest a simultaneous tension between light and shade. Thicker and wider than Hartung's delicate sheaves, Soulages' dark bands intimate a gestural urgency that belies their superficial resemblance to Oriental characters. His interest was in free expression as opposed to Oriental calligraphy, which makes literal representations of signs. In an article 'Beyond the Informal' in 1959 he declared that 'the act of painting is born of an inner necessity'. Significantly, his emphasis on personal expression recalls Kandinsky, whose *On the Spiritual in Art* had only been published in French in 1949, while his reference to the 'act of painting' reflects the impact of contemporary American painting and criticism, which had already influenced European art by this time. Apart from 'Un Art Autre', American work was shown in Parisian gallery exhibitions from 1951, including the first one-man show by Jackson Pollock in 1952, and in July 1953 twelve American painters, including Pollock, were shown at the Musée d'Art Moderne.

89 SOULAGES *Painting* 1952 >

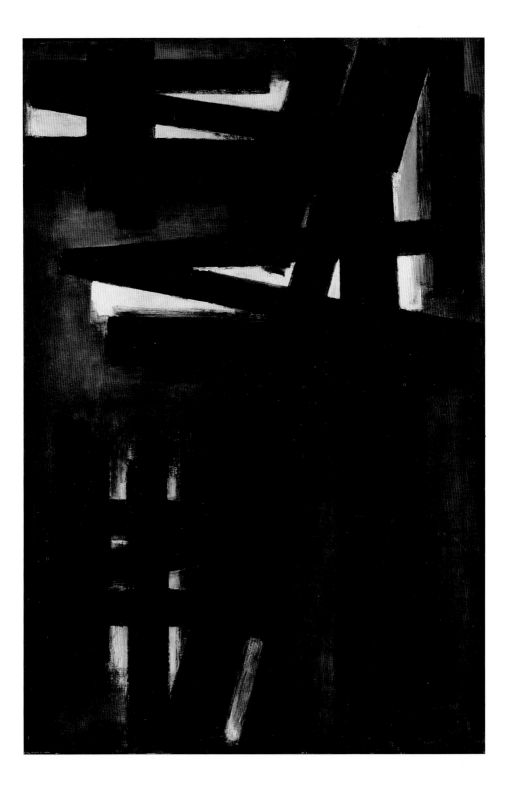

If Soulages' and Hartung's abstract marks were large-scale in relation to the canvas size, other artists investigated a more calligraphic approach to abstraction. Spontaneity and rapid movement of the hand, already suggested in the work of Wols, became a feature of the work of Michaux, Mathieu and Tobey, among others, and suggest something of the growing interest in the art of Japan at this period. Significantly, Michaux's preferred support was paper. Having been a poet, Michaux only took up painting seriously during the late 1930s, producing lyrical abstracts in an automatist mode which he described as *Phantomisme*. Following the sudden death of his wife in 1948, his style changed markedly in 1950. This is visible in a set of black China-ink drawings called *Mouvements* (1951), which combine abstract signs with poetry in an attempt to create a *seconde écriture* – hieroglyphic signs that go beyond the verbal. His attempt to free the psyche and to record the inner vibrations of the mind as fast as possible led Michaux to experiment with the drug mescalin after 1955. The works made either under the influence of the drug or inspired by it (such as *Untitled*, 1959) have no centre, and the all-over disposition of marks suggests a mysterious and indecipherable writing distributed across a page. The interest in reaching other levels of the mind through drugs intriguingly parallels the researches of the British novelist Aldous Huxley, who published descriptions of his experiments with mescalin in *The Doors of Perception* (1954) and *Heaven and Hell* (1956).

90 MICHAUX *Untitled* 1959

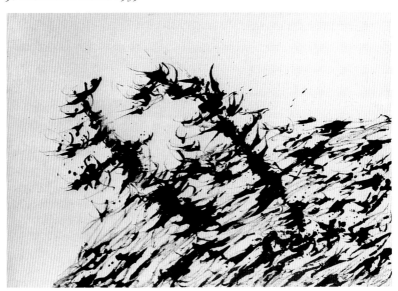

91 FRANCIS *In Lovely Blueness* 1955–57

A calligraphic abstract art was also pursued by the American artist Mark Tobey, who came from Seattle but worked in Europe. In reaction to a 'Renaissance sense of space and order', Tobey sought to free his pictorial space by decentralizing the forms and relating all parts of the picture plane to one another. From 1936 onwards, after a 86 visit to the Far East, he began to 'write' his paintings. Line usurped mass, and coloured or neutral tones (such as white) were used to create his linear compositions, infusing them with a sense of light. Unlike the New York action painters, Tobey believed that 'painting should come through the avenues of meditation rather than the canals of action', and his interest in Eastern religions (and in Oriental brushwork) was conveyed to European artists through his inclusion in the exhibition and catalogue, 'Un Art Autre'.

It is interesting that the Californian painter Sam Francis (b. 1923) also showed an empathetic response to Oriental compositional ideas in his paintings of the late 1950s. Francis' interest in colour and light came partly from contact with French art. He moved to Paris in 1950 to study at the Atelier Fernand Léger, where, besides befriending Riopelle and admiring Matisse's work, he was particularly influenced by Monet's *Waterlily* series, on permanent display at the Orangerie in the Tuileries. Monet's sense of scale, pure colour and sensibility to light in these late paintings inspired Francis to explore such options in large works, such as *In Lovely Blueness* (1955–57). Increasingly, 91 however, he began to push colour to the outer borders of the painting,

92 MATHIEU *Capetians Everywhere* 1954

leaving an empty centre of virgin canvas. The splashed colour around the perimeter intensifies the void and seems to reflect an Oriental respect for the powerful effect of negative space.

The question of the influence of the East on French artists is a vexed one. The French painter Georges Mathieu declared later (like Soulages) that he was not influenced by Japanese calligraphy, but that 'the likeness lies in the spiritual, not the formal approach'; that it is a *rencontre*, not an influence that is to be observed in these East/West connections. However, reproductions of Oriental calligraphy were published in European art magazines, and Mathieu and Tapié, as well as Francis, visited Japan in 1957. Meanwhile, French Informel painting began to be appreciated in Japan. According to the Japanese commentator Shuji Takashina, the 1951 Paris 'Salon de Mai' exhibition of work by artists including Schneider, Hartung and Soulages, came as 'a revelation to Japanese painters'. Several Japanese artists emigrated to the West in the early 1950s, and painters such as Toshimitsu Imai (b.1928) and Hisao Domoto (b.1928) adopted the Tachist style when they arrived in Paris in 1952 and 1955 respectively. For the majority of artists remaining in Japan, the 1956 exhibition 'International Art Today' represented a major opportunity to see and absorb contemporary tendencies in the West.

Georges Mathieu had developed a calligraphic approach in his own painting before his visit to Japan. In a painting completed the night of his mother's death, *Homage to Death* (1950), paint was energetically

dispersed over the surface of the canvas as though to leave an immediate trace and permanent record of the artist's emotion. Mathieu went on to develop the immediacy of his technique by using a new type of commercial paint called chrisochrome, which could be squirted directly from the tube. Rapid momentum was essential to direct the paint, and the quick squeezings resulted in a series of calligraphic marks against a usually monochromatic ground. In order to increase the tension of the enacted moment (in fact previously rehearsed), Mathieu extended his act of painting to a form of public spectacle, in which he performed in front of a live audience. This was to have a significant influence on the work of Yves Klein and on later 'Happenings'. However, the element of ritual and of action painting in Mathieu's work inevitably resembles that of Jackson Pollock, whose work Mathieu had helped to show in an exhibition in Paris (March 1951) which presented contemporary French and American paintings together as 'Véhémences Confrontées'.

92

GROUPS ACROSS EUROPE

The expressive abstraction practised in France by so many European artists also passed inevitably to other countries. In Italy, the Gruppo

93 VEDOVA *Invasion* 1952

degli Otto Pittori Italiani (1952) became the nucleus of a movement towards expressive abstraction, known as 'Informalismo'. Emilio Vedova (b. 1919) was one of the most important Italian artists to develop a style in which the improvisatory aspects of Wols' art were transformed into an intense form of personal expression. The dark forms and opposing forces in his tempera painting *Invasion* (1952) recall the energy of earlier Futurist painting, while the title, like many of his works, appears to be politically inspired.

93

In Britain during the 1950s, St Ives in Cornwall became once again a centre for abstract art. Visiting artists including Roger Hilton (1911–75), William Scott (b. 1913), Terry Frost (b. 1915), Bryan Wynter (1915–75) and Patrick Heron (b. 1920) came to Cornwall at different times and with the Cornish artist Peter Lanyon (1918–64) pursued a lyrical, romantic abstraction that was often infused with an inherently British sense of landscape and the sea. In Lanyon's *Bojewyan Farms* (1951–52), for instance, a resonant yet abstracted quality of place is combined with a vivid directness of painterly approach.

94

The inclusion of three of the St Ives artists (Frost, Hilton and Scott) in the exhibition 'Nine Abstract Artists', staged by Lawrence Alloway in London in 1954, serves to indicate the diverse nature of British abstract art by this time. The 'romantic' abstraction practised by the group based in Cornwall was displayed next to the more 'constructive' tendency pursued by a London group centred around the artist Victor Pasmore (b. 1908) which included the painter Adrian Heath (1920–93) and the 'constructionists' Anthony Hill, Kenneth and Mary Martin (p. 174). This bifurcation illustrates the broadening range of abstraction in the post-War period, which, particularly after 1956, would be extended again by the impact of American art.

94 LANYON *Bojewyan Farms* 1951–52

In Germany, the post-War art situation was complex. None of the great abstract pioneers of the pre-War period had returned. Consequently, at the end of the War, few abstract artists remained to offer a lead, except for Willi Baumeister (1889–1955), who had painted clandestinely under the Nazis until the end of the War. After 1945 he emerged as a strong advocate for an abstract style, despite opposition from the figurative realist, Karl Hefer. As debates raged between the styles, abstraction at least had the advantage of being far removed from Nazi taste, and this helped it to gain favour. However, for many of the most important artists who worked in an abstract style in the next decades, the necessity was to transcend polemics and to regain the spiritual orientation of abstract art.

In July 1949 a group of painters formed the Zen group, in which Julius Bissier (1893–1965), Ernst Wilhelm Nay (1902–68), Theodor Werner (1886–1968), Fritz Winter (1905–78), Bernard Schultze (b. 1915) and Emil Schumacher (b. 1912) all participated. Zen, as it originated in China and Japan, denotes a state of consciousness in which the individual is submerged in the absolute by a sublimation of the self. For the German artists, it was the spiritual dimension rather than the precise philosophy which was important, and they frequently used automatic, calligraphic techniques in their work as a means of attaining this state. Bissier, who had come across Chinese calligraphy as early as 1927, used calligraphy as a technique in watercolours and tempera to induce meditation. Winter, who had trained at the Bauhaus, later evolved a mystical response to the forces of creation, using grey as a symbol of the infinite, in paintings suggesting a lyrical, shadowy space, such as *Force-Impulses of the Earth* 95 (1944). Having visited Hartung in Paris in 1951, he established an important link with Parisian Art Informel which affected his own art and that of other Zen artists, such as Schumacher. By 1952, the Quadriga group in Frankfurt was also pursuing a Tachist form of lyrical abstraction derived in part from Riopelle and Wols, but also infiltrated by 'Zen' ideas. In the face of the harsh political reality of a Germany defeated and partitioned, the spiritual dimension of abstraction, which had been explored so much earlier in Germany by Kandinsky, perhaps suggested a necessary transcendence, a spiritual element that was still important for the Zero group at the end of the 1950s (p.180).

For the European CoBrA artists working as a group between 1948 and 1951, the interest in abstraction was different again. Deriving their name from the first letters of their home cities – Copenhagen,

95 WINTER
Force-Impulses of the Earth
1944

Brussels and Amsterdam – the various CoBrA artists (who were the subject of 15 separate monographs in 1950) sought to investigate the region between 'banal realism' and 'orthodox abstract art' in their work. By avoiding both extremes and operating in the territory between, they hoped to revitalize contemporary art by combining the best of the previously separated traditions. Connected to Surrealism through the Dane Asger Jorn and the Belgian Christian Dotremont, CoBrA was more political than the French abstract groups, though like them, it was opposed to both geometric abstraction and to French Socialist Realism. The Algerian-born French painter Jean-Michel Atlan (1913–60) summed up the attitude of the group when he declared in the sixth issue of their journal in 1950: 'The forms which seem to be most valid to us, both by their plastic organization and by the intensity of their expression, are properly speaking neither abstract nor figurative. They participate in

the cosmic powers of metamorphosis in which true adventure is found (which gives rise to forms that are at once themselves and something other than themselves; birds and cacti, abstraction and new representation).'

Like their French and American contemporaries, the CoBrA artists placed emphasis on the expressive immediacy of the gesture, believing that a painting could not be predicted. Writing on abstraction in the tenth issue of *Cobra* (1951), the Belgian artist Pierre Alechinsky (b. 1927) maintained that 'It is uniquely in action that thought can intercede with matter', and argued for a painting in which 'thinking and painting overlap'. He also went on to say that if the work is provoked by the sensibility and emotion of the painter, such spontaneity will never be abstract, because it will always represent the man. Meanwhile, his compatriot Pol Bury (b. 1922) proposed a 'painting of materials' in which the 'active imagination' permits a different kind of 'dreaming', where the painting is imagined during execution and not before. Thus despite their very different results, the CoBrA artists also emphasized the act, or process of painting. This paralleled the interests of the American 'gesture painters' who had already emerged across the Atlantic.

96

96 ALECHINSKY
Night Exercise 1950

Focus on Expression: USA 1939–56

> *The new painter . . . must move on to an expressive art, yet not of the painter's feelings, so well explored by the Expressionists. The truth is not a matter of personal indulgence, a display of personal experience. The truth is the search for the hidden meaning of life.*
>
> BARNETT NEWMAN

Out of the international melting-pot of styles that characterized New York during the War years, the first and most celebrated international American art movement was born: Abstract Expressionism. In fact, the movement, which also became known as the New York School, contained two separate, if related tendencies: gesture (or action) painting – represented notably by Jackson Pollock (1912–56), Willem de Kooning (b. 1904) and Franz Kline (1910–62) – and colour-field painting, epitomized in the work of Mark Rothko (1903–70), Barnett Newman (1905–70) and Clyfford Still (1904–80). However, the movement was wide-ranging and included many other artists, such as Adolph Gottlieb (1903–74), Robert Motherwell (b. 1915) and Philip Guston (1913–80), who do not fit neatly into either category, and despite its name, not all the work was abstract – nor obviously expressive. Nevertheless, the term Abstract Expressionism serves to identify a period in American art when the overwhelming debt to European modernism was finally overcome. A new vitality and formal inventiveness emerged independently of Paris, and New York moved towards the centre of the world's artistic stage.

EUROPEAN INFLUENCES

European modernism had been introduced to the American public as early as 1913 – the date of the notorious Armory Show in New York and Chicago. The Armory Show presented current European avant-garde movements alongside the work of their predecessors, such as Cézanne, and the most vital elements in contemporary American art.

<97 POLLOCK *Full Fathom Five* 1947

The innovatory work of Duchamp and Picabia, for example, shocked the public but also showed the organizers what was missing in American painting and sculpture. One of the selectors, William Glackens, ruefully acknowledged that 'everything worthwhile in our art is due to the influence of French art. We have not arrived at a national art.' From that time, the search was on to find it. In the meantime, though, European art suggested possible directions for American artists willing to experiment with abstraction. As we have seen, the Synchromists had built on the lessons of Cézanne and Orphic Cubism, while Joseph Stella had explored Futurism, and Max Weber, Cubism. During the 1920s Georgia O'Keeffe and Arthur Dove continued to pursue their individual forms of abstraction in the face of a predominantly figurative-realist style.

The dominant trends in American art during the 1930s were realist Regionalism and Social Realism (sometimes called American Scene Painting), but abstract art also started to gain interest. The collector A. E. Gallatin opened his Museum of Living Art in New York, in 1933, with an exhibition, 'The Evolution of Abstract Art'; it was introduced in the catalogue by Jean Hélion, who later came to America to live. In 1936 Alfred H. Barr Jnr organized the exhibition 'Cubism and Abstract Art' at the recently opened Museum of Modern Art (MOMA), and this was accompanied by an influential catalogue. During the same year, the American Abstract Artists Association (AAA) was founded by the painter-critic George L. K. Morris (1905–75), with the aim of making New York a centre for abstract art. Contact with European developments was maintained by the publication of the Franco-American journal *Plastique* (1937–39), co-edited by Sophie Täuber in Paris. It included articles on Constructivism and Suprematism, and provided an important source of information following the demise of *Abstraction-Création* (which had previously helped to promote abstraction in America). The first exhibition of the AAA in April 1937 included 39 artists, several of whom had been members of Abstraction-Création. Although most exhibitors were committed – in varying degrees – to a disciplined Cubist-abstract style, others (such as Fritz Glarner, Burgoyne Diller, Ilya Bolotowsky and Harry Holzman) were drawn to the more severe geometry of Neo-Plasticism, an interest that was augmented in 1940 by Mondrian's arrival in New York.

If some of their work shows Mondrian's direct influence, his own painting during the last four years of his life (1940–44) was in turn affected by New York. The rhythms of the city and of the jazz music

98 MONDRIAN
Victory Boogie-Woogie 1944

he admired are evoked in the title and in the linear syncopations of
Victory Boogie-Woogie (1944). However, although Mondrian's 98
presence in New York offered encouragement to individual geo-
metric artists, the AAA actually foundered after his arrival. Having
achieved its aim of increasing interest in abstract art (which was
complemented' in 1939 by the opening of the Museum of Non-
Objective Painting, later called after its founder: Solomon R.
Guggenheim), the Association lost momentum through being too
eclectic and derivative, and fell prey to internal dissension and, finally,
the War itself. Geometric tendencies did resurface in America, but not
until some time later.

99 MIRÓ *The Poetess (Constellation series)* 1940

Of the various European movements to affect the new generation of American abstract artists in the 1940s, it was Surrealism which had the greatest impact. As we have seen, Marcel Duchamp moved to New York permanently in 1913, where with Picabia he became leader of the New York Dada and Surrealist movements. An exhibition called 'Fantastic Art, Dada and Surrealism' was held at MOMA in 1936, and following the outbreak of the War in Europe, various key Surrealists came to America, including André Masson, Roberto Matta (b. 1911), Yves Tanguy, Max Ernst, Salvador Dali, Kurt Seligmann, as well as André Breton himself. The American heiress Peggy Guggenheim, who was married to Max Ernst, ensured a regular showing of Surrealist art at her New York gallery, Art of this Century (founded in 1942), while a major exhibition, combining 'Abstract and Surrealist Art in America' was staged at MOMA in 1944. Despite the presence of Breton (who by this stage had modified his opinions on 'pure psychic automatism' in favour of the dream), it was the automatic procedures of Miró, Masson and Matta, rather than

the illusionistic verism of, say, Dali, which created particular interest among the new generation of American painters.

Even though Miró was not personally present in New York, his work became known to American artists through exhibitions. His use of biomorphic forms suggested freedom both from realism and from the severity of geometry, and this was exemplified in the *Constellation* series, exhibited at MOMA in 1941. With their dark colours, redolent of the anguish of war, the 22 gouaches employ a language of hieroglyphic signs, while a weaving line defies spatial illusionism and suggests an all-over style of painting. Since the early 1920s Masson had made calligraphic, automatic line drawings in which frenetic lines cross the surface of the paper in an attempt to 'release' unconscious imagery. The emergent forms were frequently of a visceral, violent or sexual nature, but occasionally the results appear more abstract, as in the drypoint *Rapt* (1941). The spontaneous effect of this technique and the densely packed forms, swirling lines, dark colours, abstracted imagery and poetic titles (*Meditation on an Oak Leaf*, 1942, and *Pasiphäe* 1943) of his 1940s paintings were to be particularly influential for Jackson Pollock. If Masson's style stressed flatness, in paintings such as *The Onyx of Electra* (1944) the Chilean Surrealist Matta mapped out a spatially vertiginous structure, which pushes forward in parts while receding in others. Although derived in part from Duchamp, Matta's spatial ambiguity, his whiplash line, diluted paint

99

100

101

100 MASSON *Rapt* 1941

101 MATTA *The Onyx of Electra* 1944

and large-scale canvases also influenced younger artists, while his studio on 9th Street became a meeting place for Jackson Pollock, Robert Motherwell and Arshile Gorky.

Arshile Gorky (1904–48) has been described as 'Janus-faced'; he can be seen as the last of the great Surrealists and the first of the Abstract Expressionists. Born in Armenia, Gorky arrived in the United States in 1920, in a desperate escape from extreme poverty. Having studied painting in New York, he revealed the influence of Picasso and Cubism in his work of the 1920s. During the 1930s his work became more geometrically abstract, as in the mural he designed for Newark airport (1935–36). However, by the early 1940s he had relinquished this style for a softer, biomorphic abstraction, probably inspired by Miró, and evident in his *Garden in Socchi* series (1940–43). Through intense observation of minute forms in nature that he found in the Virginia landscape in 1943, Gorky arrived at a mature style. Paintings
102 such as *Waterfall* (1943) show his ability to transcend the immediate landscape by using hybrid, organic forms in a nebulous space that

invokes reverie. The combination of fluid, undulating colour (inspired by Kandinsky) and a thin, febrile line (suggesting Matta) is transformed to greater depths of personal expression in late works such as *Agony* (1947). Heightened tension is obvious without recourse to legible imagery, and feeling is unleashed through abstract forms.

Aside from the Surrealist influence, two German painters of the same generation, Josef Albers and Hans Hofmann, had an important impact on American art from the 1930s. Following the closure of the Bauhaus in 1933, Albers moved to America, where he became a doyen of American geometric abstraction and influenced several generations of American painters through his teaching at Yale University; he became chairman of the design department there in 1955. In 1949 he began work on the *Homage to the Square* series, which 67 exemplified his continuing interest in control and order, but which now also explored the interrelationships of colour. Believing that 'every perception of colour is an illusion . . . we do not see colours as they really are. In our perception they alter one another', he

102 GORKY *Waterfall* 1943

concentrated on placing one defined square of colour within others. Through such simple means, Albers prompted an awareness of three-dimensional space while simultaneously drawing attention to the two-dimensional forms, and ultimately, the two-dimensional picture surface. These ideas were to have important reverberations for the art of the 1960s.

Hans Hofmann (1880–1966) arrived in the United States in 1930 with considerable knowledge of earlier twentieth-century European art. His interest in rationalist Cubism and in Expressionist, particularly Matissean, colour was augmented by his contact with artists in Paris (1904–14) and in Munich (1915–30). He was thus able to draw on his direct experience in describing methods to his students at the various American art schools where he taught, including his own in New York from 1934. Despite acknowledging the importance of theory, he placed great emphasis on the free execution of painting, and played down the role of premeditation – especially during the 1940s, when he was affected by Surrealism. His own painting career shows a zest for experimentation and a willingness to tackle the rigidity of the Cubist grid. In 1961 Clement Greenberg (b. 1909), one of the most influential critics of the New York School, credited Hofmann with bringing the gift of 'a new liveliness of surface' to American painting. Significantly, as early as 1944, in paintings such as *Effervescence*, Hofmann had dripped and spattered paint onto the surface of his canvas with improvisatory freedom. In other paintings, *104* *Pompeii* (1959), for example, vigorous brushwork and high-key colour act against the underlying Cubist structure, and a 'push and pull' tension is established between the various components, although the integral flatness of the picture plane is retained. The rejection of illusionism and the obvious interest in an abstract but painterly surface provided an example to young American artists, who were wary of both the cool rationalism of geometric abstraction and the increasingly literary associations of Surrealism.

GESTURE PAINTING

In terms of creating the new American painting, it is Jackson Pollock who has been credited with 'breaking the ice'. With the discovery of new techniques leading to his characteristic 'drip' paintings after 1947, Pollock galvanized American abstraction and produced a painting style that was more direct, improvisational and larger in scale than most European examples hitherto.

Pollock's early work (once he had shed the influence of his Regionalist teacher, Thomas Hart Benton) was concerned primarily with myth. In common with several of his colleagues, including Gorky, Rothko and de Kooning, this interest was partly inspired by Pollock's friend, the artist-polemicist John Graham. In his influential book, *Systems and Dialectics of Art* (1937), Graham called upon artists to 'reestablish a lost contact with the unconscious (actively by producing works of art and passively by contemplating works of art) with the primordial racial past . . . in order to bring to the conscious mind the throbbing events of the unconscious mind'. Graham's emphasis on the primordial past and the collective unconscious suggested links between painting and the ideas of Carl Jung, especially as Graham related the use of myth to art very specifically in an article he wrote on 'Primitive Art and Picasso' in 1937. Graham proposed that the 'evocative' quality of primitive art was found in 'spontaneous exercise of design and composition', which ensured greater freedom of access to the unconscious mind. This had particular resonance for Pollock, who in 1939 attended sessions of Jungian therapy in which his own drawings provided material for discussion. From this time until his move to Long Island in 1945, allusions to mythic figures and archetypes or to mythic rites occurred regularly in his painting titles (such as *She Wolf* or *The Moon Woman Cuts the Circle*, 1943). Pollock's interest in the workings of the unconscious continued throughout his career, but in the later 1940s his language became abstract.

His formal direction was inspired by a number of factors. Around 1938 his interest was reawakened in the work of José Orozco, Diego Rivera and David Siqueiros – Mexican artists whom he had encountered a few years earlier. The epic scale of their murals and their inclusion of totemic images helped to free Pollock from Benton's influence and to inspire new, 'evocative' motifs in his own work, although he avoided the social content of the Mexicans. By 1939 he had also absorbed influences from European artists, including Picasso, Kandinsky and Masson (whose own painting *Pasiphäe* was completed shortly before Pollock's own painting of the same title in 1943). And in 1944 Pollock spoke of the significance of the Surrealists in New York, saying that he was 'particularly impressed with their concept of the source of art being the unconscious'. However, unlike the Europeans, Pollock's brushwork was violent and expressionistic, and his palette was charged with the bright hues found in American Indian art.

103 POLLOCK *Shimmering Substance (Sounds in the Grass series)* 1946

After his move to the countryside of Long Island in 1945 specific mythic connotations in his work were increasingly suppressed, and references to nature started to occur, as though the landscape itself were now providing a source of psychic nurturing. With the changed allusions came a changed attitude to the surface of the canvas. In the *103* painting *Shimmering Substance* (1946) from the *Sounds in the Grass* series, the imagery is veiled and unrecognizable. What might have

begun as a recognizable form is overpainted with short, stabbing strokes applied in a circular rhythm. The small canvas is charged with movement, which emanates from the boundless energy of the brushwork. If *Shimmering Substance* took its starting point in nature, its physical transformation through the process of painting renders its origins uncertain. The gestural application of the paint asserts itself, and the process, or act of painting takes pre-eminence over imagery. The way is prepared for a move to a larger scale, and to confidence in the gesture for its own sake.

In *Full Fathom Five* (1947) most of the canvas is painted with the thickly brushed layers and individual strokes familiar from the previous year's work, while additional texture is derived from extraneous objects embedded in the paint: nails, tacks, buttons, coins, cigarettes and matches. The most significant ingredient, however, is the dripped technique. At a late stage during the painting Pollock evidently removed the canvas from its upright easel position and placed it on the floor. He then finished it by dripping black and blue-white paint onto the surface in controlled arcs, which weave in a circular movement away from the edges to the centre of the canvas. The result is a series of free-flowing lines that challenge the conventional functions of drawing (to outline planes and define images), and allow drawing to become synonymous with painting. Pollock's earlier experience of witnessing the energetic mural painting of the Mexicans, his interest in ritual dance (inspired in part by his knowledge of Indian sand-painting, and his concern with expressing the unconscious, both through Graham and Surrealism) helped him move towards a completely new direction in terms of Western art.

By 1950 it is the very action of dripping or pouring the paint which becomes the process and the end of painting. With *Lavender Mist* (1950), for example, the entire painting was executed on the floor, and the huge surface covered entirely by interlacing trails of paint. By this stage, no under-image was necessary; the controlled and looping skeins of paint had become both subject and content. Unlike earlier abstract work, such painting had no geometric or grid construction (as in Cubism or Neo-Plasticism); no biomorphic references (as in Surrealism or Gorky); no premeditated form (Kandinsky); no illusion of spatial recession (Matta). Instead of creating structural differences between the separate sections of the work (as was usual in previous abstract painting, as much as in representational art), Pollock created a style of painting in which the surface was virtually uniform. The paint

covered the entire canvas, with no division into parts. This new concept became known as 'all-over painting' and was extremely influential for other American painters. Pollock's drip paintings also created different demands on the spectator. Because of its physical size the canvas could not be assimilated in a single look; it required the participation of the observer, who was encouraged to walk along its length in order to engage with the energy and scale of the painting. To get something from the work, Pollock advised that people should 'not look for, but look passively' – a useful guideline perhaps, for how to look at Abstract Expressionist painting generally, and, indeed, abstract art as a whole.

As with French informal art, so with Pollock, the success of the final painting depended on the rapport between painter and canvas in the process of making the image. However, painting on the floor made even more demands: complete spontaneity – on account of the great scale, the composition could not be rehearsed like those of Hartung or Mathieu – and complete control – for 'mistakes' could not be disguised by overpainting. Consequently, for the composition to work, Pollock needed to be literally 'in the painting', both physically and psychically. Inspired by the freedom and 'greater ease' offered by placing the canvas on the floor, Pollock found that with experience it was 'possible to control the flow of paint'. Greenberg has compared Pollock's technique to that of a Western lassoo-thrower, and the analogy is very apt. The film and photographs of Pollock painting (1950) by Hans Namuth show him propelling the paint with skilful precision from the end of a stick to create a serpentine arc on the canvas. Considering the judgment and dexterity this required, it is not surprising that Pollock denied that accident had anything to do with his technique: choice, not chance, determined each step of the process. Balancing this, however, it is equally important to remember Pollock's assertion that when he was 'in' the painting, the work had a life of its own.

When the painting was going well, there was an easy give and take between the artist and the canvas, which is borne out by the confidence of works such as *Lavender Mist*. Speaking in a radio broadcast in 1950, Pollock suggested that the modern artist expresses 'the energy, the motion and the other inner forces' of an 'inner world'. But while the very physical action of the drip technique perhaps helped Pollock gain access to his inner world, as he freely admitted, loss of such contact could result simply in a mess. Emphasis on the spontaneous gesture or *act* of painting itself (without the second,

107

104 HOFMANN *Pompeii* 1959 >

105 STILL *Painting* 1944

image-forming stage employed by the Surrealists) placed a tremendous onus on the artist to succeed with the initial composition, and Pollock had to be acutely aware of his own actions in order to control the outpourings. The Existential ramifications of this situation were fully explored by the art critic Harold Rosenberg, who defined the term 'Action Painting' in a famous article in *Art News* (December 1962).

In the wake of the Second World War, it was perhaps inevitable that Existentialism should also percolate to America. It fitted the

American artists' desire both for personal expression and for the freedom to break away from past traditions. As Clyfford Still put it in 1952: 'We are now committed to an unqualified act, not illustrating outworn myths or contemporary alibis. One must accept total responsibility for what he [sic] executes. And the measure of his greatness will be in the depth of his insight and his courage in realizing his own vision.' Working 'out west and alone', Still had to fight in himself 'any tendency to accept a fixed, sensuously appealing, recognizable style' (1961). Unlike Pollock's, his paintings were composed of large, flat colour areas, frequently broken by small flashes of lighter pigment which interrupt the otherwise hard and tarry surface. Works such as *Painting* (1944) suggest Still's wilful *105* independence from any compromising softness or debt to the sensuous handling of paint associated with the French tradition.

By 1950 the Dutch-American painter Willem de Kooning was hailed, along with Pollock, as one of the leaders of the new abstract school of American painting. De Kooning's first one-man show (1948) included only black and white paintings. These abstracts were characterized by a forceful and energetic approach in which neatness of finish was relinquished for directness of effect. *Painting* (1948) *106* demonstrates the rawness and immediacy of this series. Spatters and

106 DE KOONING *Painting* 1948

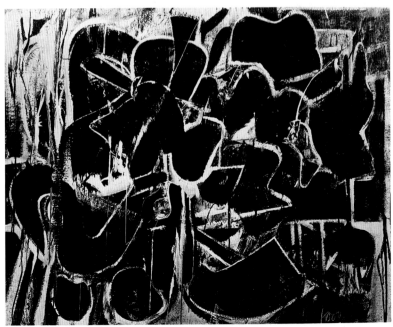

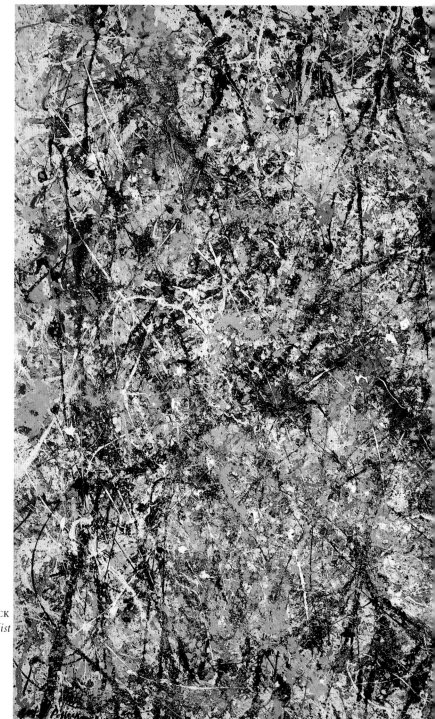

107 POLLOCK
Lavender Mist
1950

108 DE KOONING *Excavation* 1950

drips cover the surface – not intentionally, as in a Pollock of this period, but as a result of his form of painterly attack on the canvas. A fascinating interplay of shapes occurs in the painting as one area of non-colour is played off against another. Figure and ground can no longer be distinguished, as positive and negative areas of the canvas duck and delve beneath each other, pointing to a tendency that de Kooning was to develop in his major works of 1950. With the unusual

108 pictorial space of *Excavation*, for example, a challenge is made to earlier forms of European modernism, and the lessons of Cubism make way for something rather different.

Having trained in Rotterdam for eight years before coming to the States in 1926, de Kooning had a thorough grounding in painting techniques. An early member of the AAA, he was also well aware of the legacy of his fellow countryman Mondrian. But although

attracted by the possibilities of geometric abstract painting, de Kooning had strong reservations about Mondrian's approach. Calling him 'that great merciless artist . . . who had nothing left over', he characteristically declared in 1949, 'order, to me, is to be ordered about and that is a limitation'. Consequently, he felt free to move between styles, and his abstract paintings often contain figurative echoes. *Attic* and *Excavation* (1950) are full of references to the human *108* body (shoulders, breasts, heads, etc.), but to recognize and identify them as such, it is necessary to have a knowledge of his earlier figure paintings and drawings, in which different parts of the anatomy are isolated and diagrammatically juxtaposed, often through the use of collage techniques. In formal terms, de Kooning's work was extremely important for its energy of gesture and for its skilful manipulation of space. What Pollock had achieved with the drip and pour method, de Kooning achieved with the painted stroke; and both questioned the traditional distinction between painting and drawing.

For both de Kooning and Pollock, abstraction was not the only path. Like certain European artists, such as Léger and de Staël, they did not exclusively follow one tradition. De Kooning engaged in full-frontal figuration with his *Woman* series (1950–52) and has continued to make both abstract and representational paintings throughout his career, refusing 'to sit in style'. In Pollock's case, the return of imagery in his late work was perhaps part of the natural cycle of his art, and his remark in 1956 that he was 'very representational some of the time, and a little all of the time', prompts the speculation that even his drip paintings – with evocative titles such as *Lavender Mist* and *Autumn* *107* *Rhythm* – are not as abstract as they might appear. It is interesting that it was in a series of 'black' paintings in 1951 (where black enamel paint was poured onto unprimed cotton duck canvas) that the 'early images' began to come through, with the majority containing interpretable configurations of fish, faces, figures and so on.

It is perhaps indicative of the mood of the period that black pigment was important for many American artists, as it was also for their European counterparts. In the immediate post-War years, overshadowed by Hiroshima and the implications of the nuclear arms race, they were faced with the Cold War abroad, including events such as the Berlin air-lift (1948) and the Korean War (1950–53), while at home, the spectre of McCarthyism was rampant. Interestingly, this was also the time when the *film noir* was the vogue in Hollywood, as film-makers sought to explore some of the anxieties unleashed by the War and its aftermath. In 1950 the Sam Kootz Gallery in New York

109 ROTHKO *White, Yellow, Red on Yellow* 1953

showed an entire series of black and white paintings by de Kooning, Baziotes, Gottlieb and Motherwell, and in the same year, Franz Kline made a strong impression with black and white paintings at his first one-man show. Significantly, in 1949 an exhibition had been held in New York of Matisse's black Vence paintings, and this, along with Picasso's *Guernica* (1937) – brought to New York in 1939 – had had a powerful influence.

In 1949 Motherwell used black and white to powerfully stark effect in his *Elegies to the Spanish Republic* series, inspired by the Spanish *110* Civil War. The series of over one hundred paintings incorporated mainly black rectangular or ovoid planes placed against a white ground. Although the shapes relate to earlier, more figurative imagery in his work (such as *Pancho Villa, Dead or Alive*, 1943) and to the formal features of biomorphism and the flat planes in the work of Matisse, Miró and Picasso, the *Elegies* themselves were abstract. The dripping paint and large scale of the series suggests they belong to American gestural abstraction, but their sensuous surface betrays Motherwell's continued interest in the School of Paris.

A greater rawness is found in the 1950s work of Franz Kline. With the use of a huge decorator's brush and a delight in the large scale, Kline's black and white paintings, such as *Chief* (1950), seem to *111* magnify a tiny detail. Although in reproduction Kline's work may appear to resemble that of Pierre Soulages, on the canvas, the comparison does not hold. Apart from the difference in scale,

110 MOTHERWELL *Elegy to the Spanish Republic* 1953–54

111 KLINE *Chief* 1950

Soulages places his dark marks against a lighter ground, which gives the appearance of slight recession; Kline paints the white 'ground' as thickly as the black shape, overlapping the paint in various parts of the composition until the two sections appear to be locked together. Thus, the lingering thin scaffold of Cubist painting in Soulages' work is entirely lost in the uncompromising assertion of the flat picture plane in Kline's painting. Moreover, while Soulages' paint application is smooth and sensuous, Kline's is rough and unfinished. By 1950 American 'gesture painting' seemed committed to overthrowing the European legacy, and a similar direction was being pursued by the so-called 'colour-field' painters.

COLOUR-FIELD PAINTING

Rather than being concerned with the gestural trace of paint on canvas, the colour-field painters concentrated on chromatic values and explored the retinal effects of colour as opposed to the expressive impact of line. Unlike previous European painting, there tends to be

no relation between the separated parts of the composition; instead, the entire surface is uniform and smooth, presenting a 'holistic' field. The unified field of saturated colour and the large scale of the canvas mean that the spectator is totally surrounded by the work. A dramatic and even physically affective rapport is set up, in which the extensive canvas surface and the intense colour suggest something beyond the physicality of the painting itself. Underpinning the extreme abstraction of the work is a constant desire to convey feeling and meaning.

Like the early work of Jackson Pollock and Willem de Kooning, that of the colour-field painters was also concerned with myth. In a radio broadcast of 1943 Mark Rothko discussed his and Adolph Gottlieb's work, saying, 'if our titles recall the known myths of antiquity, we have used them again because they are the eternal symbols upon which we must fall back to express basic psychological ideas'. The myth was of interest precisely because it expressed 'something real and existing in ourselves'. Gottlieb added that they professed kinship to the art of primitive man because of the particular factor of the War: 'In times of violence, personal predilections for niceties of colour and form seem irrelevant. All primitive expression reveals the constant awareness of powerful forces, the immediate presence of terror and fear.'

Thus, for Rothko and Gottlieb, the subject matter of painting, its content and meaning, remained 'crucial' at this time. In a letter to the *New York Times* (published 13 June 1943), they asserted that 'only that subject matter is valid which is tragic and timeless', and gave this reason for professing spiritual kinship with primitive and archaic art. Aesthetically, they claimed to favour the 'simple expression of the complex thought' and the promotion of 'the large shape', flat forms and the reassertion of the picture plane. Such criteria offered a very different prospect for art from the deep illusory space and figurative content of American Scene Painting, then dominant in the United States. Having no sympathy for the values encapsulated in the realist tendency, which they found restrictive and out-moded, these artists wanted 'to start again from scratch'.

In the early 1940s concern with subject matter was revealed in work that was essentially figurative, as Gottlieb's hieroglyphic 'pictographs', such as *Voyager's Return* (1946), suggest. However, by 1947 it was harder to see the references in figurative terms at all. In the catalogue for 'The Ideographic Picture' show (1947), Barnett Newman wrote of Hofmann, Still and Rothko, as well as of himself, that here was a group of painters 'working in what is known as the

112

abstract style', although he denied that they were 'abstract painters'. To these artists meaning was so essential that they felt it necessary to dissociate themselves from other abstract painters for whom they felt this was not the case. Insisting on the integral meaning of the work, Newman called the new force in American painting the modern counterpart of the primitive art impulse. The primitive artist, like the new American painter, used an abstract shape, directed by a 'ritualistic will' towards 'metaphysical understanding'. Consequently, the abstract shape was 'a living thing', a vehicle for abstract thought complexes, a 'carrier of the awesome feelings he felt before the unknowable'.

During 1947 Mark Rothko moved away from the biomorphic, Surrealist phase which had characterized his mid-1940s painting, and began instead to divide up his canvas into the flat, floating bands of colour that anticipate his mature work. In these 'multiform' paintings, such as *Untitled* (1947), the rounded contours of his earlier forms become more oblong; the separated shapes begin to hover and the scumbled areas of colour (in which one opaque layer of paint was applied over another of different tone to create an uneven effect) suggest a delicate luminosity emanating from within the painting. These tendencies were to be fully developed in the major colour–field paintings from 1949 onwards.

113

109

Although Rothko deliberately turned away from figuration and representation at this point, he declared that colour was the means and not the end of his painting. He denied and despised any decorative intention in his own art, despite his great admiration for both Matisse and the figurative American colourist Milton Avery, and dedicated his art to a lofty purpose. Claiming that his preoccupations were primarily moral, he stated that, 'The progression of a painter's work . . . will be toward clarity: toward the elimination of all obstacles between the painter and the idea, and between the idea and the observer.' As 'obstacles' he cited, among others, 'memory, history' and 'geometry'. These were mere 'parodies of ideas', while he sought to convey an idea 'in itself'.

As we have seen (Chapter Two), Platonic theory played an important role in the history of abstraction. However, in Rothko's case, the moral purpose which brought him to pure abstraction was formed by tragic circumstances. Following the War and the atrocities suffered by the Jews, Rothko, the son of Jewish Russian émigrés, found that 'human incommunicability' rendered use of the figure in art no longer adequate – or as he put it, 'the solitary figure could not

112 GOTTLIEB
Voyager's Return 1946

raise its limbs in a single gesture that might indicate its concern with the fact of mortality'. An exhibition of Clyfford Still's work in February 1946 helped to show him how an abstract colour-field *109* painting could overcome this obstacle. Colour, light, hieratic disposition of flat, abstract shapes, symmetry and scale became his formal vocabulary, while the living spectator replaced the abandoned pictorial figure.

Meaning, however, remained of paramount importance. Rothko's desire was to produce an art which would be universal and poignant like tragedy (Aeschylus and Shakespeare), but also like music (Mozart). He wanted people to experience his work as 'a revelation, an unexpected and unprecedented resolution of an eternally familiar need'. By absorption in the picture plane with its glowing colour, the spectator could, if willing to be engaged, transcend the immediate surroundings and experience a sense of infinity. The fact that people

broke down and cried in front of his work showed Rothko that he was meeting a need. He welcomed the fact that some people turned to his work because they were 'looking to a spiritual basis for communion', and often discussed his late works as 'mood pictures'. In such late paintings as the Seagram mural series (1958–59), the scale increases and the colours darken, while the sense of the sublime is interwoven with intimations of mortality, and the tone becomes tragic.

For Barnett Newman it was specifically the American artist who was ideally placed 'to come closer to the sources of tragic emotion'. Freed from the weight of European and classical culture borne by his European counterpart, the American artist could explicitly 'deny that art has any concern with the problem of beauty', and instead, like a 'barbarian', reassert 'man's natural desire for the exalted, for a concern with our relationship to the absolute emotions'. By December 1948, Newman equated his vision with that of the sublime, and was advocating an art 'where form can be formless'. The notion of the 'sublime' was scarcely new. It referred to a type of art traditionally opposed to the 'beautiful', which was first defined in these terms by the English philosopher Edmund Burke in 1757. However, for Newman, the sublime was significant because it represented a reaction against the ideal of beauty and perfect form which he identified in most European art.

It was at this time that Newman produced his first 'zip' paintings, such as *Onement III* (1948), in which a flat field of colour was divided *114* by a vertical band crossing the centre of the canvas. Two years earlier a central band had appeared in *The Command* (1946) to unify and exert control over the surrounding chaos. As with other paintings, such as *Pagan Void* and *Genesis–The Break* (both of 1946), the meaning was drawn from Old Testament theology, reflecting his Jewish heritage. At the beginning of creation, in Genesis (I, 1–3): 'The earth was without form and void; and darkness was upon the face of the deep. And God said, Let there be light, and there was light.' The dividing band in *The Command* and the void around it, seem to echo the first stages of creation: the appearance of light, the bifurcation and eventual separation of the elements that comprise the world. The development of form from chaos may also suggest the symbolic birth of a new world following the traumas of War, and a fresh beginning for art.

With the *Onement* series and the subsequent zip paintings, the specific referential basis of *The Command* was left behind. In formal

167

terms, the composition was rationalized; the field was made a uniform colour and the zip was symmetrically placed to invite a central viewing position. Contemplation of the zip beyond the confines of the picture plane is encouraged, as both ends of it touch the edge of the canvas. Yet if the zip divides the surface, it is also an integral part of it; both zip and surrounding field are mutually dependent. The unity of opposites implies 'atonement', and this can be extended to the underlying meaning. The zip may be seen as the Divine Light; it may represent order, or even suggest an analogy for the human being in the face of the absolute.

136 Newman's later paintings, like his remarkable *Vir Heroicus Sublimis* (1950–51), continue with these early concerns, but use a larger scale and a greater brilliance of colour to absorb the spectator. The verticality of the zips remains, but their number and disposition on the plane are variable. The increased height and length of the canvases occupy the entire field of vision, and the hand-painted (therefore uneven) surfaces pulsate on the viewer's eye. The titles of other works, such as *Jericho* (1968–69) and the black and white *Stations of the Cross* (1958–66), imply very direct religious concerns, but like the rest of Newman's oeuvre, these images remain completely abstract in form. Newman's work was not appreciated when first exhibited, and when it was eventually recognized by critics such as Clement Greenberg, his paintings were interpreted in formal terms: relationships of lines and rectangles, post-Cubist structures and geometry. Consequently, the purpose, the integral content of Newman's paintings was overlooked in the 1960s, and soon gave rise to a band of followers who admired the appearance of the work, while overlooking its attempt to convey meaning.

ABSTRACT EXPRESSIONIST SCULPTURE

The grandeur and vision of the New York School of painting was echoed a little later in metal sculpture. Seymour Lipton (b. 1903), David Hare (b. 1917), Herbert Ferber (b. 1906), Ibram Lassaw (b. 1913), Reuben Nakian (b. 1897), Theodore Roszak (b. 1907) and David Smith produced sculpture in the 1940s and 1950s which paralleled the work of the Abstract Expressionists. They similarly tended to abandon representation, using quasi-organic forms and loose figurative associations in open works frequently made of welded steel. Of this group of sculptors, David Smith (1906–65) was perhaps the most original.

As we have seen, sculpture in the twentieth century was particularly concerned with overcoming many of the traditional restraints of the medium. Since Picasso had made his influential reliefs based on motifs such as the guitar, the medium had begun to admit features of frontality, colour and illusionism previously reserved for painting. With Brancusi came the possibility of exploring reductive form, reconciling figure and base, and perceiving sculpture as an independent object. In the hands of Gabo, Rodchenko, Giacometti and Calder, sculpture had become more open, less monolithic, more concerned with the effects of light and movement. In order to help break free of mass, several sculptors had used welded metal for the structural possibilities it offered: Tatlin and Medunetsky had used welded iron for their constructions; Picasso had made welded steel sculptures in 1928–29; and his friend the Spanish sculptor Julio González (1876–1942) had used forged iron from 1927 onwards to create sculptures which, while retaining figurative associations, had become increasingly abstract. It was due particularly to the latter's technical inspiration that David Smith began to make metal sculpture in the early 1930s, having previously studied painting with Gorky and de Kooning at the Art Students' League in New York. Smith's painterly background led him to feel that there was no essential difference between painting and sculpture, and prompted him during the 1950s to work flat on the floor, like Pollock, cutting out shapes or even painting them on sheets of steel, which were then assembled and welded together vertically. An open, linear effect and unusual framing of space may be found in works such as *Hudson River Landscape* or *Australia* (both 1951), in which the natural setting, seen through voids, introduces ever-changing suggestions of colour, depth and movement.

If Smith's sculptures of the early 1950s had subjects that were loosely derived from nature, his works of the late 1950s were marked more by their monumental scale, their sense of surface and abstract 115 play of forms. The separate elements within *8 Planes and 7 Bars* (1958), for instance, reflect the flat forms of pre-War geometric painting and an admiration for Mondrian. The frontal and planar character of Smith's later work, his interest in working in series and his concern with light in the *Cubi* (early 1960s), influenced the next generation of American abstract painters, while his choice of materials and welding techniques were taken one step further by the English sculptor Anthony Caro. Smith's short career thus offered important links between one era in abstract art and the next.

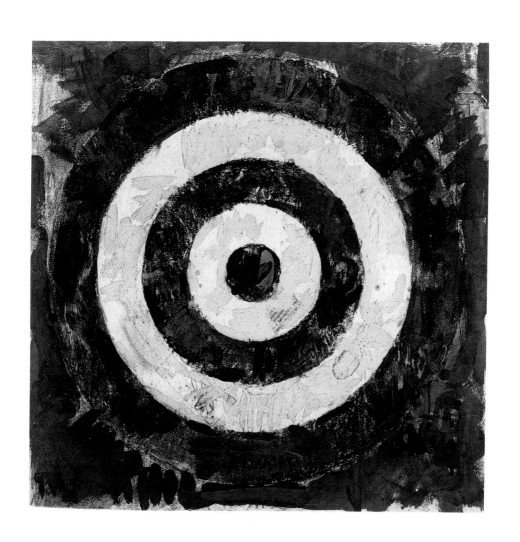

116 JOHNS *Target* 1958

Objective Approaches: Abstract art since 1956

It is language which speaks, not the author.

ROLAND BARTHES

The form of my painting is the content.

ELLSWORTH KELLY

In 1949 the popular magazine *Life* ran a three-page colour feature entitled, 'Jackson Pollock: Is he the greatest living painter in the US?' The accompanying photographs of the brooding, solitary figure established in the public eye the notion of the artist as a man of Angst, ready to put into his paintings the restless troubles of the decade. Pollock's premature death in 1956 intensified this image, and in the same year a touring exhibition, 'Modern Art in the United States', marked the international recognition of Abstract Expressionism. Yet ironically, just as the expressive abstraction of the post-War years was becoming accepted throughout the Western world, with Art Informel and Tachisme also spreading beyond France, reaction was beginning to set in. In 1956 an exhibition called 'This is Tomorrow' at the Whitechapel Art Gallery, London, heralded the inception of Pop art, and in the two decades that followed, abstract art came to be dominated by a cooler, more impersonal attitude far removed from the expressive individualism of Pollock.

Two main approaches eventually became apparent. One concentrated on the formal, object-oriented qualities of abstract painting and sculpture, related essentially to the formal aspects of Pop art; the other continued the traditional quest for 'metaphysical' meaning beyond the work itself. While the former tendency predominated particularly in America, the latter generally characterized European abstract art. However, it was not a matter of a clear-cut division between the two continents, particularly towards the end of the Sixties. The increasing internationalism, proliferation and broad dissemination of art magazines, and of travelling museum exhibitions and catalogues, meant that movements and ideas spread more quickly than before,

and that the ever-growing numbers of artists were inspired by developments not just across national borders but across continents as well.

As the aftermath of war gradually gave way to increased prosperity, the mood of existential gloom that had partly fuelled the art of the late 1940s and early 1950s began to lift. Artists in Europe in particular began to celebrate the scientific advances of the age, creating work that either drew upon new technological resources or reflected Utopian ideals inspired by the possibilities of space travel. Anonymity and impersonality were championed, as opposed to assertive individuality. Part of the reaction against personality was also a reaction against expressive painting. Once again, art tended to be 'constructed' rather than 'created', outward-looking rather than inward-looking, and, for the most part, optimistic. Within this frame of reference, which recalls the period of 'reconstruction' following the First World War, art was perceived as a means of changing consciousness. The mathematical and scientific basis of much of the work was not seen as an end in itself, but, frequently, as a means of aspiring towards perfect beauty or absolute truth. Such ambitions revived the metaphysical strain within earlier European abstraction and were in marked contrast to the dominant impulse of American art that began to emerge in the 1950s.

While their contemporary associates in St Ives, Cornwall, continued to pursue expressive and lyrical abstraction of the landscape in painting, the British 'constructionists' Anthony Hill (b. 1930) and Kenneth (1905–84) and Mary Martin (1907–67) were inspired by the American geometric artist Charles Biederman (b. 1906) to leave painting behind in favour of reliefs, mobiles and constructions. According to Biederman, whose book *Art as the Evolution of Visual Knowledge* (1948) was introduced to them by the British artist Victor Pasmore (b. 1908), the task of imitating natural appearances was no longer necessary, as mechanical means had replaced the previous role of the artist. Given the logical progression of art since Cézanne, even painting could now be abandoned because of its almost inevitable allusion to three dimensions. Instead, the 'construction' was seen as the successor to both painting and sculpture.

Mary Martin explored systemic procedures involving numerical permutations to create reliefs through which she sought to explore

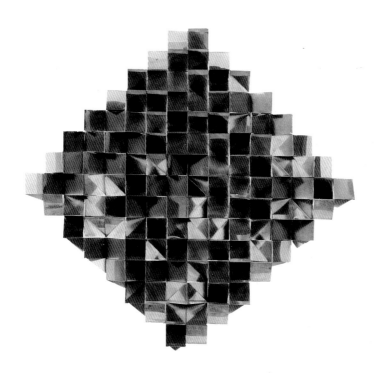

117 MARY MARTIN *Compound Rhythms with Blue* 1966

fundamental truth and beauty. Echoing earlier preoccupations during the century, she wrote in 1962 that 'the artist and the philosopher pursue reality, or essence. The philosopher expresses it and the artist creates it.' The metaphysical implications of her stance were echoed in *Compound Rhythms with Blue* (1966), where the use of stainless steel applied to faceted wooden cubes creates reflections that dissolve mass and instead suggest ever-changing patterns of light. For Martin, such constructions were based 'on implications of movement and infinity by positive and negative means', but their success rests on the understated and meditative effect they produce on the viewer.

117

A number of Mary Martin's reliefs were based on the Golden Section (a system of proportion involving division of a line into two parts, in which the ratio of the smaller part to the larger is the same as the ratio of the larger part to the whole). Since the time of Luca Pacioli's book *Divine Proportions* (1509), the Golden Section was believed to be the aesthetic principle underlying natural and organic

beauty, as well as the beauties of art and architecture. As such, it was also seen as a symbol of the inevitability and incomprehensibility of the cosmic order. Although countless artists had used the Golden Section as an aid to composition through history, its organizational (and mystical) principles obviously lent themselves particularly well to geometric abstract art. Its possibilities were also explored by later abstract artists such as the American Dorothea Rockburne, who came to prominence during the 1970s.

While Mary Martin was concerned with conveying movement through the play of natural light, her husband Kenneth Martin translated such ideas into moving objects, or kinetic constructions. As he wrote in the European magazine *Structure* in 1964, 'events are changed or rhythmically related by means of kinetics. The primitive forces of kinetics are universal, they are within us and without. Therefore, through their use it is possible to express life.' For Martin, the investigation of real movement resulted in the mobile. Yet unlike Calder's mobiles, Martin's kinetic constructions such as the *Screw Mobile* (1953) followed a system rather than a random configuration; the rational development of the shape echoes the logical and serial progression of the helix. Intriguingly, such links between nature and geometry were intensified when in 1953 the structure of DNA (and hence of life itself) was discovered to take the form of a double helix.

119

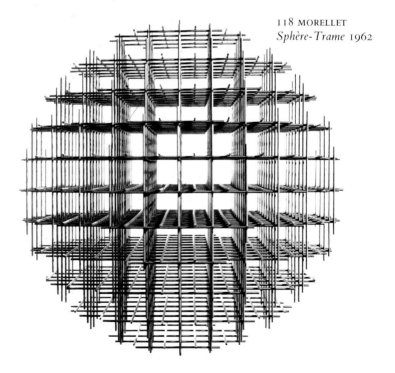

118 MORELLET
Sphère-Trame 1962

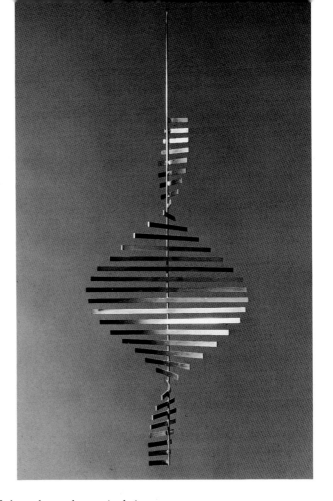

119 KENNETH MARTIN
Screw Mobile 1953

The Martins' 'scientific' and mathematical interests were not unusual in terms of European abstraction in the 1950s and 1960s. Following an important pioneering exhibition called 'Le Mouvement' in Paris in 1955, for example, a number of the participating artists – including the Belgian ex-CoBrA artist Pol Bury, the Venezuelan Jesús-Rafael Soto (b. 1923), the Israeli Yaacov Agam (b. 1928), the Swiss Jean Tinguely (b. 1925) and the Frenchman François Morellet (b. 1926) – continued to explore kinetic options in powered constructions or unpowered mobiles that followed programmed series. While Tinguely anarchically programmed his 'metamatic' 120 sculptures to produce their own abstract drawings by mechanistic means, Morellet exemplified a more detached approach in his *Sphère-* 118

Trame (1962). The materials (metal) and the form of the work (a perfect sphere) emphasize qualities of smooth precision in machine production, while the lack of focal point or of emotional content suggest the very different basis of this work from that of previous expressive art. A similar 'scientific' approach can be seen in the controlled and calculable illusion of Julio Le Parc's (b. 1928) *Continual Mobile, Continual Light* (1963). Tiny reflective squares of aluminium rotate on their axes through the smooth operation of a silent motor. The clean-cut forms and impersonal appearance of Le Parc's kinetic sculptures are indicative of a positive response to mechanized form, reflecting the technological optimism of the late 1950s and 1960s.

121

For other artists, the advances of new technology had visionary and Utopian implications, and the employment of 'real, mass-produced materials' was considered to be 'forward-looking'. The Hungarian artist (based in France) Victor Vasarély (b. 1908), for example, saw the machine as a way of overthrowing 'the myth' of craftsmanship and

120 TINGUELY *Metamatic No.9 ('Scorpion')* 1959

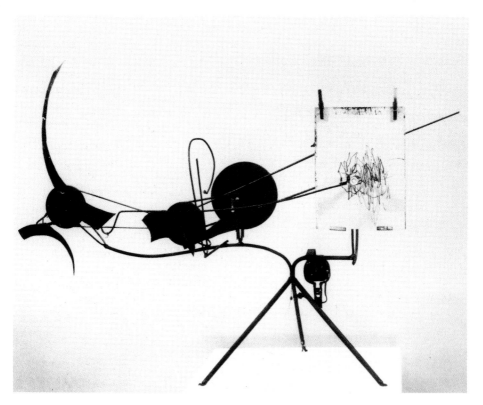

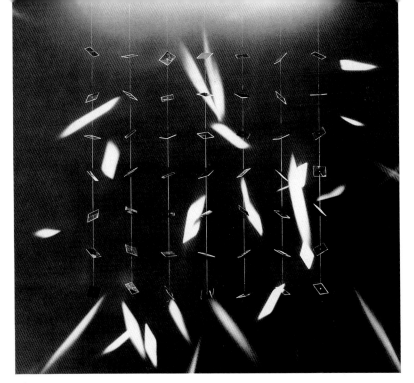

121 LE PARC *Continual Mobile, Continual Light* 1963

the unique work of art, and of reaching a wide public through mass-production. He sought ways of 'democratizing' his work through print-making and by integrating it with architecture. Vasarély used visual ambiguity to incorporate hallucinatory impressions of movement in abstract forms. In the screenprint *Tlinco* (1956) he suggests 132 movement within the strictures of a stable grid by distorting squares into lozenges and by exploiting the powerful contrast of black and white forms. Through both his work and writings Vasarély had a pervasive influence on other artists, which helped lead to the brief flowering of Op art in the 1960s: an art that curiously created intense visual experience through perceptual discomfort. In a painting such as *Fall* (1963), for example, another major 'Op' practitioner, the British 144 artist Bridget Riley (b. 1931), employed sequences of curved lines in black on white, to create an optical tension of movement between vertical and horizontal. In an effort to incorporate the visual counterpoint, the eye is forced to fluctuate both left and right.

179

While the use of black and white, and the interest in suggesting movement on a physically flat, two-dimensional surface inevitably linked Op art with the widespread impact of television, light also began to be exploited by artists as an independent art form and was applied both to abstract sculpture and to light spectacles. As early as 1948 in the *First Spatial Art Manifesto*, and in other writings, the influential Italian experimental artist Lucio Fontana (1899–1968) argued that 'a new art will be possible only with light and television' and that the skies could be opened up with 'artificial forms, rainbows of wonders, luminous sky writing'. If the phrasing is reminiscent of earlier Futurist aims, such grandiose schemes were now finally within the realms of possibility. At the entrance to Milan's 9th Art Triennale (1951), Fontana twisted two hundred metres of neon tubing to make abstract light patterns over the heads of visitors mounting the principal stairwell, fulfilling his prophecy of creating 'an aerial expression of art' and of 'freeing art of matter'. Ten years later, he expanded his use of neon lighting as decorative design to create an enlarged environmental concept for the Fonti di Energie in the Italian pavilion at Turin (1961).

'The fascinating attraction of light' was one of the major concerns of the Düsseldorf group Zero, founded in 1957. Heinz Mack (b. 1931) constructed light 'reliefs', such as *Light Dynamo* (1963), in which light vibrations are employed for their immaterial colour and tonality. Even the intention of his work was expressed mystically: in 1964 he wrote that the 'untouched and entirely distantly objective manner of appearance shows a possible reality whose emanation and secret beauty we now already love'. Another member of Zero, Otto Piene (b. 1928), worked with light in various forms, using reflectors, heliographs and shadow projections. Interested in spectator participation, he spoke of 'Utopia' in the magazine *Zero* (1961) in terms of shooting the viewer into space (like the first astronaut Yuri Gagarin) using twelve powerful searchlights. His wish was to light up the sky with 'art not weapons', so that man can 'experience eternity'. Günther Uecker (b. 1930) also believed in the importance of spectator participation, and his work exploited light to create shadow-patterns across monochromatic fields of white nails hammered into white

122 composition board, as in *White Field* (1964). In these works, the movement derives from entirely natural sources: the light in the surrounding environment activates the field and causes patterns of shadow to create rhythmic undulations across the surface as the spectator shifts position. Acknowledging the monotony of creating

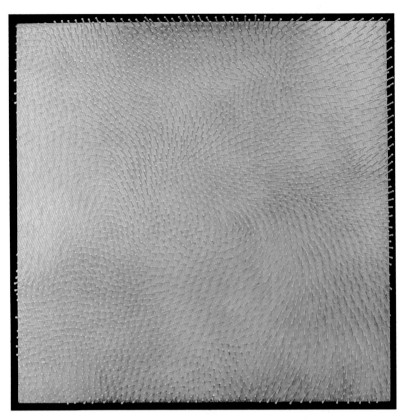

122 UECKER *White Field* 1964

so many similar constructions, Uecker stated that 'To render the development of a movement visible as a dynamic state is a significant action. It is not a matter of routine but fertile in its repetition, in its very monotony, like the experience of prayer.' Thus the group's belief in the spiritual potential of art revived the strand of pre-War European Constructivism, while their interest in new technological achievements placed them within the loose contemporary international association known as the Nouvelle Tendance.

The work of Zero was connected with the mystical idealism of the French artist Yves Klein (1928–62) – Uecker's brother-in-law. Klein's work, like Duchamp's before him, was particularly provocative and idiosyncratic. It was inspired by belief in the esoteric cult of Rosicrucianism (and later, by the works of Gaston Bachelard), and

consequently, Klein's famous blue monochromes (conceived as early as 1946 but only publicly exhibited in Paris in 1956) had a cosmic significance for him. Following Max Heindel's *The Rosicrucian Cosmo-conception* (1909, published in Paris 1925), he believed that blue possessed a metaphysical quality of immateriality and was thus imbued with meaning. In a lecture at the Sorbonne in 1959 he stated, 'Blue has no dimensions, it is beyond dimensions, whereas the other colours are not. . . . All colours arouse specific associative ideas, psychologically material or tangible, while blue suggests at most the sea and sky, and they, after all, are in actual, visible nature what is most abstract.' Klein's obsessional concern with blue led him to feel delighted when the first man in space stated that 'the world is blue', and to patent his own inimitable paint recipe, IKB (International Klein Blue). When this was used to make a monochrome, the base evaporated, leaving an optical experience of pure dry pigment: the particular *colour* blue.

While on the one hand the monochrome suggested the ultimate in abstraction (a logical reworking of the 'end' of painting that had already been engaged by Rodchenko and was being explored contemporaneously by artists as diverse as Ad Reinhardt, 1913–67, Lucio Fontana, Robert Rauschenberg and Piero Manzoni, 1933–63), on the other it was capable of suggesting a more metaphysical concern with silence. By emptying the canvas (and even his gallery exhibition room, 'Le Vide' in March 1958) of things, Klein drew attention to the power of silence ('immateriality'). If purity of silence could imply 'freedom from the prison of things', as suggested by the art historian Renato Poggioli, 'silent' abstract art in the 1960s gained resonance from its cultural juxtaposition with an increasingly active consumer society. Ironically, the problem of the 'value' of art was particularly well understood by Klein, who in 1959 sold zones of 'Immaterial Pictorial Sensibility' (nothing) in exchange for gold – an act reminiscent of the American composer John Cage, who recorded '4 Minutes, 33 Seconds of Silence' in 1954. In doing this, Klein enacted a magical, shamanistic function, transforming perception and providing access to higher metaphysical regions, in return for payment in the highly sought-after substance of his 'alchemical' trade. Hailed as either genius or charlatan, Klein at least pointed to the commercial incongruities of art at this time.

Given the purity of silent abstract art, it is not surprising to find several American artists interested in pursuing this option during the period of increasing commercialization of art in the 1960s and 1970s.

123
125, 126

123 REINHARDT
Abstract Painting
1951–52

124 RAUSCHENBERG
Untitled 1956

125 MANZONI
Achrome 1958

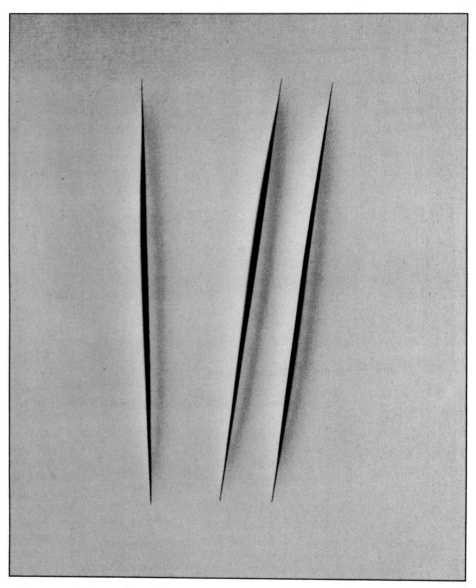

126 FONTANA *Concetto Spaziale* 1965

127 RYMAN *Mayco* 1965

Various artists, including Agnes Martin (b. 1912), Robert Ryman (b. 1930), James Turrell (b. 1943) and Brice Marden (b. 1938) went on to exercise enormous restraint in their art, which ranged from an almost immaterial, substanceless quality in the case of Turrell's light works, to an obdurate concentration on white in the quiet monochromes of
127 Ryman. Although for his part, Ryman has declared that 'there is never a question of what to paint, but only *how* to paint. The how of painting has always been the image – the end result', Martin and Marden have expressed their intentions in a more metaphysical vein.

In the 1960s Martin poetically described her paintings as having 'neither objects nor space, nor time, not anything – no forms. They are light, lightness, about merging, about formlessness, breaking down form', stating that 'you wouldn't think of form by the ocean'.

128 AGNĒS MARTIN *Morning* 1965

Underpinning her approach to painting is a search for eastern
transcendence, which drives her away from the world of matter,
nature and the ego to arrive instead at the arrested motion of the grid.
Her delicate and precise compositions suggest a mandala-like *128*
contemplativeness, while the thin pencilled lines suggest
something of this world as they hold the field together like the weft of
a rug. In the case of Marden, the serenity of the monochromatic,
encaustic panels in an ensemble such as the *Annunciation* series (1978) *129*
implies the power of abstract painting to evoke higher realms. By
suggesting that 'the rectangle, the plane, the structure, the picture are
but sounding boards for a spirit', Marden hints at the potential of
purely abstract form to reveal immanence: a concern that has led him
in the 1980s to investigate a more calligraphic type of abstraction,

187

129 MARDEN *Humiliatio (Annunciation series)* 1978

which is concerned with light and movement, and undoubtedly related to his designs for stained-glass cathedral windows.

Although certain artists may contest the notion of spiritual quality in their art, there is, as the American critic Donald Kuspit has pointed out, a certain mysticism associated with silent paintings. The evocation of spiritual experience connects the more 'silent' abstract art to the attempts of the early pioneers. Kandinsky's concern with the atmosphere or mood of abstract painting and Marc's search for a 'mystical inner construction' were not linked to a desire to communicate specific religious dogma, but to convey a more generalized spiritual experience. In recent years, this effect has been the topic of much discussion. For many critics the precise operation of

the spiritual in art has proved extremely difficult to put into words, and this in fact helped lead to a school of criticism that totally shunned discussion of meaning in order to concentrate upon the purely formal merits of the work itself. However, the very fact that spiritual experience does not lend itself easily to explanation means that it has continued to hold an attraction for artists wary both of discursive critiques and of the demand for instant communication that has played so great a part in late twentieth-century culture.

Although a metaphysical tradition continued after Abstract Expressionism, it is true to say that during the 1960s, at least in America, that tradition was temporarily eclipsed by other powerful impulses which made themselves felt in abstract art and criticism. Broadly speaking, two main related issues dominated the period: one revolved around the formal appearance of the work, and the other hinged upon its literal, object-based quality. While the first argument was developed by critics such as Clement Greenberg, Michael Fried and William Rubin, the second was put forward most notably by the relevant artists themselves. Despite their differences, both strains were united in trying to develop abstract art beyond the formidable achievements of the New York School. By 1960 the need to do so was already pressing. Mannered followers of de Kooning were filling the galleries in one area of New York with an undesirable 'Tenth Street touch': imitating the appearance of gestural abstraction without understanding its point. Meanwhile, representational challenges to abstract art were already successfully presenting themselves in the form of Pop art. However, in the more affluent and optimistic climate of the new decade, the existential agonizing of Abstract Expressionism seemed peculiarly out of place. Inevitably perhaps, American abstract art began to stress its own autonomy – but in so doing, it was in perilous danger of becoming hermetically sealed.

FORMALIST APPROACHES: POST-PAINTERLY ABSTRACTION

Clement Greenberg's critical position was already formed before the Second World War. In an essay of 1939, called 'Avant-garde and Kitsch', he propounded the view that 'content is to be dissolved so completely into form that the work of art or literature cannot be reduced in whole or in part to anything not itself . . . subject matter or content becomes something to be avoided like the plague'. While he conceded later that abstract art can 'convey a content equally important or equally unimportant' as all previous representational

art, he also felt 'the great masters of the past achieved their art by virtue of combinations of pigment . . . and that their greatness is not owed to the spirituality with which they conceived the things they illustrated so much as it is to the success with which they ennobled raw matter to the point where it could function as art'. Hence, in looking at abstract art, Greenberg shunned discussion of content and maintained instead that painting should insist exclusively upon its material attributes: on pigment, the shape of the canvas and upon its inevitable flatness.

By stressing the formal qualities of, for example, Barnett Newman's work, Greenberg overlooked the content, even though, as we have seen, it was a prime concern for the artist. In the first exhibition of Newman's work in New York for eight years, held at the French & Co. Gallery in March 1959, Greenberg's catalogue introduction noted the complex 'exploration of the tensions between different light values of the same colour and between different colours of the same light value'. To the critic, Newman's significance lay in the way 'he has enlarged our sense of the capacities of colour and of the capacities of the art of painting in general'.

Greenberg's formalist approach was extraordinarily influential during the late 1950s and 1960s and helps to explain why meaning ceased to be a central preoccupation for many American abstract artists at that time. In an article in *Art International* (May 1960), Greenberg hailed the Washington-based painters Morris Louis (1912–62) and Kenneth Noland (b. 1924) as new heirs to Newman's formal skills. In a discussion of Louis' *Veils* series (begun in 1954), Greenberg admired the artist's ability to 'create variations of hue' rather than of Cubist value (tone). Louis' technique, he said, conveyed 'a sense not only of colour as somehow disembodied and therefore more purely optical, but also of colour as a thing that opens and expands the picture plane'. Such concerns in Morris Louis' work were paradigmatic of the colour painting that came to prominence in the following decade.

Since 1952 Louis had developed a particular technique that gave his paintings a freshness and delicacy derived from 'open colour' almost 'breathing' through the canvas. Unlike the dense, matted surface of previous gesture painting, the work was allowed to operate without any 'painterly' effects, such as expressive brushstrokes or personalized facture. If this was partly true of Barnett Newman's paintings, Louis went further in allowing the image (colour veils) and the support (the canvas) to become literally one. Such results came from his discovery of staining and from his use of newly developed acrylic paint.

On a weekend visit to New York in 1952, Louis had visited the studio of the painter Helen Frankenthaler (b. 1928) and had been inspired by her large stain painting *Mountains and Sea* (1952). In effect, *134* Frankenthaler's example acted as a bridge between Jackson Pollock and the new generation of painters. Having visited Pollock's studio in East Hampton in 1951, Frankenthaler saw Pollock's black enamel house-paint 'pourings' of that year, in which the paint created matt areas where it had been absorbed into the unprimed cotton duck fabric, as well as shiny sections where it had been 'puddled'. Frankenthaler realized that the staining technique could be extended to colour and put to fully abstract use (for by this stage, Pollock was recognizing his 'early images' coming through). Thus, unlike the dark, heavily puddled areas of Pollock's 1951 work, Frankenthaler's first major stain painting, *Mountains and Sea*, despite its represent-ational overtones, has a luminosity of colour, a brilliance of light and a sensuous quality which were effected by thinning down the oil paint and allowing large areas of the light canvas to show through. The hitherto 'macho' and muscular connotations of action painting were transformed into a quieter, but effective lyricism in Frankenthaler's art. This was confirmed in later work which incorporated, as in *Eden* (1957), a greater degree of airiness, a lucidity and delicacy of colour obtained through staining and through the artist's interest in light.

For his part, Louis developed Frankenthaler's colour-staining by turning to a new medium. From 1947 he experimented with acrylic resin paint that had recently begun to be manufactured in America. Leonard Bocour's formula, Magna, offered Louis a new quality of light reflection and refraction, providing a luminosity and depth apparently unattainable in any other medium. (The acrylic resin Acryloid F-10 which was used as a medium in Magna has a transparency clearer than all but the highest grade of optical glass.) When used on unprimed canvas, as Louis preferred, Magna completely penetrated the fibres of the fabric and thus added to the painting's luminosity. As Bocour perfected the consistency of Magna, working in response to the artist's requirements, so Louis refined his technique. By 1960, with the availability of a new acrylic mixture that could now be thinned down, Louis began to pour fluid paint in smooth rivulets down the surface of the unprimed canvas to produce the *Unfurleds* series (1960–61). Once a mistake was made, the canvas *133* could not be corrected and the 'failed' painting had to be discarded. In 'painting' terms, this obviously meant that tremendous concentration was required during the period of making, an effort belied by the

130 POONS *Nixe's Mate* 1964

apparent fluidity and ease of the result. While the 'one-shot' technique, as it came to be known, and the concept of pouring paint bears obvious similarities to Pollock, the coolness of the result and the openness of space is quite different. The huge paintings, with their large expanses of pale, unprimed canvas broken only by harmonious colour bands, were daringly minimal statements at the time.

Along with Greenberg's formalist response, Louis' example encouraged other artists to utilize raw canvas positively, to experiment with acrylics and to explore the aesthetics of pure colour without subjective or symbolic reference. Emphasis therefore came to be placed on the actual process of making art, which came to be seen as the subject of the painting itself. A great variety of methods were explored: Jules Olitski (b. 1922), for instance, took up the use of the stained canvas in his 'core' paintings of the early 1960s, and then moved on to develop the technique of dyeing the surface through successive sprayings. This allowed him to dispense entirely with contoured shape or perspective and to create a delicate all-over colour haze. Larry Poons (b. 1937) used heavily saturated colour as a background for the placing of shimmering ovoid shapes, an approach that would lead eventually to Op art in the mid-1960s. In Washington

130

131 NOLAND
Turnsole 1961

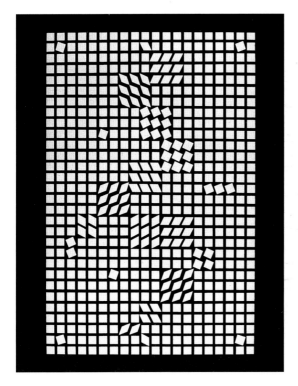

132 VASARÉLY
Tlinco 1956

133 LOUIS
Beta Kappa

itself, a number of artists pursuing Louis' example were quickly identified as the Washington Color Painters. Kenneth Noland, a friend of Louis, was one of these.

Having accompanied Louis to Frankenthaler's studio, Noland attested how both of them 'were interested in Pollock but could gain no lead to him. He was too personal. But Frankenthaler showed us a way – a way to think about and use colour.' Noland derived the staining technique from her, and the concept of 'one-shot' painting from Louis. In 1956 Noland found his first characteristic motif, the circle, possibly in answer to Josef Albers' square. Albers had taught Noland at Black Mountain College, but while Albers exploited the static balance of the square with interacting colour to create an illusion of movement and depth, Noland used the rotary implications of the circle within a plain field to emphasize the basic quality of flatness. While both artists were concerned with colour, Albers' awareness of

131, 67

134 FRANKENTHALER *Mountains and Sea* 1952 >

the spatial ambiguities of his chosen form related his work to the history of European abstraction, looking back to Malevich and Mondrian – a path that was simultaneously being explored by Vasarély. Noland's rings, on the other hand, belonged to the purely formal concerns of American 'Post-Painterly Abstraction': colour was used for its optical effect alone, and reference to the European tradition seemed deliberately shunned.

132

By 1964, when the term was coined by Clement Greenberg as the title of an important exhibition at the Los Angeles Museum of Art, Louis, Frankenthaler, Olitski and Noland (with twenty-seven others) were perceived as belonging to this new trend. The name derived from the idea that if the gestural painting of the New York School was 'painterly', then the new direction that followed must be 'Post-Painterly'. As most of the exhibiting participants had in common a

135 CARO *Early One Morning* 1963

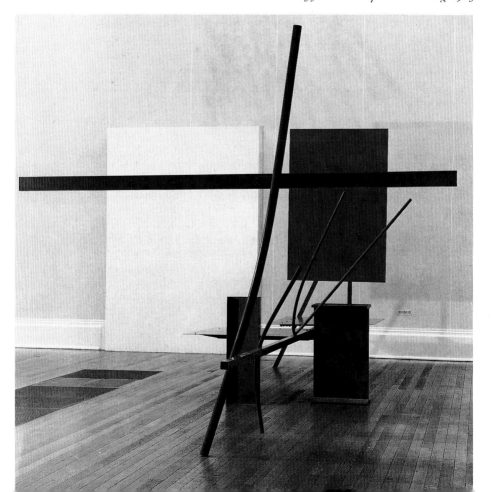

high-key and lucid colour, shunning thick paint and tactile effects, the artists were seen to be moving towards either 'a physical openness of design' or a 'linear clarity', or both. In comparison to Pop art (which he described as 'not really fresh'), Greenberg found the qualities of openness and clarity 'more conducive to freshness in abstract painting than most other instrumental qualities'.

While Greenberg's formalist approach provided excellent terms in which to discuss the work of abstract artists of the 1960s, and while it offered a *modus operandi* for art criticism generally, it was also prescriptive, and in that sense limiting. Though he could appreciate the sculpture of the British artist Anthony Caro (b. 1924), comparing his 'sustained quality' in 1965 to that of the late David Smith, it is significant that to Greenberg, Caro was 'the only sculptor' whose quality could compare.

135

ART AS OBJECT

While 'formalist' abstraction relied upon openness, clarity and colour to create an emphatically two-dimensional art, other artists working at the time pursued a more 'literalist' approach that stressed the 'objectness' of the work of art. In an important article in *Artforum* (April, 1970), the editor of the magazine, Philip Leider, explained this difference in relation to responses to Pollock's work. He argued that whereas formalists hailed in Pollock the 'triumph of the two-dimensional manner', literalists responded to the breakthrough of his technique: the fact that paint was transferred from can to canvas without any intermediary 'art' manipulation by brush, and that Pollock treated his picture as a thing – the receptacle for hand-prints and cigarette butts, as well as for paint itself. While this materialistic approach was not new to art (it was, after all, the same rationale that had led to Picasso's collages and Schwitters' *Merz* pictures, for example), the notion of the painting as object now began to emerge as a dominant force in American art. The way was paved by the work of two important artists during the 1950s: Robert Rauschenberg (b. 1925) and Jasper Johns (b. 1930).

In his first one-man show at the Betty Parsons Gallery (1951), Rauschenberg showed a series of identically sized canvases called *White Paintings* (1951) – the first monochromes to be exhibited by an American artist. However, his concern was not with metaphysics but rather with the autonomy of the work. By painting the series of canvases with a roller in house paint, with the full understanding that

136 NEWMAN *Vir Heroicus Sublimis* 1950–51

in order to keep them pristine they would need to be repainted, even by another person, Rauschenberg challenged the sanctity of the 'original' art work, the 'autograph' of the artist (in terms of his brushwork or gesture), and hence the notion of personal expression and the uniqueness of the individual work. Such ideas were confirmed in his comment about the series, that 'it is completely irrelevant that I am making them. *Today* is their creator'. Other early projects, including the *Black*, *Red* and *Gold-Leaf* paintings (which employed

124

textured materials such as crushed newspaper), showed a similar desire to spurn self-expression and emphasize the use of the real. Although Rauschenberg was later assimilated within Pop, his early work provides a conceptual bridge to later abstraction in America.

The same is also true of his friend and collaborator Jasper Johns, whose first one-person show at the Leo Castelli Gallery (1958) was an overnight sensation. Exhibiting three series of *Flag*, *Target* and *Number* paintings, Johns said that he chose such 'mundane' imagery in

137, 116

order to 'open men's eyes': the flag and target were 'both things which are seen and not looked at, examined'. As well as drawing attention to their real prototypes (to what is really there: How many stripes make up the American flag, for instance?) all three series were also abstract. The flag – always painted in its unfurled position, never wrinkled – comprised basic elemental shapes; the target consisted of simple concentric circles; while numbers are by nature abstract. However, the difference between Johns' literalist approach and Noland's

116, 131 formalist one can be seen by comparing a *Target* with a circle painting. Whereas Noland is concerned with the complete and centred flatness of the colour rings and shuns reference to anything outside the province of painting at all, Johns makes an object out of the image by stressing the literal connotations of both the title and the work. If a target is an object, so also is a painting. Moreover, rather than exploring optical colour effects, Johns uses encaustic (a thick, wax-based medium) to create a densely thick, emphatically physical surface. His concern to see the painting 'as an object, as a real thing in itself' was further amplified when he allowed the image to occupy the

137 entire field, without border or frame, as in *Flag* (1954–55).

One college student to explore further the potential of Johns' stripes, without making any reference to an object beyond the

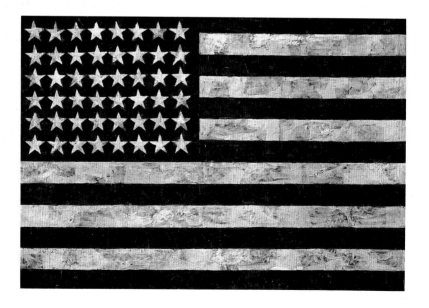

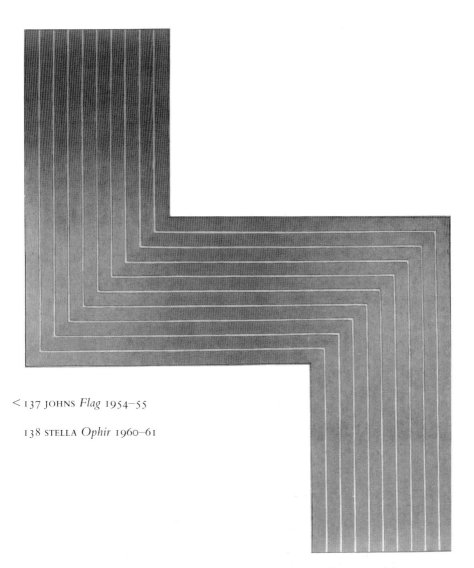

< 137 JOHNS *Flag* 1954–55

138 STELLA *Ophir* 1960–61

painting itself, was Frank Stella (b. 1936). In a series of paintings that were exhibited to shocked public response at MOMA, New York, in 1960, Stella rejected colour entirely and concentrated on the structural and compositional problems of abstraction, emphasizing total flatness. The paintings were executed in black enamel on canvas, and the smooth surface was interrupted by a sequence of stripes that crossed the diameter of the canvas and ran co-extensively with it.

Their direction was determined or 'deduced' from the shape of the support itself; a square format would tend to prompt a square patterning of lines. If this was logical, it was also rigorous and stark in its simplicity. As the lines neither marked contours nor created forms, the distinction between figure and ground was virtually obliterated, while the 'all-over' procedure ensured that no single part dominated the rest. Stella described this approach to painting as 'non-relational', to distinguish it from what he saw as the 'relational' striving for balance of parts to whole in previous European geometric abstract art. In comparison with his Abstract Expressionist predecessors, such as

136 Barnett Newman, Stella's approach was distinctly non-metaphysical, impersonal and dispassionate.

Following the internal logic of the black canvases, Stella went on to

138 modify the outer shape of the canvas, in unusual formats such as *Ophir* (1960–61). By the mid-1960s, the use of a thick stretcher was also raising the pictures off the wall, in the manner of a relief. While to Stella such a device seemed 'to actually accentuate the surface quality – to enhance the two-dimensionality of the painting's surface', to other artists such a strategy seemed rather to emphasize its literal 'objectness' – particularly in the light of his insistence on the work's non-referential intention. As he said in 1964, 'My painting is based on the fact that only what can be seen *is* there. It really is an object . . . and anyone who gets involved enough in this finally has to face up to the objectness of whatever it is that he's doing. He is making a thing. . . . All I want to get out of my paintings, and all I ever get out of them, is the fact that you can see the whole idea without any confusion. . . . What you see is what you see.' The crucial final sentence, which suggests that meaning follows on from the presence of the painting itself, and not from its capacity to signify absent events or values, became a vital reference point for other artists concerned with the autonomy of the art work.

Although Stella found that painting had everything he needed at the time and provided 'a full range of possibility and involvement', a number of his contemporaries believed that 'objectness' could be better pursued in three-dimensional form. For Ellsworth Kelly (b. 1923) the two were not mutually exclusive; his sculpture sprang naturally from concerns within his painting, and vice versa. Kelly's early fascination with shape, which was actually derived from physical observation of nature, later led him to experiment with curved forms in unusual relationships to the edge of the picture plane. *Red Blue* (1964), for example, shows the round curve of the form

139 KELLY
Blue Red Rocker 1963

meeting the straight edge of the canvas, thus breaking the traditional hierarchy of pictorial composition, creating ambiguity between image and ground, and producing a curious visual effect, in which the image appears to bend outwards. Given these concerns, it was a fairly logical step to free the integral shape entirely from the confines of the picture space, and allow it to exist autonomously, as in the aluminium *Blue Red Rocker* (1963). *139*

While Kelly continued to paint, artists such as Carl Andre (b. 1935), Donald Judd (b. 1928), Robert Morris (b. 1931) and Dan Flavin (b. 1933) completely relinquished painting in favour of three-dimensional works. The results were shown at a museum exhibition called 'Primary Structures' in New York in 1966. Despite the varying appearance of their work, the artists shared a concern with stripping sculpture down to its essence: a tendency that, like the contemporaneous reductive urge in painting, became identified at the time as

140 ANDRE *36 Pieces of Steel and Zinc* 1969

Minimal or ABC art. Its difference was immediately apparent: in 1965 the art historian Barbara Rose described ABC as an art 'whose blank, neutral, mechanical impersonality contrasts . . . violently with the romantic, biographical Abstract Expressionist style.' In terms of sculpture, such art involved various strategies: abolition of the pedestal; the use of industrial materials with smooth surfaces and mechanically precise joints to create an impersonal finish; flat, overall colour; serial form; a new approach to space; and above all, simplicity of shape. In terms of the last quality, it was ironically an earlier European sculptor, Brancusi, who provided particular inspiration. Exhibitions of his work had been staged in America in 1955–56 and special recognition was accorded him in Europe in 1959 and 1960.

Initially, it was Brancusi's practice of direct carving that appealed
141 strongly to Carl Andre. His early sculpture *Last Ladder* (1959) has affinities with Brancusi's wooden version of *Endless Column* (1918–20), for in this work Andre took up Brancusi's repetition of the modular unit in space. However, when he had finished *Last Ladder*, his friend Frank Stella pointed out that the back of the work was sculpture too. Realizing that 'the wood was better before I cut it than

204

141 ANDRE
Last Ladder 1959

after. I did not improve it in any way', Andre put carving aside and explored the possibility of using materials to 'cut into space', rather than personally cutting into the materials.

If carving became one of the 'unnecessaries' of sculpture in Andre's paring down to essences, space remained a prime concern. Inspired by the flatness of water on a canoeing holiday in 1965, Andre realized that the space occupied by sculpture need not be vertical. In his first firebrick piece, *Lever* (1966), Andre 'levelled' Brancusi's *Endless Column*, putting it 'on the ground instead of in the air'. The effect is disarming, because horizontality and flatness defy our expectations of what sculpture should be ('in the round', free-*standing*, 'solid' etc.). The spectator has to decide whether to maintain a regard for the integrity of the sculptural space, and walk round the piece, or to simply step over it. Further complications arise when the work is very long (*Lever* stretches $34\frac{1}{2}$ feet) or when it is so flat – like the scatter pieces, such as *36 Pieces of Steel and Zinc* (1969) – that it positively invites crossing. In fact Andre is happy for his metal 'rugs' to be walked over and uses the analogy of a road to suggest that 'there should be no one place or even a group of places where you should be' when viewing his work.

Although Andre renounced Brancusi's direct carving and reinterpreted his sculptural space, he retained the modular arrangement of *Endless Column*. In Andre's work, however, the notion of hand-crafted variety is totally repudiated in favour of industrial mass-production. Like the 'One-Image' painting of his contemporaries such as Noland, Andre's approach is 'systemic'. He takes a simple, standardized module and repeats it in a run (or system) to create a multiple structure. As the critic Lawrence Alloway described it in 1966, this kind of art is more concerned with 'factual display' than with 'underlying composition'. Andre's technique serves to focus attention on the essential nature of the materials he uses, on the actual qualities of stone, wood or steel. Given their simplicity, it is ironic that Andre's pieces belong to the age of conspicuous consumption and modern technology which was being iconized by Andy Warhol in the 1960s. Yet apart from the image, there is less difference between Andre's prefabricated industrial units and Warhol's multiples than might at first appear.

A similarly consistent use of technological materials may be found in Dan Flavin's light sculptures and Donald Judd's stacked wall pieces. Flavin's work reflects recent American interest at the time in the work of the Russian Constructivists, following the publication in 1962 of

142 FLAVIN *Monument to V. Tatlin* 1964

Camilla Grey's seminal account of *The Russian Experiment in Art 1863–1922*. Like Andre's 'rugs', his neon-light pieces, such as *Monument to V. Tatlin* (1964), share with the Russian Constructivists 142 the principle of 'real materials in real space'. The 'materials', however, are those of more recent technology, used in a streamlined, minimal style quite unlike Fontana's more baroque experiments in the same medium.

Like Stella, Donald Judd renounced the 'relational' concept behind art, and was instead committed to 'unrelational' work, to a sense of the whole. Nevertheless, Judd was aware that in sculptural terms, a sense of the 'whole' is a loaded concept, as one does not perceive any sculpture 'whole' at a glance. Being three-dimensional, sculpture involves perception over time; the spectator must consider (or feel) the work from all sides until the various 'views' can be assembled, and a complete image formed. Aware of this ambiguity, Judd plays on perceptions of form and space so that anticipation and actual experience are at variance. This occurs at the most basic level with a primary form, such as the large, open box *Untitled* (1973). Viewed from a short distance, the structure is perceived as a single, open, geometric cube made of copper. However, on standing immediately above the piece the viewer's understanding changes. The glowing red interior is not the result of polished copper, as we anticipate, but instead the red laquer base reflected in an inner skin of aluminium. The discovery is strangely satisfying; the anticipated known becomes a vehicle of surprise, and apparent simplicity forces a more complex reassessment of our powers of perception. Judd's more recent pieces continue to refer to these issues, and like Andre he uses both natural materials (wood) and industrially manufactured products, such as plexiglass.

The notion that simplicity of shape does not equate with simplicity of experience was elaborated on a theoretical as well as a practical level by Robert Morris. In a series of articles in 1966, Morris argued for a critical discourse that recognized the autonomy of modern sculpture and did not discuss it merely in terms of painting, as he felt was customary. Shape, he suggested, is the single most important sculptural value, but the aesthetic effect, rather than deriving merely from the object itself, is also dependent on unfixed variables such as the particular space (environment), the light for the display and the viewpoint of the spectator. Morris elaborated his conclusions after a period of making primary structures of his own. He had already pared down his own forms to a basic minimum (truncated pyramids and flattened cubes) in his fibreglass *Untitleds* (1965–66), and had rejected superimposed colour (as belonging to the province of painting) in favour of neutral grey tones.

If the work of the Minimalist painters and sculptors seems extraordinarily spare, it is worth remembering that a similar direction was being pursued in other arts at the time: the music of John Cage, for example, or the 'empty space' theatre of Peter Brook. Morris'

143 MORRIS *Untitled* 1965–66

theoretical research was also related to recent psychological and philosophical concerns. In America, Rudolph Arnheim had recently made a systematic attempt to apply the principles of Gestalt psychology to the visual arts in his book *Art and Visual Perception* (1951), while in Europe, Maurice Merleau-Ponty's book *The Phenomenology of Perception* (1945) emphasized the mind's constructive powers in perception and the independence of the object of perception. Similar ideas were being developed in the *nouveau roman* in France. In a 1965 English collection of his critical writings, Alain Robbe-Grillet negated the idea that art is a means to the attainment of some value that transcends it, to argue that 'if art is anything, it is everything, and it is consequently sufficient unto itself, and there is nothing beyond it'. With similar views having been expressed by Frank Stella, ('what you see is what you see') it is not surprising that the American critic Allen Leapa should have argued in the anthology *Minimal Art* (1968) that, whereas the Existentialist felt that at least he

144 RILEY *Fall* 1963

could define himself in terms of action (de Kooning or Pollock), the Minimalist believed that no definitions of self or art were possible. Instead, one was back to what alone could be known: the object's autonomy and the mind's powers of perception. Determinant meaning does not exist, and all that counts is the presence (factuality) of the work itself.

By the mid-1960s, however, this concentration on formalism and factuality in abstract art was threatening to lead to a cul-de-sac. If formalist abstraction was already non-illusionistically flat, how much

145 KING *Rosebud* 1962 >

flatter could it become? Abstract art was also facing an external double bind: extreme public incredulity on the one hand, versus unprecedented cultural assimilation on the other. If Andre's interest in 'significant blankness' left the public cold (a fact endorsed by the notorious row over the purchase and exhibition of his *Equivalent VIII*, 1966, by the Tate Gallery a full ten years later), the emergence of Op art gained popular acclaim through its rapid absorption into commercial design and fashion. Following the publication of an article in *Life* magazine in December 1964, Bridget Riley was *144* dismayed to discover on her arrival in New York that her paintings had been copied by fabric designers and were on display in Fifth Avenue shop windows even before the opening of the major Op exhibition 'The Responsive Eye' at the Museum of Modern Art.

At the same time the decorative and collectable potential of much 1960s abstraction was also being realized. Colourful abstracts began to be rapidly consumed through corporate and private patronage alike. Works by the British 'New Generation' group of St Martin's School sculptors, for instance (so called after their exhibition at the Whitechapel Art Gallery in 1965), were enthusiastically purchased in bulk by a British collector, Alistair McAlpine, who was smitten by their colour, though until then he had never collected contemporary work. The inclusion of three of these sculptors – Philip King (b. 1934), *145*

Tim Scott (b. 1937) and William Tucker (b. 1935) – in the 'Primary Structures' exhibition in New York (1966) revealed the affinities between the 'New Generation' sensibility and the zest and colour of Pop art, and posed a striking contrast to the rigorous theoretical approach of the American sculptors.

CONCEPTUAL STRATEGIES

McAlpine donated his sculpture collection to the Tate Gallery in 1971, yet for a large number of artists working in the late 1960s and 1970s, institutional assimilation of this kind was considered a dubious privilege. Modernist art had historically been an art of resistance that aimed to challenge the established order. In the revolutionary climate of 1968, this was called to mind again. Thus, rather than selling off 'inspiration to buy influence' (which Andre remarked seemed to be the paradoxical lot of artists), many made work that was in some way unsuitable for immediate consumption. Instead of pursuing abstraction within the definable categories of painting and sculpture (as commodities that could be bought and sold), artists tended to question previous categories, using impoverished materials to make transitory installations (*arte povera*); creating abstract works from natural resources in open-air locations that were frequently difficult to reach (Land art); or setting themselves verbal or mathematical problems (Concept art). The work was international in scope and later came to be grouped under the umbrella term of Conceptual art.

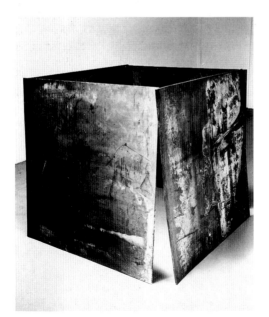

146 SERRA *One Ton Prop* (*House of Cards*) 1968–69

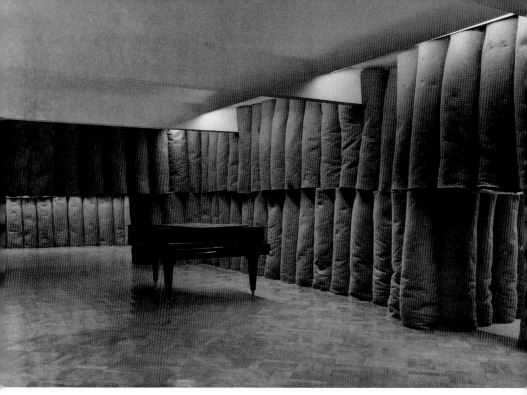

147 BEUYS *Plight* (detail) 1958–85

In the diverse work of the influential artist, teacher and spokesman Joseph Beuys (1921–86), for instance, the choice of materials was perhaps more significant than their eventual form. His selection of such materials as felt and fat to make sculptures was the result of his own extraordinary experience during the Second World War, when his plane was shot down over the Crimea and his life saved by Tartars who wrapped him in these substances to keep him warm. However, these natural (rather than technological) materials had wider implications through Beuys' belief in their power to transform human consciousness. In an age in which man's actions constantly threaten the natural environment, Beuys hoped to bring mankind back to a unity with nature. The objects and materials he used in his installations, performances and vitrines were intended to draw attention *147* to the precarious balance in the world and to 'promote thoughts about what sculpture *can* be'. In this instance, the artist hoped to effect a change in consciousness through his activities and example.

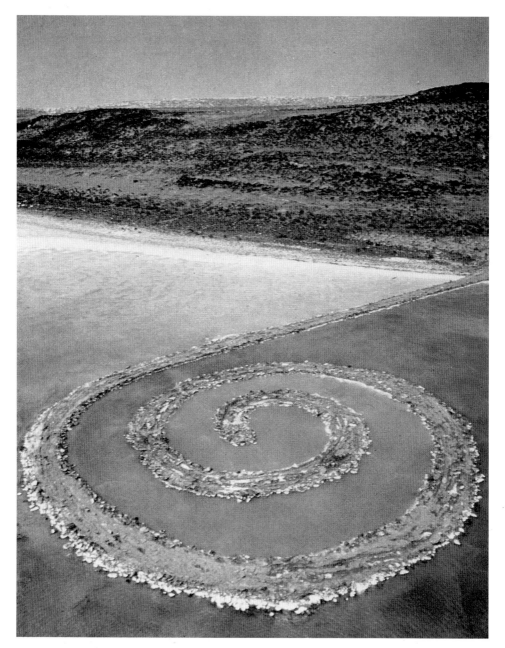

148 SMITHSON *Spiral Jetty*, Great Salt Lake, Utah 1970

During the 1970s the Land artist Richard Long (b.1945) charted the *149*
countryside on predetermined walks, documenting his activities by
photography, written statements, and by the relocation of parts of the
landscape into a gallery context, forming simple shapes such as circles,
spirals and lines on the floor and wall. While the shapes themselves are
abstract, the configurations of natural materials invite deeper
speculation about age and time, continuity between past and present
and the uncertain shifting relationship between modern man and the
environment. Similar strategies involving interaction with nature in
external locations were also pursued, though for different reasons, by
Robert Smithson (1928–73) and Michael Heizer (b. 1944); and a *148*
comparable use of photography is found in the work of Jan Dibbetts
(b. 1941) and Walter de Maria (b. 1935), among others.

The anti-commercialism of Conceptual art can clearly be seen in
the work of Daniel Buren (b. 1938), who used a simple abstract motif
– the stripe – to alter public perception of extant architecture and
natural surroundings. By placing the stripe on structures in the road, *151*
the park, the metro, even on water, as well as in (or even outside)
public galleries, Buren forced reconsideration of what the relevant
arena for art might be and for whom it was provided. Other artists,
such as Sol LeWitt (b. 1928) and Richard Serra (b. 1939), developed

149 LONG *Six Stone Circles* 1981

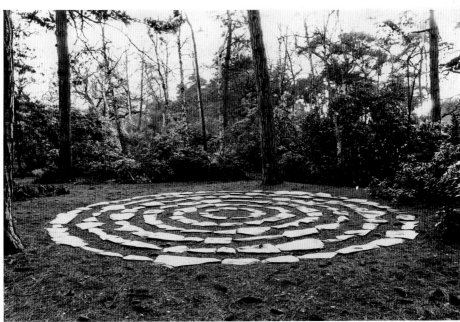

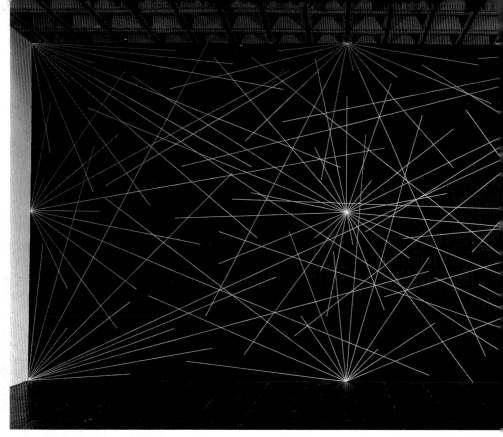

150 LE WITT *Lines to Points on a Grid* 1976

written concepts as the basis for an art procedure that also resulted in
150 abstract forms. Le Witt produced formulas for making wall drawings
that were executed not necessarily by himself but by various
technicians, while Serra constructed a list of over 120 verbs, beginning
'to roll, to crease, to fold, to store, to bend', as a basis for making
146 sculpture from a malleable material such as lead.

While the strategies of Conceptual art offered possibilities to scores
of artists eager to override accepted categories, they also meant that
during the 1970s painting and sculpture as traditional disciplines
tended to be marginalized by experimental artists. When a popular
revival of painting came, as it did in the late 1970s, the style was
figurative and predominantly expressionistic. Did this signal the end
for abstraction?

216

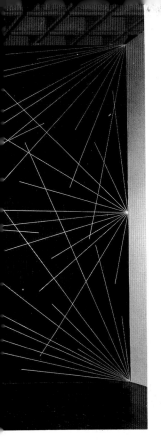

151 BUREN
Views of
Les Deux Plateaux
in the Cour d'Honneur,
Palais-Royal,
Paris 1985–86

152 STELLA *The Try Works (B-6, 2X)* 1988

Afterword

Art since the late 1970s has often been described as pluralist: rather than encompassing one dominant style, the period has embraced many. Terms such as 'appropriation', 'deconstruction', 'simulation', and 'post-modern' have been liberally applied by observers and practitioners trying to deal with the complex nature of the times, and abstraction has been in the forefront of a debate that has centred on the so-called 'death' of Modernism.

Yet despite the undeniable dominance of conceptual attitudes to art during the 1970s (which also helped to create new hybrids), abstract art as such did not entirely wither away. As we have seen Marden, Martin and Rockburne continued to paint, the reductive appearance of their work mitigated by what Andrew Kagan and Donald Kuspit have defined as a 'moral object', with dimensions of the absolute'. Equally, the 'literalist' approach to abstraction continued throughout the 1970s – but in a new guise. Feeling ill at ease with severe geometries, although hard-edge painting also continued, a number of artists practised a bright, hedonistic style that drew unashamedly upon colour and frequently also upon texture (either painterly or materialistic). However, rather than using objects found in nature to make their work, as many of the more conceptually orientated artists were doing, these artists tended either to continue the vibrant colouristic element in the art of Matisse, Hofmann and Pop, or to broaden their cultural perimeters by looking to the traditions of non-Western art, or to the decorative arts and design.

Claude Viallat (b. 1936) of the Support-Surface group in France, for example, used extant materials such as woven cloth or even window blinds (in *Window in Tahiti: Homage to Matisse*, 1976) as 153 supports for colourful abstractions that hang on the wall like rugs – although, like the other members of the group, the decorative appearance of his work is actually underpinned by a dense body of semiotic theory. In Britain, Stephen Buckley (b. 1944) has commented visually on Pop in his colourful abstracts. *Untitled* (1978) 154 consists of a square canvas placed over a rectangular one; but in setting

153 VIALLAT *Window in Tahiti:
Homage to Matisse* 1976

154 BUCKLEY
Untitled 1978

155 AYRES *Anthony and Cleopatra* 1982

one at an angle against the other, and in painting over the double
thickness of support with ribbon-like stripes, he contradicts the
picture's apparent flatness. Gillian Ayres (b. 1930), one of the twenty
artists who exhibited at the important abstract 'Situation' exhibition
in 1960, has continued to paint colourful, large-scale works which
now incorporate more decorative patterning. While Ayres' use of the
large scale remains particularly distinctive, many other artists have
also explored colour with increasing confidence during the 1970s and
1980s. In different ways and with varying intentions, painters such as
John Hoyland (b. 1934) and Howard Hodgkin (b. 1932) have pursued
highly sensuous colour within the strictures of carefully balanced

156 HOYLAND
25.4.78
1978

157 HODGKIN *Interior at Oakwood Court* 1978–83

158 RICHTER *Brick Tower* 1987

156

157 compositions. While Hoyland's vivid canvases of the late 1970s declared his continued allegiance to the concerns of American post-War painting, Hodgkin's smaller, bright-hued paintings of the 1980s seem particularly to endorse his long-term interest in Indian miniatures.

In America, a self-styled group called 'P & D' (many of whom are women) used 'pattern' and 'decoration' to unite paintings with architecture and furniture. Deriving inspiration from non-Western decorative schemes and frequently using mass-produced textiles, they created colourful abstract grounds against which more representational imagery could be placed. Their work also drew attention to the role of design in society and to the way in which decoration was considered generally suspect in the canons of modernist art and architecture. Similar challenges to our perceptions of the internal environment were also being made in Europe – albeit in more conceptually-inspired ways. Two pupils of Joseph Beuys, Blinky Palermo (1943–77) and Imi Knöbel (b. 1940), for instance, created total environments in the 1970s, in which the decorative ensemble of the whole room constituted the art work. While Palermo used subtle differences of colour to force perception of fluctuation and change

159 KNÖBEL *Double Counter in the Right Corner* 1986

160 ARTSCHWAGER *Round Mirror II* 1988

between individual series of paintings, Knöbel's more recent *159*
constructed reliefs have taken on the appearance of abstract furniture
pinned against the wall. A similar mixing of disciplines was also
pursued by the Swiss artist John Armleder (b. 1948), whose
combination of abstract paintings and furniture reliefs with obvious
architectural references, have – along with the sculpture of the
American Richard Artschwager (b. 1924) – paved the way for a *160*
contemporary variant of sculpture being pursued by a host of
younger European and American sculptors in the 1980s.

Nevertheless, the continuing vitality of abstraction was largely
obscured at the end of the 1970s by the well-publicized explosion of
figurative imagery. Following in the wake of the conscious
anonymity of Minimal and Conceptual art, a number of major
exhibitions at the turn of the decade unleashed evidence of a burning
zest for personal expression and pictorial representation among many
artists. Shows such as 'A New Spirit in Painting' (London, 1980) and
'Zeitgeist' (Berlin, 1981) marked the new direction, with numerous

publications by writers such as Achille Bonito Oliva providing critical support. The new figurative impulse, which sometimes went under the heading 'Neo-Expressionism', was interpreted as a timely response to the apparent dead-end of Modernism. With economic confidence shattered by the 1973 oil crisis, the notion of progress (which had underpinned modernity and hence modernist concepts of art) was increasingly called into question. In the context of the heart-searching that ensued, abstract art, like modernist architecture, came under attack. While recent modernist art had paradoxically been accepted by museums and institutions, it was also seen as elitist, lacking in popular appeal. Figurative art could, by this token, make up the shortcomings. The return to painting and to subject matter (frequently drawn from other traditions) seemed to at least one commentator – Charles Jencks – to correspond to Post-Modern trends in architecture: the use of polychromy, ornament, combined materials, pluralisms and disjunctures, as opposed to modernist truth to materials, logical consistency, straightforwardness and simplicity.

However, far from killing abstract art stone dead, the dominance of European figuration in the early 1980s helped to encourage an American counter-reaction in the form of a neo-abstract explosion. Like 'Neo-Expressionism', 'Neo-Geo' as it is known (amongst other things), was a self-conscious style, aware of its own manipulations and 'appropriations' of extant forms of art – hence 'neo' in the sense of revival and imitation, rather than 'new'. Unlike its figurative predecessor, however, Neo-Geo was the child of Pop, Minimal and Conceptual art as well as of technology and critical (sociological and structuralist) discourse. Rather than appealing to the senses or the emotions, it was cooler, more distanced, critical of, yet curiously complicit with, the consumer society that helped it shoot to fame. Encompassing a great many disparate artists, Neo-Geo did not form a cohesive group, although it became a convenient marketing label. Included in its ambit is the 'neo-conceptual' work of artists such as Haim Steinbach, Jeff Koons and Richard Gober, as well as the 'neo-abstract' paintings of their contemporaries.

Many of the painters – Ross Bleckner (b. 1949), Sherrie Levine (b. 1947), Peter Halley (b. 1953) and Philip Taaffe (b. 1955), draw freely on the abstract art of the 1960s, and earlier. By looking at such sources and by appropriating certain elements from them, they seem consciously to highlight the confidence of 1960s abstraction while also underlining their inevitable social, cultural and psychological – as well as temporal – distance from it.

The strategy of borrowing was in fact already being used by the painter Sherrie Levine as an 'appropriation' device in the early 1980s, *161* in delicate 'copies' of abstract works by modern masters such as Klee and Miró. Rather than continuing to copy a specific artist's work, her more recent paintings distil geometric forms from the wider field of 1960s abstraction, frequently in small-scale formats. The reduction of scale, not apparent in reproduction, invokes a sense of loss, alerting us to the fact that our familiarity with famous paintings tends not to be derived from live experience of their own particular 'aura', but from mechanical reproductions. In the current age of unprecedented and sophisticated media and technological expansion, the difference between the original and the copy, between the real and the simulated becomes even harder to sustain than when Walter Benjamin first published his seminal essay, 'Art in the Age of Mechanical Reproduction' (1936).

A rationale for simulation was provided by the emergence on the New York East Village scene of the artist–polemicist Peter Halley. Consciously inspired by the writings of the French theorists Jean Baudrillard and Guy Debord, Halley posited a technological universe of communication networks where only the model or the façade (no longer truth or essence) has meaning; or where, to cite Baudrillard, 'the only residue of reality is a surface without depth'. Halley's own paintings since 1981, although apparently abstract in style, draw upon the image of a cell and an underlying conduit system for their content. In *Yellow Prison with Underground Conduit* (1985), for example, *1*

161 LEVINE *Untitled*
(after Kandinsky) 1985

allusions to a prison cell, an architectural façade with hidden ducts, and the internal system of a computer, may all be found. Rendering his forms in pseudo materials (imitation stucco and day-glo colours – the last reminiscent of Frank Stella), Halley rationalized the 'simulacrum' in terms derived from French sociology and linguistics, citing the cell and conduit as models for his interpretations of 'hyper-reality'.

The modernist historical quest for a flat, depth-denying picture surface meant that geometric abstraction lent itself well to Halley's pictorial statements of depthlessness. However, Halley's work also shows how the optimism of the abstract pioneers has been undermined by the current consciousness of a very different, over-technological world in which artists are less certain of 'reality' and 'truth'. Hence, other Neo-Geo artists, such as Ross Bleckner and Philip Taaffe, tend to look to the abstract art of the 1960s as the last (p.2) moment of modernist confidence. Taaffe's appropriation of motifs from Bridget Riley, Barnett Newman and Ellsworth Kelly, for example, reflects his admiration for their work, but his own artistic procedures (which involve collages created by a complicated reproductive technique) distance us both from the originals and from the possibility of discovering any distinctive aura. Matt Mullican (b. 1951) and Ashley Bickerton (b. 1959) draw upon computer sign systems and advertising logos for their abstract design potential, using precise metallic finishes to echo mechanical reproduction and commercial packaging. The prominence of stylized pattern in Mullican's art, as in his *Untitled* (1984), hints at the universal language of the sign – a sort of visual Esperanto – employed to encode the immediate message communicable through a globally computerized network.

The Neo-Geo manifestation in America nostalgically refers to the heights of past art, while recognizing in many cases an emptiness and lack of direction in the current political, social and cultural climate. But it has not been the only abstraction to exist in the second half of the 1980s. Older abstract artists have continued to make contributions to abstract art as a continuing tradition, confirming their faith in its efficacy. Frank Stella and Gerhard Richter (b. 1932), for instance, have been aware of the need to rethink its language and purpose: while Richter has reconsidered the metaphysical basis of abstraction, Stella has probed formal issues of how abstract art can progress.

In 1982 Richter wrote in the Kassel 'Documenta' catalogue that we should not consider colour alone as the purpose of painting, but

'instead allow ourselves to see the unseeable'. The possibility of transcendence, of finding the 'incomprehensible reality' that we 'yearn for' links Richter to earlier traditions. However, the optimism of the metaphysical pioneers is subverted or deconstructed in his own approach. In recent work, such as *Brick Tower* (1987), superimposed 158 layers of paint are dragged into rills and rifts of dry pigment to reveal the rich texture of the underlying colour. Nevertheless, the formal composition of the work conveys the impression that it is incomplete, a frozen detail, and results in a sense of unreality, strangeness and loss. By exhibiting slightly blurred, painted reproductions of still photographs of natural scenes, Richter also seems to call into question our perceptions of meaning, certainty and truth, of what is abstract and what is 'real'.

In a published lecture, 'The Dutch Savannah' (1986), Frank Stella has forcefully reiterated his support for abstract art, but has argued that painting has to build in order to flower again. Suggesting that the roots of 1960s abstraction lay in the anti-materialism of the North (in the work of abstract pioneers such as Malevich, Kandinsky and Mondrian), he believes that it must now be reinforced by the energy of the South: 'the tough stubborn materialism of Cézanne, Monet and Picasso'. If 'solidity' and a sense of corporeal depth must come back into abstract painting, it is interesting to note that Stella's own work during the 1980s has moved into deep relief, becoming more illusionistic, more baroque and more ebullient in form, suggesting 152 indeed that abstraction still has force and potential for further spatial development.

It is also true to say that over the last twenty years, the distinctions between abstraction and representation have been increasingly and insistently dissolved. Many artists working today are discounting such traditional categories. As Jennifer Bartlett has said recently (echoing Robert Ryman – a very different kind of painter): 'My interest is in how it can be done, rather than what the imagery is.' Thus, far from playing a reductive role, abstract art has greatly increased the range of ideas, techniques and materials open to all kinds of artists. This has obviously been the case throughout most of the twentieth century, and with the benefit of hindsight its particular contribution is now becoming easier to assess. For the future, it seems safe to say that as art continues to be made, it will be so in both representational and abstract terms, though if current trends continue, it may not be long before the distinction between these different types of art ceases altogether to be an issue.

Bibliography

The following is a guide to the main sources on which this book is based and also to selected further reading.

General

Barr, A. H., *Cubism and Abstract Art*, MOMA, New York (1936); repr. Cambridge, Mass., and London (1986)

Blok, C., *Geschichte der abstrakten Kunst 1900–1960*, Cologne (1975)

Chipp, H. B., *Theories of Modern Art. A Source Book by Artists and Critics*, Berkeley, Los Angeles, and London (1968)

Dabrowski, M., and J. Elderfield, *Contrasts of Form: Geometric Abstract Art 1910–1980* (exh. cat.), MOMA, New York (1986)

Osborne, H., *Abstraction and Artifice in Twentieth-Century Art*, Oxford (1979)

Oxford Companion to Twentieth-Century Art, H. Osborne (ed.), Oxford (1981)

Ragon, M., *L'Art abstrait*, Paris, 4 vols. (1971–74)

Seuphor, M., *L'Art abstrait, ses origines, ses premiers maîtres*, Paris (1950)

The Spiritual in Art: Abstract Painting 1890–1985 (exh. cat.), Los Angeles County Museum of Art and tour, New York (1986)

Vallier, D., *L'Art abstrait*, Paris (1967); English lang. ed. New York (1970)

1 Observing the World: Paths to Abstraction 1910–14

THE FRAGMENTATION OF FORM

Abstraction: Towards a New Art. Painting 1910–20 (exh. cat.), Tate Gallery, London (1980)

Berger, J., *The Moment of Cubism, and other Essays*, London (1969)

Golding, J., *Cubism: A History and an Analysis 1907–14*, London and New York (1959); third, rev. ed. (1988)

Léger, F., *Functions of Painting*, London (1973)

Towards a New Art. Essays on the background to abstract art 1910–20, publ. to accompany the Tate Gallery exhibition, London (1980)

COLOUR FREED

Frantisek Kupka: A Retrospective (exh. cat.), Solomon R. Guggenheim Museum, New York (1975)

Synchromism and American Color Abstraction 1910–25 (exh. cat.), Whitney Museum of Art, New York (1978)

Vriesen, G., and M. Imdahl, *Robert Delaunay: Light and Colour*, Cologne and New York (1967)

Weiss, P., *Kandinsky in Munich: the formative Jugendstil years* Princeton, New York (c.1979)

SPEED AND THE MACHINE

Cork, R., *Vorticism and Abstract Art in the First Machine Age*, 2 vols., London (1976) and California (1977)

Futurism and Futurisms (exh. cat.), Palazzo Grassi, Venice (1986); English lang. ed. London (1986)

Michel, W., *Wyndham Lewis*, London (1971)

MUSICAL ANALOGIES

Hahl-Koch, J. (ed.), *Arnold Schoenberg, Wassily Kandinsky: Letters, Pictures and Documents*, London (1984)

Kagan, A., *Paul Klee: Art and Music*, Ithaca and London (1983)

Vergo, P., and K. C. Lindsay (eds.), *Wassily Kandinsky, Complete Writings on Art*, London (1982)

Worringer, W., *Abstraktion und Einfühlung*, Munich (1908); English lang. ed. London (1948)

2 Looking Inwards: Investigations 1912–20

KANDINSKY

Ringbom, S., 'Art in the epoch of the Great Spiritual', *Journal of the Warburg and Courtauld Institutes*, vol. xxix, London (1966); *The Sounding Cosmos, A Study of the Spiritualism of Kandinsky and the Genesis of Abstract Painting*, Copenhagen (1970)

Vergo and Lindsay, op.cit. (1982)

Washton Long, R. C., *Kandinsky: The Development of an Abstract Style*, Oxford (1980)

MONDRIAN

Mondrian, P., *The New Art – The New Life: The Collected Writings of Piet Mondrian*, London (1987)

Piet Mondrian 1872–1944 (exh. cat.), Solomon R. Guggenheim Museum, New York (1971)

Seuphor, M., *Piet Mondrian: Life and Work*, English lang. ed. New York (n.d.)

MALEVICH

Andersen, T. (ed.), *Malevich: Essays on Art* (2 vols.), Borgen, Copenhagen (1968) and London (1969)

Bowlt, J. E., 'Esoteric Culture and Russian Society', essay in *The Spiritual in Art*, op.cit. (1986)

Dalrymple Henderson, L., 'The Merging of Time and Space: The Fourth Dimension in Russia', *The Structurist*, vol. 15 (1976); *The Fourth Dimension and Non-Euclidean Geometry in Modern Art*, Princeton (1983)

Douglas, C., 'Beyond Reason: Malevich, Matiushin and their Circles', essay in *The Spiritual in Art*, op.cit. (1986)

Williams, R., *Artists in Revolution*, London (1978)

Zhadova, L. A., *Malevich: Suprematism and Revolution in Russian Art*, London (1982)

ARP, TÄUBER AND SCHWITTERS

Ades, D., *Dada and Surrealism Reviewed* (exh. cat.), Hayward Gallery, Arts Council of Great Britain, London (1978)

Arp 1886–1966 (exh. cat.), Württembergischer Kunstverein, Stuttgart, and the Minneapolis Institute of Arts and tour (1986)

230

Elderfield, J., *Kurt Schwitters*, London (1985)
Foster, S. C. (ed.), *Dada/Dimensions*, Ann Arbor (1985)
Jean, M. (ed.), *Arp: Collected French Writings*, London (1974)
Motherwell, R. (ed.), *The Dada Painters and Poets: An Anthology*, New York (1951)
Sophie Täuber Arp (exh. cat.), MOMA, New York (1981)

3 Social Ideals: Constructing the Future 1920–39

AFTER THE REVOLUTION IN RUSSIA
Art into Production: Soviet textiles, fashion and ceramics 1917–35 (exh. cat.), MOMA, Oxford (1984) and Crafts Council, London (1985)
Bann, S. (ed.), *The Tradition of Constructivism*, London (1974)
Barron, S., and M. Tuchman (eds.), *The Avant-Garde in Russia, 1910–1930: New Perspectives* (exh. cat.), Los Angeles County Museum of Art and tour (1980)
Grey, C., *The Russian Experiment in Art*, London (1962)
Lissitzky-Küppers, S., *El Lissitzky: Life, Letters, Texts*, first publ. Dresden (1967); rev. English ed. London, (1980)
Lodder, C., *Russian Constructivism*, New Haven and London (1983)
Milner, J., *Tatlin and the Russian Avant-garde*, Yale and London (1983)
Nash, S. A., and C. Lodder, *Naum Gabo: Sixty Years of Constructivism*, Museum of Art, Dallas, and tour (1985)

DE STIJL
Baljeu, J., *Theo van Doesburg*, New York (1974)
Doig, A., *Theo van Doesburg*, New York (1986)
Jaffé, H. L. C., *De Stijl*, London (1970)
De Stijl 1917–1931. Visions of Utopia (exh. cat.), Walker Art Center, Minneapolis, and tour (1982)
Troy, N., *The De Stijl Environment*, Mass. (1983)

THE BAUHAUS
Geelhaar, C., *Paul Klee and the Bauhaus*, Bath (1973)
Passuth, K., *Laszlo Moholy-Nagy*, London (1985)
Rotzler, W. (ed.), *Johannes Itten: Werke und Schriften*, Zurich (1972)
Spiller, J. (ed.), *Paul Klee: The Thinking Eye* (The Notebooks of Paul Klee), London (1961)
Whitford, F., *The Bauhaus*, London (1984)

RETREAT TO PARIS AND BEYOND
Apart from the original catalogues and magazines cited in the text, further contemporary periodicals which deal with abstract art in this period are: *Axis* (Quarterly Review of Contemporary Abstract Painting and Sculpture), London (1935–37) and *Vehsch-Gegenstand-Objet* Berlin (1922).

Further insights may also be gained from the following exhibition catalogues: *Abstraction-Création 1931–1936*, Musée d'Art Moderne de la Ville de Paris, and Westphälisches Landesmuseum, Münster (1978); *Constructivism in Poland 1923–36*, Museum Folkwang, Essen (1973); *Geometric Abstraction 1926–42*, Dallas Museum of Fine Arts (1972).

4 Abstractions in Europe 1939–56

Aftermath: France 1945–54. New Images of Man (exh. cat.), Barbican Art Gallery, London (1982)
Apollonio, U., *Hartung*, Milan (1966) and Paris (1967)
L'Art en Europe. Les années décisives, 1945–53 (exh. cat.), Musée d'Art Moderne, St Etienne, and Paris (1987)
Cobra (exh. cat.), Musée d'Art Moderne de la Ville de Paris (1982)
German Art of the Twentieth Century: Painting and Sculpture 1905–85 (exh. cat.), Royal Academy of Art, London (1985)
Heath, A., *Abstract Painting, its origins and meaning*, London (1953)
Lambert, J.-C., *Cobra*, London (1983)
Lewis, A., 'The Fifties. British Avant-garde Painting 1945–56', *Artscribe*, London, nos. 34, 35, 36 (March–Aug. 1982)
Leymarie, J., et al., *Abstract Art since 1945*, London (1971)
Paris-Paris, 1937–1957: Créations en France (exh. cat.), Centre Georges Pompidou, Paris (1981)
Paulhan, J., *L'Art informel*, Paris (1962)
Réalités Nouvelles 1946–56 (exh. cat.), Musée des Beaux-Arts, Calais (1980)
St Ives 1939–64. Twenty-five Years of Painting, Sculpture and Pottery, Tate Gallery, London (1985)
Spalding, F., *British Art Since 1900*, London (1986)
Takashina, S., 'New Directions in Japanese Art'; G. Washburn, 'Japanese Influences on Contemporary Art: A Dissenting View': essays in C. F. Yamada (ed.), *Dialogue in Art: Japan and the West*, London (1976)
Tapié, M., *Un art autre où il s'agit de nouveaux évidages du réel*, Paris (1952)
Wilson, S., 'Informal Painting in France, 1939–1949', unpublished M.A. thesis, Courtauld Institute, University of London (1979)

5 Focus on Expression: USA 1939–56

Abstract Painting and Sculpture in America 1927–1944 (exh. cat.), Carnegie Institute, Pittsburgh (1983)
Artforum, San Francisco, vol. IV, no. 1 (Sept. 1965). Special issue: 'The New York School'
Ashton, D., *The Life and Times of the New York School*, Bath (1972)
Auping, M. (ed.), *Abstract Expressionism: The Critical Development*, London (1988); publ. for an exhibition at the Albright-Knox Art Gallery, Buffalo
Greenberg, C., *Art and Culture: Critical Essays*, Boston and London (1961)
Guggenheim, P., *Out of this Century: Informal Memoirs*, New York (1946); rev. ed. London (1980)
Guilbaut, S., *How New York Stole the Idea of Modern Art: Abstract Expressionism, Freedom and the Cold War*, Chicago (1983)
Rose, B., *American Art since 1900: a critical history*, London (1967)
Rosenberg, H., *The Tradition of the New*, New York (1959)
Rosenblum, R., *Modern Painting and the Northern Romantic Tradition, Friedrich to Rothko* (Chapter 8, 'Abstract Expressionism'), London (1975)

Sandler, I., *The Triumph of Painting. A History of Abstract Expressionism*, New York (1970). A seminal study of this movement, also containing a comprehensive bibliography. See this for contemporary magazine articles and monographs to date.
Surrealism in America (exh. cat.), Rutgers University Art Gallery, New Brunswick (1977)
Transformations in Sculpture. Four Decades of American and European Art (exh. cat.), Solomon R. Guggenheim Museum, New York (1985)
Tuchman, M. (ed.), *The New York School: Abstract Expressionism in the 40s and 50s*, London (c.1970)

One-person retrospective catalogues since 1970 include: *Barnett Newman* (text by Thomas B. Hess), MOMA, New York (1971); *Barnett Newman* (The Complete Drawings 1944–1969), Museum of Art, Baltimore (1979); *Franz Kline* (The Vital Gesture), Art Museum, Cincinatti, and tour (1985); *Hans Hofmann* (Late Paintings), Tate Gallery, London (1988); *Jackson Pollock*, Centre Georges Pompidou, Paris (1982); *Mark Rothko* (1903–70), Tate Gallery, London (1987); *Willem de Kooning* (Drawings, Paintings, Sculpture), Whitney Museum of Art, New York, and tour (1983)

6 Objective Approaches: Abstract art since 1956

TECHNOLOGICALLY INSPIRED ART AND 'SILENT' PAINTING
Agnes Martin (exh. cat.), Institute of Contemporary Arts, University of Pennsylvania, Philadelphia (1973)
Ballo, G., *Lucio Fontana*, New York (1971)
Brett, G., *Kinetic Art*, London (1968)
Brice Marden: Paintings, Drawings and Prints 1975–80 (exh. cat.), Whitechapel Art Gallery, London (1981)
Directions in Kinetic Sculpture (exh. cat.), University Art Museum, University of California, Berkeley (1966)
Kenneth and Mary Martin (exh. cat.), Annely Juda Fine Art, London (1987)
Kinetic and Optic Art Today (exh. cat.), Albright-Knox Art Gallery, Buffalo, New York (1965)
Kuspit, D., 'Concerning the Spiritual in Contemporary Art', essay publ. in *The Spiritual in Art*, op.cit. (1986)
Mary Martin (exh. cat.), Tate Gallery, London (1984)
Poggioli, R., *The Theory of the Avant-garde*, Mass. and London (1981); first publ. in Italian (1968)
Robert Ryman (exh. cat.), Whitechapel Art Gallery, London (1977)
Robert Ryman (exh. cat.), INK, Zurich (1980)
Sekules, V. (ed.), *The University of East Anglia Collection*, University of East Anglia (1984)
Uecker, Zero and the Kinetic Spirit (exh. cat.), Howard Wise Gallery, New York (1966)
Vasarély, V., 'Notes pour un Manifeste', *Le Mouvement* (exh. cat.), Gal. Denise René, Paris (1955)
Yves Klein 1928–1962. A Retrospective (exh. cat.), Institute for the Arts, Rice University, Houston (1982)
Zero (reprints of three *Zero* magazines, intro. by Lawrence Alloway), Cologne and Mass. (1973)

FORMALIST APPROACHES: POST-PAINTERLY ABSTRACTION
Fried, M., *Three American Painters* (exh. cat.), Fogg Art Museum, Cambridge, Mass. (1965)
Greenberg, C., 'Avant-garde and Kitsch', 1939 article repr. in *Art and Culture*, op.cit. (1961); 'Art Chronicle: Irrelevance versus Irresponsibility', *Partisan Review*, 15 (1948); 'Louis and Noland', *Art International* (4 May 1960); *Post-Painterly Abstraction* (exh. cat.), Los Angeles County Museum of Art (1964); Preface to catalogue of *Caro and Paolozzi* (exh. cat.), Rijksmuseum Kröller-Müller, Otterlo (1965); repr. in *Studio International*, vol. 174, no. 892 (Sept. 1967); 'Recentness of Sculpture', essay in *American Sculpture in the Sixties* (exh. cat.), LACMA (1967).
Upright, D., *Morris Louis: The Complete Paintings* (a catalogue raisonné), New York (1985)
Waldman, D., *Kenneth Noland: A Retrospective* (exh. cat.), Solomon R. Guggenheim Museum, New York (1977)
The Washington Color Painters (exh. cat.), Fogg Art Museum, Cambridge, Mass. (1965)

ART AS OBJECT
The Alistair McAlpine Gift (exh. cat.), Tate Gallery, London (1971)
Alloway, L., *Systemic Painting* (exh. cat.), Solomon R. Guggenheim Museum, New York (1966); repr. in Battcock, *see below* (1968); *Robert Rauschenberg* (exh. cat.), Smithsonian, National Collection of Fine Art, Washington, D.C. (1976)
Battcock, G. (ed.), *Minimal Art: A Critical Anthology*, New York (1968)
Bourdon, D., *Carl Andre: A Redefinition of Sculpture*, New York (1978)
British Sculpture in the Twentieth Century (exh. cat.), Whitechapel Art Gallery, London (1981)
Crichton, M., *Jasper Johns*, London (1977); publ. on occasion of Whitney Museum of Art, New York, retrospective.
Dan Flavin (exh. cat.), Vancouver Art Gallery, Vancouver (1969)
Glazer, B., 'Questions to Stella and Judd', transcript of radio interview originally broadcast in Feb. 1964; repr. in Battcock, op.cit. (1968)
Goosen, E. C., *Ellsworth Kelly: Retrospective Exhibition of Paintings* (exh. cat.), MOMA, New York (1973)
Jasper Johns: Exhibition of Paintings, Drawings and Sculpture (exh. cat.), Whitechapel Art Gallery, London (1964)
Leider, P., 'Literalism and Abstraction: Frank Stella's Retrospective at the Modern', *Artforum* (April 1970)
Morris, R., 'Notes on Sculpture', publ. in *Artforum*: 1) Feb. 1966; 2) Oct. 1966; 3) Summer 1967; 4) April 1969. First three parts repr. in Battcock, op.cit. (1968)
Rose, B., 'ABC Art', *Art in America* (Oct./Nov. 1965); repr. in Battcock op.cit. (1968)
Rubin, W. S., *Frank Stella* (exh. cat.), MOMA, New York (1970)
Smith B., *Donald Judd: Retrospective Exhibition of Works* (exh. cat.), National Gallery of Canada, Ottawa (1975)

CONCEPTUAL STRATEGIES
Celant, G. (ed.), *Arte Povera. Conceptual, Actual or Impossible Art*, Milan and London (1969)

Fuchs, R. H., *Richard Long*, London and New York (1986)

Lippard, L. (ed.), *Six Years: The Dematerialization of the Art Object from 1966 to 1972*, London (1973)

Live in Your Head. When Attitudes become Form (exh. cat.), Kunsthalle, Bern, and ICA, London (1969)

Pier and Ocean (exh. cat.), Hayward Gallery, London (1980)

Afterword

Back to the USA: Pattern and Decoration, New Image, New Wave (exh. cat.), Rheinisches Landesmuseum, Bonn (1983)

Brougher, K., *The Image of Abstraction* (exh. cat.), Museum of Contemporary Art, Los Angeles (1988)

Cameron, D., *Art and Its Double* (exh. cat.), CCdiFC de Pensiones, Barcelona (1986); *NY Art Now*, The Saatchi Collection, London and Milan (1987)

Coleman, R., *Situation (An Exhibition of British Abstract Painting)* (exh. cat.), RBA Galleries, London (1960)

Endgame: Reference and Simulation in Recent Painting and Sculpture (exh. cat.), ICA, Boston (1986)

Foster, H. (ed.), *Post-Modern Culture*, London (1985)

Gablik, S., *Has Modernism Failed?* London and New York (1984)

Jencks, C., *What is Post-Modernism?*, London and New York (1986)

Kagan, A., *Arts Magazine*, various issues 1977–78 incl. no. 52, (pp. 136–40) Nov. 1977; no. 53, (pp. 115–17) Nov. 1978 and no. 61, (pp. 54–60) May 1987

Neo-Geometry (exh. cat.), Kunstverein, Munich (1986)

Pincus-Witten, R., *Postminimalism into Maximilism. American Art 1966–1986*, Ann Arbor (1987)

Rodgers, P., *The Subject of Painting* (exh. cat.), MOMA, Oxford (1982)

Simila/Dissimilia: Modes of Abstraction in Painting, Sculpture and Photography Today (exh. cat.), Städtische Kunsthalle, Düsseldorf (1987)

Stella, F., *Working Space*, London and Mass. (1986)

Weil, R. (ed.), 'Talking Abstract': interviews with American artists, in two parts: *Art in America* (July 1987, Dec. 1987)

While most of the quotations included in the text may be found in the major reference works cited above, the following are more obscure: Braque's statement on p.12 derives from an interview with John Richardson in the *Observer*, London (1 Dec. 1957). Meyerhold's declaration on p.81 was made in a magazine article in *Vestnik Teatra* (1920) and is reprinted in Edward Braun's book *Meyerhold on Theatre*, London (1978); Max Bill's analysis of *Fifteen Variations on a Single Theme* (1938) was taken from his exhibition catalogue from the Albright-Knox Art Gallery (1974); Yves Klein's Sorbonne lecture comments on blue, on p.182, were translated in a catalogue of an exhibition at Gimpel Fils, London (1973); the Robbe-Grillet quotation on p.209 is taken from *Snapshots: Towards a New Novel*, London (1965); and Jennifer Bartlett's comment on p.230 derives from an article by John Russell on her work in the *New York Times* (27 Feb. 1987).

List of Illustrations

Measurements are given in centimetres, followed by inches, height before width.

137 *Flag* 1954–55. Encaustic and collage on canvas 104.8 × 154.3 (41¼ × 60¾). The Museum of Modern Art, New York

KANDINSKY WASSILY
10 *Painting with the Black Arch* 1912. Oil on canvas 186 × 193.3 (73¼ × 76). Musée National d'Art Moderne, Paris
15 *Composition IV* 1911. Oil on canvas 159.5 × 250.5 (62¾ × 98⅝). Kunstsammlung Nordrhein-Westfalen, Düsseldorf
26 *Composition VI* 1913. Oil on canvas 195 × 300 (76¾ × 118⅛). Hermitage Museum, Leningrad
63 *Swinging* 1925. Oil on board 70.5 × 50.2 (27¾ × 19¾). Tate Gallery, London

KELLY ELLSWORTH
139 *Blue Red Rocker* 1963. Aluminium sculpture 185 × 101 × 155 (72⅞ × 39¾ × 61). Stedelijk Museum, Amsterdam

KING PHILIP
145 *Rosebud* 1962. Plastic sculpture 152.4 × 182.9 (60 × 72). The Museum of Modern Art, New York

KLEE PAUL
24 *Abstract: Coloured Circles with Coloured Bands* 1914. Watercolour on card 11.7 × 17.2 (4⅝ × 6¾). Kunstmuseum, Bern
64 *Crystal Gradations* 1921. Watercolour 24.5 × 31.5 (9⅝ × 12¾). Oeffentliche Kunstsammlung, Basel, Kupferstich-kabinett
65 *Polyphonic Setting for White* 1930. Watercolour 33.3 × 24.5 (13⅛ × 9⅝). Kunstmuseum, Bern

KLINE FRANZ
111 *Chief* 1950. Oil on canvas 148.3 × 186.7 (58¾ × 73½). The Museum of Modern Art, New York. Gift of Mr and Mrs David M. Solinger

KLIUN IVAN
36 *Composition* c.1917. Oil on canvas 68.9 × 87.9 (27⅛ × 34⅝). Thyssen-Bornemisza Foundation, Lugano, Switzerland

KLUTSIS GUSTAV
34 *Axiometric Painting* c. 1920. Oil on canvas 66 × 47.5 (26 × 18¾). Thyssen-Bornemisza Foundation, Lugano, Switzerland

KNÖBEL IMI
159 *Double Counter in the Right Corner* 1986. Installation in the Staatliche Kunsthalle, Baden-Baden 310 × 240 × 45 (122 × 94½ × 17¾). Photo Franz Silzner, Baden-Baden

KOBRO KATARZYNA
76 *Spatial Sculpture* 1928. Painted steel 44.8 × 44.8 × 46.7 (17⅝ × 17⅝ × 18⅜). Musée National d'Art Moderne, Paris

KOONING WILLEM DE
106 *Painting* 1948. Enamel and oil on canvas 108.3 × 142.5 (42⅝ × 56⅛). The Museum of Modern Art, New York. Purchase
108 *Excavation* 1950. Oil on canvas 203.5 × 254.3 (80⅛ × 100⅛). The Art Institute of Chicago

KUPKA FRANTISEK
6 *Disks of Newton* 1911–12. Oil on canvas 49.5 × 65 (19½ × 25⅝). Musée National d'Art Moderne, Paris
23 *Amorpha, Fugue in Two Colours* 1912. Oil on canvas 211 × 220 (83 × 86⅝). National Gallery, Prague

LANYON PETER
94 *Bojewyan Farms* 1951–52. Oil on masonite 121.9 × 243.9 (48 × 96). The British Council

LARIONOV MIKHAIL
18 *Rayonist Composition: Domination of Red* 1913–14 (dated on painting 1911). Oil on canvas 52.7 × 72.4 (20¾ × 28½). The Museum of Modern Art, New York. Gift of the Artist

LECK BART VAN DER
28 *Geometric Composition No.2* 1917. Oil on canvas 94 × 100 (37 × 39⅜). Kröller-Müller Museum, Otterlo

LÉGER FERNAND
3 *Contrasting Forms* 1914. Oil on canvas 80.7 × 65.2 (31¾ × 25⅝). Kunstsammlung Nordrhein-Westfalen, Düsseldorf

LE PARC JULIO
121 *Continual Mobile, Continual Light* 1963. Painted wood, aluminium and nylon thread 160 × 160 × 21 (63 × 63 × 8¼). Tate Gallery, London

LEVINE SHERRIE
161 *Untitled* (after Kandinsky) 1985. Watercolour 35.6 × 27.9 (14 × 11). Courtesy Mary Boone Gallery, New York

LEWIS WYNDHAM
22 *Composition* (for *Timon of Athens*) 1912. Coloured drawing 26 × 38.5 (10⅝ × 15¼). Private Collection

LE WITT SOL
150 *Lines to Points on a Grid* 1976. White crayon lines and black pencil grid on black walls. Whitney Museum of American Art, New York. Purchase, with funds from the Gilman Foundation

LISSITZKY LAZAR EL
35 *Crack! All is shattered!* (from *A Story of Two Squares*), 1920
49 *Beat the Whites with the Red Wedge* 1919
55 *Proun Room* 1923 (reconstruction 1965). Van Abbe-museum, Eindhoven

LONG RICHARD
149 *Six Stone Circles* 1981. Delabole slate. Diameter 1032 (406). Photo Courtesy Antony d'Offay Gallery, London

LOUIS MORRIS
133 *Beta Kappa* 1961. Acrylic resin on canvas 262.3 × 439.4 (103¼ × 173). National Gallery of Art, Washington, D.C. Gift of Marcella Louis Brenner

MACDONALD-WRIGHT STANTON
9 *Conception Synchromy* 1915. Oil on canvas 76.2 × 61 (30 × 24). Whitney Museum of American Art, New York

MALEVICH KASIMIR
30 *Eight Red Rectangles* 1915. Oil on canvas 57.5 × 47.9 (22⅝ × 18⅞). Stedelijk Museum, Amsterdam
31 *Volumetric Suprematist Elements* 1915. Pencil on paper 7.7 × 10.2 (3 × 4). Museum Ludwig, Cologne, Ludwig Collection
33 *Untitled: Dynamic Suprematism* 1915. Oil on canvas 101.5 × 62 (40 × 24⅜). Stedelijk Museum, Amsterdam

MANESSIER ALFRED
81 *Morning Space* 1949. Oil on canvas 130 × 162 (51⅛ × 63¾). Musée National d'Art Moderne, Paris

MANZONI PIERO
125 *Achrome* 1958. Mixed media on canvas 100.3 × 100.3 (39½ × 39½). Tate Gallery, London

MARC FRANZ
5 *Tyrol* 1913–14. Oil on canvas 135.7 × 144.5 (53⅜ × 56⅞). Staatsgalerie Moderner Kunst, Munich

MARDEN BRICE
129 *Humiliatio (Annunciation series)* 1978. Oil and wax on canvas 213 × 244 (83⅞ × 96). Museum Ludwig, Cologne, Ludwig Collection
MARTIN AGNES
128 *Morning* 1965. Acrylic on canvas 182.5 × 181.9 (71⅞ × 71⅝). Tate Gallery, London
MARTIN KENNETH
119 *Small Screw Mobile* 1953. Metal 63.5 × 22.9 (25 × 9). Tate Gallery, London
MARTIN MARY
117 *Compound Rhythms with Blue* 1966. Stainless steel, aluminium, painted wood 107.4 × 108 × 7.6 (42¼ × 42½ × 3). Collection The Arts Council of Great Britain
MASSON ANDRÉ
100 *Rapt* 1941. Drypoint 30.8 × 40.6 (12⅛ × 16). The Museum of Modern Art, New York. Anonymous loan
MATHIEU GEORGES
92 *Capetians Everywhere* 1954. Oil on canvas 295 × 600 (116 × 236). Musée National d'Art Moderne, Paris
MATTA ROBERTO
101 *The Onyx of Electra* 1944. Oil on canvas 127.3 × 182.9 (50⅛ × 72). The Museum of Modern Art, New York. Anonymous fund
MICHAUX HENRI
90 *Untitled* 1959. Indian ink on paper 75 × 105 (29½ × 41¾). Musée National d'Art Moderne, Paris
MIRÓ JOAN
72 *The Birth of the World* 1925. Oil on canvas 250.8 × 200 (96¾ × 78¾). The Museum of Modern Art, New York. Acquired through an anonymous fund, the Mr and Mrs Joseph Slifka and Armand G. Erpf Funds, and by gift of the Artist
99 *The Poetess (Constellation series)* 1940. Gouache and essence on paper 36 × 46 (14⅛ × 18⅛). Private Collection
MOHOLY-NAGY LÁSZLÓ
58 *A pn 3* 1923. Oil on canvas. Private Collection
59 *Photogramme (Positive)* 1922–26.
MONDRIAN PIET
25 *Painting I* 1921. Oil on canvas 96.5 × 60.6 (38 × 23⅞). Wallraf-Richartz Museum, Cologne
27 *Composition No.10 (Pier and Ocean series)* 1915. Oil on canvas 85 × 108 (33½ × 42½). Kröller-Müller Museum, Otterlo
29 *Composition in Colour B* 1917. Oil on canvas 50 × 44 (19⅝ × 17¾). Kröller-Müller Museum, Otterlo
98 *Victory Boogie-Woogie* 1944. Oil on canvas 126 × 126 (49⅝ × 49⅝). Private Collection
MORELLET FRANÇOIS
118 *Sphère-Trame* 1962. Stainless steel 45 (17¾) diameter. University of East Anglia Collection
MORRIS ROBERT
143 *Untitled* 1965–66. Installation. Courtesy Leo Castelli Gallery
MOTHERWELL ROBERT
110 *Elegy to the Spanish Republic* 1953–54. Oil on canvas 209 × 351 (82¼ × 138⅛). Museum Ludwig, Cologne, Ludwig Collection
NEWMAN BARNETT

114 *Onement III* 1948. Oil on canvas 182.9 × 86.4 (72 × 34). The Museum of Modern Art, New York. Gift of Mr and Mrs Joseph Slifka
136 *Vir Heroicus Sublimis* 1950–51. Oil on canvas 242.2 × 513.6 (95⅜ × 213¼). The Museum of Modern Art, New York. Gift of Mr and Mrs Ben Heller
NICHOLSON BEN
78 *White Relief* 1935. Oil on mahogany 101.6 × 166.4 (40 × 65½). Tate Gallery, London
NOLAND KENNETH
131 *Turnsole* 1961. Synthetic polymer paint on canvas 239 × 239 (94⅛ × 94⅛). The Museum of Modern Art, New York. Blanchette Rockefeller Fund
O'KEEFFE GEORGIA
13 *Evening Star III* 1917. Watercolour 22.9 × 30.2 (9 × 11⅞). The Museum of Modern Art, New York. Mr and Mrs Donald B. Straus Fund
OUD J.J.P.
53 Design for the façade of the Café de Unie 1925. Gouache on paper 73 × 84 (28¾ × 33). Private Collection
PICABIA FRANCIS
21 *I see again in Memory my dear Udnie* 1914. Oil on canvas 250.2 × 198.8 (98½ × 78¼). The Museum of Modern Art, New York. Hillman Periodicals Fund
PICASSO PABLO
2 *Female Nude* 1910. Oil on canvas 187.3 × 61 (73¾ × 24). National Gallery of Art, Washington, D.C. Ailsa Mellon Bruce Fund
POLLOCK JACKSON
97 *Full Fathom Five* 1947. Oil on canvas, with nails, tacks, buttons, key, coins, cigarettes, matches 129.2 × 76.5 (50⅞ × 30⅛). The Museum of Modern Art, New York. Gift of Peggy Guggenheim
103 *Shimmering Substance (Sounds in the Grass series)* 1946. Oil on canvas 77 × 63 (30⅛ × 24¾). Private Collection
107 *Number 1, 1950 (Lavender Mist)* 1950. Oil, enamel and aluminium on canvas 221 × 299.7 (87 × 118). National Gallery of Art, Washington, D.C. Ailsa Mellon Bruce Fund
POONS LARRY
130 *Nixe's Mate* 1964. Acrylic on canvas 177.8 × 284.5 (70 × 112). Private Collection
POPOVA LYUBOV
48 Design for the stage set for *The Magnanimous Cuckold*, 1922. Collage, ink and gouache on paper 32.7 × 23.8 (12⅞ × 9¾). Tretyakov Gallery, Moscow. Photo courtesy Arts Council of Great Britain
PUNI IVAN
43 *Suprematist Construction* 1915. Wood, metal and cardboard 69.8 × 48.7 × 7 (27½ × 19⅛ × 2¾). National Gallery of Art, Washington, D.C. Andrew W. Mellon Fund 1977
RAUSCHENBERG ROBERT
124 *Untitled* 1956. Gold leaf, fabric and collage 26 × 26 (10½ × 10½). Private Collection
REINHARDT AD
123 *Abstract Painting* 1951–52. Oil on canvas 203.2 × 106.7 (80 × 42). Tate Gallery, London
RICHTER GERHARD
158 *Brick Tower* 1987. Oil on canvas 200 × 140 (78¾ × 55). Courtesy Antony d'Offay Gallery, London

RIETVELD GERRIT
52 'Red and Blue' chair 1917–19. Painted wood 86.5 × 67.3 × 67.3 (34⅛ × 26½ × 26½). The Museum of Modern Art, New York. Gift of Philip Johnson
RILEY BRIDGET
144 Fall 1963. Acrylic on board 141 × 140.3 (55½ × 55¼). Tate Gallery, London
RIOPELLE JEAN–PAUL
88 Chevreuse 1954. Oil on canvas 301 × 391 (118½ × 154). Musée National d'Art Moderne, Paris
RODCHENKO ALEKSANDR
50 Cover design for Novy Lef 1928
ROTHKO MARK
109 White, Yellow, Red on Yellow 1953. Oil on canvas 230.5 × 180.3 (90¾ × 71). Private Collection
113 Untitled (Multiform) 1947. Oil on canvas 154.9 × 109.2 (61 × 43). Private Collection
ROZANOVA OLGA
51 The Universal War 1916. Collage 22.9 × 33 (9 × 13). Private Collection
RYMAN ROBERT
127 Mayco 1965. Oil on canvas 198 × 198 (76 × 76). Saatchi Collection
SCHLEMMER OSKAR
61 Costume designs for the Mechanical Ballet 1923. Archiv Hochschule für Architektur und Bauwesen, Weimar
SCHMIDT JOOST
60 Poster for the Bauhaus exhibition 1923. Bauhaus-Archiv/Museum für Gestaltung, Berlin
SCHWITTERS KURT
37 Merzpicture Thirty-One 1920. Assemblage 97.8 × 65.8 (38½ × 25⅞). Sprengel Museum, Hanover
40 Revolving 1919. Relief construction of wood, metal, cord, cardboard, wool, wire, leather and oil on canvas 122.7 × 88.7 (48⅜ × 35). The Museum of Modern Art, New York. Advisory Committee Fund
SERRA RICHARD
146 One Ton Prop (House of Cards) 1968–69. Lead. Each plate 139.7 (55) square. Saatchi Collection
SEVERINI GINO
14 Sea = Dancer 1914. Oil on canvas 105.3 × 85.9 (41½ × 33⅞). Peggy Guggenheim Collection, Venice (The Solomon R. Guggenheim Foundation)
SMITH DAVID
115 8 Planes 7 Bars 1958. Stainless steel 316.9 × 195.6 × 57.8 (124¾ × 77 × 22¾). Private Collection
SMITHSON ROBERT
148 Spiral Jetty, Great Salt Lake, Utah 1970. Mud, precipitated salt crystals, rocks, water; coil 457 metres (1,500 ft) × 457.2 cm (15 ft) (approximate width).
SOULAGES PIERRE
89 Painting 1952. Oil on canvas 194.9 × 130.2 (76¾ × 51¼). Tate Gallery, London
STAËL NICOLAS DE
87 Marathon 1948. Oil on canvas 85 × 65 (31⅝ × 25½). Tate Gallery, London
STELLA FRANK
138 Ophir 1960–61. Copper oil paint on canvas 250.2 × 210.2 (98½ × 82¾). Private Collection

152 The Try Works (B-6, 2X) 1988. Mixed media on cast aluminium 281.3 × 235.6 × 114.3 (110¾ × 92¾ × 45). Courtesy Knoedler Gallery, New York
STELLA JOSEPH
19 Battle of Lights, Coney Island c.1913–14. Oil on canvas 99 × 74.9 (39 × 29½). Sheldon Memorial Art Gallery, University of Nebraska-Lincoln. J. M. Hall Collection
STEPANOVA VARVARA
47 Abstract textile design 1924
STILL CLYFFORD
105 Painting 1944. Oil on canvas 264.5 × 221.4 (104¼ × 87¼). The Museum of Modern Art, New York. The Sidney and Harriet Janis Collection
TAAFFE PHILIP
Frontispiece Big Iris 1986. Linoprint collage, acrylic on canvas 160 × 160 (63 × 63). Saatchi Collection
TATLIN VLADIMIR
42 Corner Counter Relief 1915 (reconstruction 1980). Iron and wood 78.5 × 80 × 70 (30⅞ × 31½ × 27½). Photo courtesy Annely Juda Fine Art, London
44 Contemporary photograph of Monument to the IIIrd International 1919–20
TÄUBER SOPHIE
77 Planes Outlined in Curves 1935. Oil on canvas 55.5 × 46 (21⅞ × 18⅛). Kunstmuseum, Winterthur
TINGUELY JEAN
120 Metamatic No.9 ('Scorpion') 1959. Iron, sheet metal, wood, wires, rubber belt, electric motor 110V, painted black 85 × 144 × 36 (33½ × 56⅝ × 14⅛). Museum of Fine Arts, Houston
TOBEY MARK
86 Edge of August 1953. Casein on composition board 121.9 × 71.1 (48 × 28). The Museum of Modern Art, New York. Purchase
UECKER GÜNTHER
122 White Field 1964. Mixed media relief 87 × 87 × 7.6 (34¼ × 34¼ × 3). Tate Gallery, London
VANTONGERLOO GEORGES
56 Construction of Volumetric Interrelations 1924. Cement cast painted white 25.5 × 25 (10 × 9⅞). Peggy Guggenheim Collection, Venice (The Solomon R. Guggenheim Foundation)
VASARÉLY VICTOR
132 Tlinco 1956. Silk screen print 66 × 50.5 (26 × 19⅞). University of East Anglia Collection
VEDOVA EMILIO
93 Invasion 1952. Tempera 170 × 135 (66⅞ × 53⅛). Private Collection
VIALLAT CLAUDE
153 Window in Tahiti: Homage to Matisse 1976. Mordants and acrylic on a fringed blind 207 × 170 (81½ × 67). Musée National d'Art Moderne, Paris
WINTER FRITZ
95 Force-Impulses of the Earth 1944. Oil on paper 30 × 21 (11⅞ × 8¼). Kunstsammlung Ruhr-Universität Bochum
WOLS (OTTO WOLFGANG SCHULZE)
82 The Butterfly Wing 1947. Oil on canvas 55 × 46 (21⅝ × 18⅛). Musée National d'Art Moderne, Paris

Index